THE COWBOY WAY

THE COWBOY WAY

A PICTORIAL SAGA OF THE LEGENDARY AMERICAN COWBOY

Photographs by
DON CONTRERAS

Text by
MIMI ALTREE

LONGSTREET PRESS
Atlanta

Published by
LONGSTREET PRESS
2974 Hardman Court
Atlanta, Georgia 30305

Printed in Hong Kong
1st printing 2003

Library of Congress Catalog Card Number: 2003100232

ISBN: 1-56352-688-3

Jacket and book design by Burtch Hunter Design LLC

To all who live the cowboy way.
To all who rode before us.

CONTENTS

THE COWBOY WAY

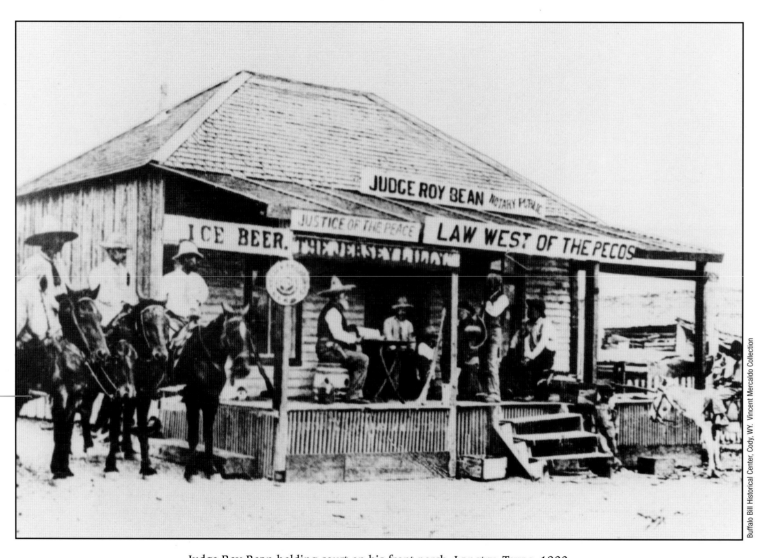

— Judge Roy Bean holding court on his front porch, Langtry, Texas, 1900 —

FOREWORD

By JUDGE ROY BEAN
SASS MEMBER #1

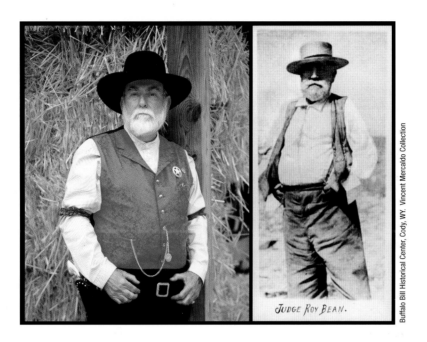

JUDGE ROY BEAN.

Buffalo Bill Historical Center, Cody, WY. Vincent Mercaldo Collection

This book records the "golden days" of Cowboy Action Shooting (CAS) and the Single Action Shooting Society (SASS) through photos and interviews with some of the movers and shakers of our sport. After seeing other work by Don Contreras and Mimi Altree, I'm proud to write the foreword to this book. I thoroughly enjoyed the unique approach they use in telling the story of the creation of CAS and SASS through the life of a Colt Single Action revolver. The tale begins with the gun's inception in 1873, follows it through the hands of its many owners, and finally ends up with its inheritance and use by a SASS member. I appreciate the many miles of travel, the numerous hours of interviewing and photographing people, and the unimaginable hours of editing involved in bringing this project to fruition. I truly believe that this is one book that should have a special place in every action shooter's library. I'm glad to be a part of it.

Judge Roy Bean
SASS 1

A WORD FROM THE AUTHORS

The sun has finally settled down after a long, blistering day. Nestling over the tops of the mountains, it is finally giving in to the dense blanket of stars spreading across the sky. A lone figure, tall and darkly silhouetted against the fading light, swings into his saddle and turns his horse for home. Pulling the wide brim of his hat lower against the waning wrath of the orange sun, he rides hard. The shrill of the cicadas, the clatter of his bay's hooves, and the jangle of his spurs sing a song of sundown.

This is not a fictional scene. It is not just a pretty picture painted to escape the day-to-day grind of modern life. It happens almost every weekend, all over the United States, when the Single Action Shooting Society comes together to celebrate the Code of Honor that became legendary in the Old West. In our present world, violence and crime have driven back romance, caused hearts to harden, and created a yearning for a simpler time and place. We want to "go back." And we need a place to "go back" to.

One thing that most of us Americans have in common is our love for the cowboy. Mounted on our spring-framed steeds and yarn-maned hobby horses, waving our little red hats in the air, we posed for countless pictures, hoping that we looked as rough and tough as our favorite gun-toting stars of the silver screen. But as we grew older and life got faster, we traded in our cap-gun dreams for work-a-day lives, relegating our Old West fancies to an occasional John Wayne "shoot-em-up," interrupted by commercials.

But there are still folks out there who walk the walk, and over the past few years we've been traveling across the country searching for them. We found them perched on the top rails of corrals, "kicked back" on front porches, and slinging lead with some of the best Single Action shooters in the United States. They told us their stories; told us why they still believe in the power of a white hat and a silver badge. They told us how the West was really won and, in

the winning, how it was ultimately lost. And they shared with us their strongest desire to bring back the spirit of that mythical time to an America that is hungry for honor.

Adventure forth, dear reader. We'll introduce you to some horn-swagglers, some side-winders, and some dead-eyed dudes who all have one thing in common: they all live the Cowboy Way. So saddle up your dreams and come with us. An exodus to nostalgia has begun, and these modern-day cowboys will lead us West . . . lead us home.

Don Contreras ★ Mimi Altree

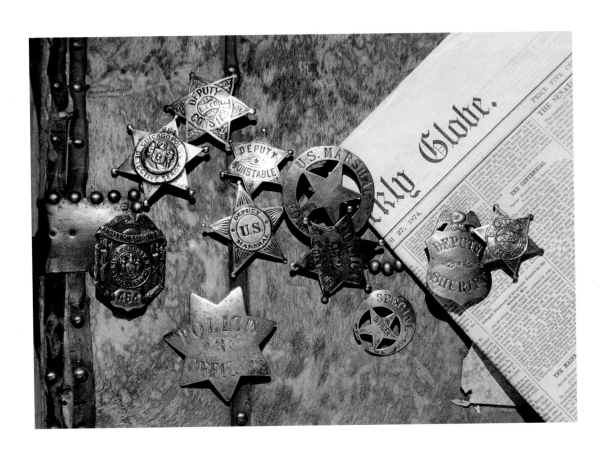

THE COWBOY WAY

Chapter One

GUNFIGHTERS

BEADLE'S
Dime
New York Library

Copyrighted, 1893, by BEADLE AND ADAMS. ENTERED AS SECOND CLASS MATTER AT THE NEW YORK, N. Y., POST OFFICE. January 18, 1893.

No. 743. Published Every Wednesday. *Beadle & Adams, Publishers,* 98 WILLIAM STREET, NEW YORK. Ten Cents a Copy. $5.00 a Year. Vol. LVIII.

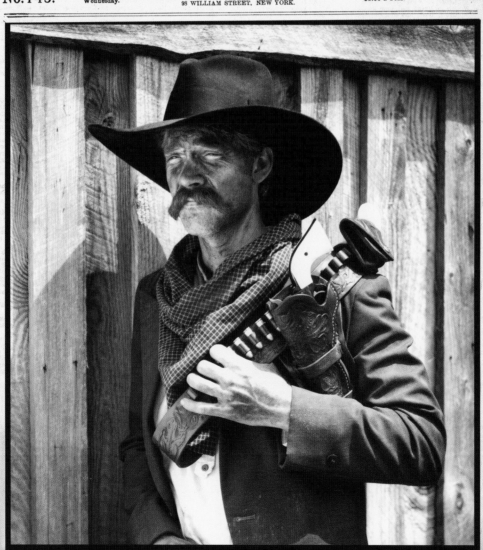

He was a stranger. And in the one-horse border town of Brownsville, that meant trouble. He was a Bounty Hunter, down on his luck and back from Mexico emptyhanded. His partner Billy was dead, shot in an ambush by a gang of bandits south of La Venada. But he had survived and was bringing Billy in, slung across the back of his dusty nag.

Crossing the miry street, he dodged a freight wagon pulling dry goods from Laredo. A pretty yellow surry with a smart team of bays pranced by. He stepped aside for it, and the driver, a handsome, bored woman in an imported bonnet, tried to catch his eye. But the Bounty Hunter had no time for such gentle distractions. He had to take care of business.

Stepping up on the plank walkway across the street, he looked up at the storefront before him. The peeling sign said "Gun Smith," its red letters sadly fading in the blistering heat.

The door complained loudly under the stranger's push. From behind the counter a clerk in thick, round glasses peeked up, blinking like a mole in the stream of mean Texas sun that the tall man brought in with him.

"Can I help you?" asked the older man suspiciously.

"You buy guns?" grunted the Bounty Hunter.

"Matter of fact, yes," replied the crafty Gunsmith.

Looking over his shoulder through the dirt-streaked window, the stranger glanced for a moment at the body lashed to his mare. "He's got no more need for this," growled the lean man, his eyes dull from a long string of failures. Unbuckling the worn rig from around his waist, he threw it on the smith's dirty counter.

From the dusty leather holster, the old man pulled a Peacemaker. She was a real beaut, an angel of death with carved ivory grips.

"How much do you want for her?" asked the Gunsmith, shrewdly taking in the stranger's cheap boots and hard-worn clothes.

The Bounty Hunter looked at the old man, his eyes blue and clear for a second. Then he lowered his gaze, lingering for a moment over the .45 in the smith's hands. "Just give me enough to buy a box to put Billy in." ✒

GUNFIGHTERS

They were rascals. They were rogues. They were lawmen. They were the heroes of the Western myth, playing hard and fast in the gray areas between the black and white of wrong and right. Some were educated men, foregoing a proper career for a more profitable one. Some were illiterate men, seeking greater power and fortune at the end of a gun. Some were killed with the peach-fuzz of youth still on their cheeks. Some lived to be old and gray, dying peacefully in their beds. But they were all gunfighters.

Their names are well known—they have been the subjects of more films and books than almost any other historical characters from any other time. The Earp Brothers, Pat Garrett, and Wild Bill Hickok stood among the men who kept the laws and worked to bring their own brand of civilization to the Western territories. Men such as John Wesley Hardin, Jesse James, Billy the Kid, and Doc Holiday were known for just the opposite reason: they had come to the West to escape the restrictions of the East, and would not live by any man's laws except their own.

In legend, the gunfighters were the Samurai of the Old West, moving from territory to territory, meting out single-action justice as far west as their horses could travel. In reality, they were men of great ambition, opportunists who used fear of their reputations to carve out a place for themselves in an unbridled new world.

We talked with some modern-day gunfighters who are carving their own place in the Single Action Shooting Society world. They talked about their sport, told us about their heroes, and filled us in on the gunfighter's place in the wild, wild West. ✪

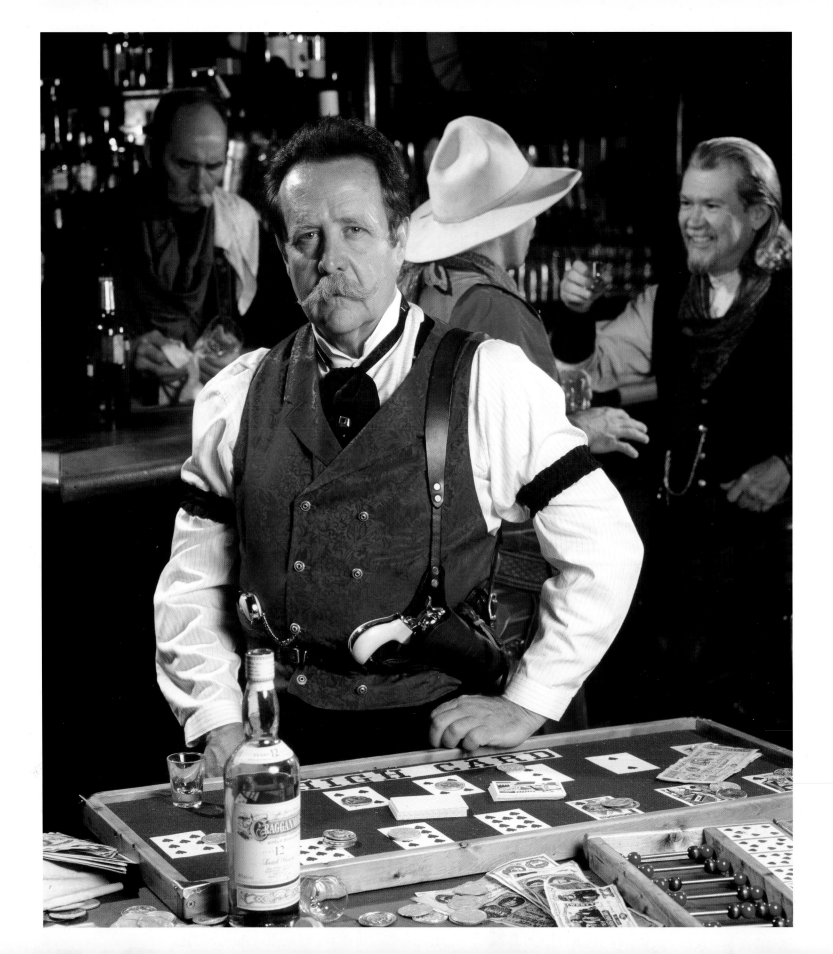

"Wyatt Earp said, 'To win in a gunfight, you have to take your time in a hurry.'"

TB BOSS

Gunfighter

WHAT YEAR DID THE GUNFIGHTER COME ON THE SCENE?

Well, most of the historians—of which I am an amateur—agree that the period known as the "Wild West" was relatively short. Twenty years. Most people put it between 1870 and 1890. Of course there was a little runover here and there, but that was when most of the famous things we all know about happened. Wild Bill Hickok came up following the Civil War and up to 1876. The Earps and Doc Holliday were in the mid-1870's until 1885-1890. That's when everything happened.

WHAT STARTED OFF THE "WILD WEST" PERIOD?

I don't know if you can put your finger on any one thing. There was a period of rapid expansion immediately after the Civil War. Lots of people in the South didn't want to stay in the South. Everybody was going west and the West was TOUGH. A lot of the Colt firearms in the 1880s and

90s were shipped to a place called "Simmons Hardware" in St. Louis, Missouri. That was the jumping-off point if you were going west, where you'd gather up all your gear. When Doc Holliday went west about 1872, he took a train from Atlanta to Chattanooga to Memphis. Then he took a boat down to New Orleans, then another train to Texas.

WHEN DOC GOT TO TEXAS, WHAT DID HE DO?

Doc was well educated, well to do, not who you would think would turn into a frontier gambler. When he got to Texas, he opened up a dentist's office and went in with Doctor Seeger, I believe, around Houston. But he had been diagnosed with TB, and as you can imagine, a dentist who is bent over looking in your face and coughing doesn't get many return customers. And Doc found that he enjoyed gambling. When he was a young boy in Georgia, a black lady who worked for the Holliday family had taught Doc a card game where the advantage was to remember what

cards had been played. And Faroh, which they played in the Old West, was that kind of game. So Doc fell right into it. He moved on from Texas and went to Denver for a while. Doc was pretty easy to track most of the time, because there was always something in the newspaper about him. It might be as simple as a dentist's office advertisement, or it might be a report of a gunfight. One time he was in the arrest records with a couple of guys and women for running a "bawdy house." As he progressed farther and farther along, he did less dentistry and more gambling.

WHERE WAS HIS BIG HURRAH?

That was in Tombstone, Arizona. He had met Wyatt Earp in Dodge City. Saved Wyatt's life by some accounts, but we don't really know. But there is no doubt that they became friends there. Wyatt went to Tombstone and Doc ended up there too. Offering to help the Earp brothers the day of the gunfight was what really made Doc's reputation. . . the reputation we remember. He actually had quite a reputation at the time as a gunfighter. It wasn't totally true. Doc was pretty small, pretty frail. The gunfighter Bat Masterson made the comment that "a fourteen year old boy could whip Doc Holiday in a fair fight." So Doc, and a lot of the old gunfighters, didn't correct erroneous information about their careers. If Doc was sitting at a table playing cards and overheard somebody at the next table saying "Hey, that's Doc Holiday. He's killed 25 men," Doc didn't stop them and say, "No, I've only killed 2 people." Because Doc wanted everybody to leave him alone. A lot of the gunfighters embellished their reputations. If you were thought of as a "bad man" or a fast man with a gun, people left you alone.

WHAT MADE A GOOD GUNFIGHTER?

The definition of a gunfighter is really hard to pin down. To me, he could be either a lawman or an outlaw; it was

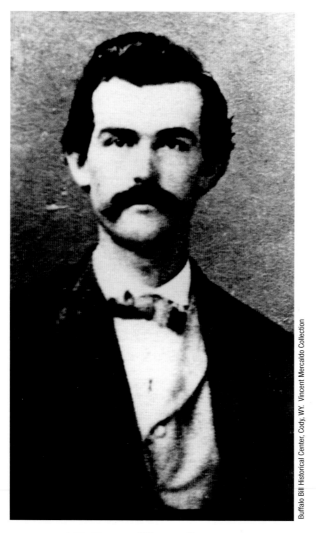

— J. H. "Doc" Holiday, Dallas, 1874 —

Buffalo Bill Historical Center, Cody, WY. Vincent Mercaldo Collection

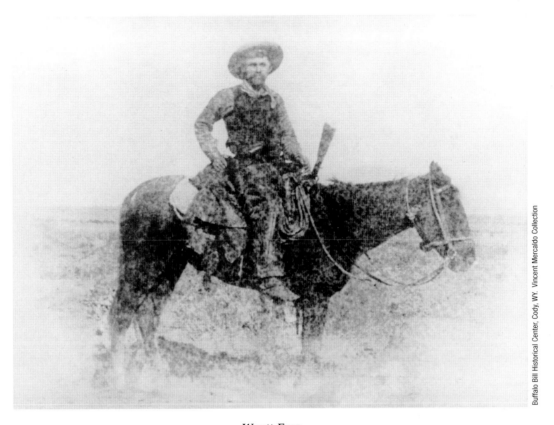

Buffalo Bill Historical Center, Cody, WY. Vincent Mercaldo Collection

— Wyatt Earp —

just somebody who was good with a gun. Wyatt Earp said, "To win in a gunfight, you have to take your time in a hurry." When somebody asked Bat Masterson what was more important, speed or accuracy, he replied, "Well, speed is probably the least important." So what's the most important thing? Deliberation. You have to be very deliberate. No hesitation. That was one of Doc's trademarks.

WHAT WAS THE GUNFIGHTER'S FAVORITE SIDE IRON?

Probably the Colt Single Action revolver. The Peacemaker. They were durable and relatively cheap. A run-of-the-mill

one would have been 16-17 bucks. Something real nice was 50-60 dollars, but of course you didn't make but 20 dollars a month, so that was a lot of money.

DESCRIBE A REAL GUNFIGHT.

What we think of as a gunfight—they argue at the table, "meet me in the street at two o'clock," they face off and draw—very seldom happened. If you were sitting across the table from someone and he caught you cheating, there was a very good chance he'd just shoot you without saying a word. Wild Bill Hickok and Dave Tutt did the classic "walk down the street" thing once and that's probably

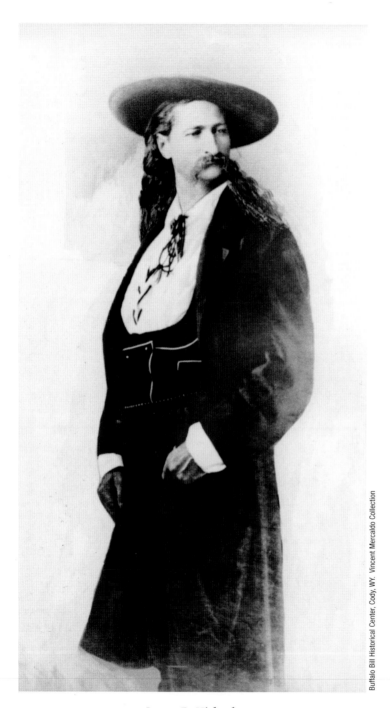

— James B. Hickock —

Buffalo Bill Historical Center, Cody, WY. Vincent Mercaldo Collection

where we got the myth. They actually got in the street, walked toward each other, drew and fired. But Hickok was another gunfighter who didn't have any hesitation. When he was Marshal, I think at Abilene, there was an altercation in the street and he went out and saw that Phil Coe had a gun in his hand. Hickok said, "You're not supposed to be shooting a gun in town." Coe said, "Well, I was shooting at a dog." It didn't matter. They had a few words. Coe tries to shoot Wild Bill. He gets off two shots—one in the dirt, one goes through Bill's coattail. Bill gets him twice in the center, so he hits the ground dead or dying. But there are a bunch of Coe's friends there in the street, so Bill is still watching everybody. Somebody steps up on the boardwalk behind him and says, "Bill. . ." He spins, fires, and kills his deputy.

HOW WAS HICKOCK KILLED?

Bill was playing cards in Deadwood, South Dakota, and this guy walks up behind him and shoots him in the back of the head. There've been all kinds of theories, but it was about 1876 and Hickok was getting older, slower, his eyes were giving him trouble. In his heyday, if Bill walked into a saloon and said, "I want that chair," well, everybody at the table would get up. He could have any chair he wanted. But that day he walked in and said "I want that chair" (at the back of the wall) and nobody paid any attention to him. So he took a chair with his back facing the door. That's why aces and eights became the "deadman's hand." Because Bill was holding a pair of aces and a pair of eights.

WHO WERE THE MOST FAMOUS GUNFIGHTERS?

Doc Holliday, Wyatt Earp, Bat Masterson, and Wild Bill Hickok. All kinds of lesser-knowns come to mind, but those four probably get all the press.

IF THOSE GUYS MET IN AN ALTERCATION, WHO WOULD HAVE WON?

A four-way altercation? (Laughs) Well, Wyatt Earp was never even grazed by a bullet. That doesn't mean he was that great, it just means that he was lucky. Which means he might be due to get shot. . . . I wouldn't place a bet on any of them. Basically, the one who comes out on top is the one who acts first. The one who makes the deliberate move . . . the one who gets rolling first. That could have been any of them, depending on the day. If Doc's feeling poorly, he might be slow.

THE MOVIE "THE QUICK AND THE DEAD" DEPICTED A CONVENTION OF GUNFIGHTERS. WAS THAT REALISTIC?

I don't think so. The gunfighters liked to have the reputation, because it kept them from actually having to fight. I don't think any of them went to a town where all of the other well-known gunfighters were having a contest. Their hobby was staying alive, so I don't think anything like that ever happened . . . but that WAS a good movie. ✪

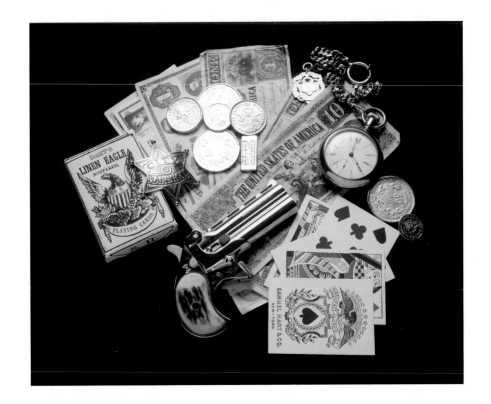

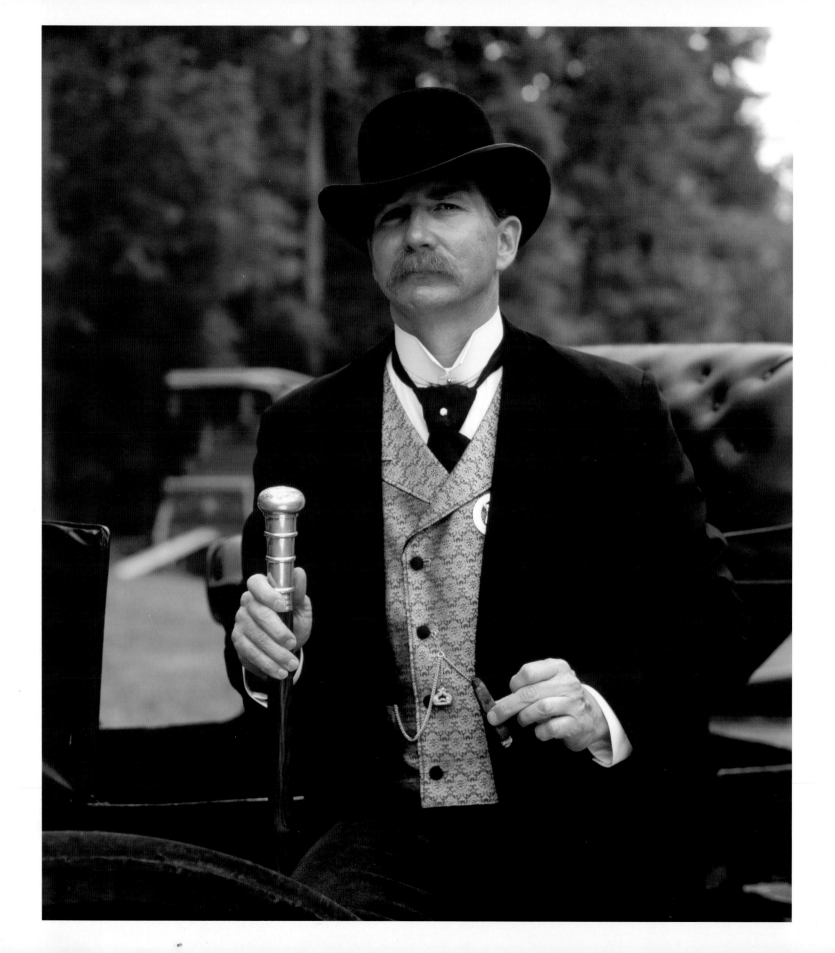

"I've even been accused of looking like a gunfighter when I was dressed in my street clothes."

BAT MASTERSON

TELL ME A LITTLE ABOUT THE REAL BAT MASTERSON.

Nobody's really sure where he was from. I think he was born in Canada. His family had wanderlust and moved around. They finally settled in Kansas, where he set out on his own to make his fortune. He was sort of a journalist by chance. He loved boxing and even acted as a "second" for several boxers from time to time; he bet on it every chance he got. At one point he ended up living in Denver and owning a saloon called "The Palace." There he wrote for a weekly publication called "The George's Weekly."

WHY DID YOU PICK HIM AS YOUR ALIAS?

I've always had a love for the Old West. Always loved western characters and felt like I was born out of my time. And Bat's one of those. He was pretty much a straight shooter. A lot of the other western gunmen had a reputation for doing things a little on the shady side. They were lawman one week and outlaws the next, whatever served their own purpose. Bat never seemed to drift into that. I'm not going to tell you Bat didn't indulge in anything. He loved to deal Faroh. He was a great practical joker. The census for Dodge City listed Bat, and Wyatt for that matter, as having residences where "concubines" lived. As far as looking like Bat, I realized that we sort of bore a resemblance. Because I admire the man, when I picked up the alias, I started going out of my way to look like him. I've even been accused of looking like a gunfighter when I was dressed in my "street clothes."

WHAT WAS THE BIGGEST TROUBLE BAT EVER GOT INTO?

The first man Bat killed was an Army corporal by the name of Melvin King. This was in the panhandle of Texas when Bat had no reputation whatsoever. He went to see a young lady by the name of Molly Brennan. Molly and Bat were good friends. Molly was working in the saloons of

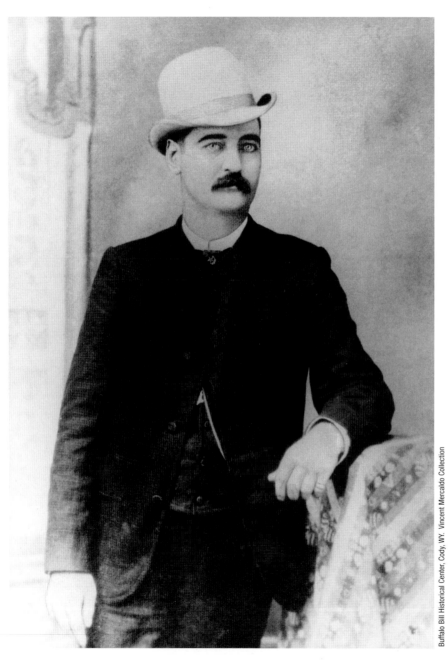

— W. B. "Bat" Masterson —

Mobeeite, or Sweetwater back then. History doesn't say if she was a soiled dove. I think she was probably doing whatever she could to survive. Melvin King had a bad reputation as a brawler and a head thumper; he was sweet on Molly, too. When Molly met Bat, she fell for him, and Melvin got jealous. Bat was a young man, in his teens, and hadn't ever run into any trouble like this before. He had a friend who owned a saloon and that's where he met Molly during closing time. He managed to get a key and he and Molly went into the saloon. History doesn't record what they were doing or how they were dressed when Melvin King burst in, but my guess is that they were in a compromised position. History would have us believe that Molly jumped in front of Bat and took a bullet for him. In any event, Molly was killed and Bat was wounded either by that bullet or by another fired by Melvin King; we don't know which. Bat took a round through the hip. Medicine wasn't very advanced then, so Bat was lucky to live through it. He walked with a cane from that time on.

WHAT HAPPENED TO MELVIN KING?

Bat did manage to get off a round before he fell and his aim was a little truer than Corporal King's, so Bat brought him down. That was his first man. At least one version of the story has

the fight happening in a crowded saloon, and a famous Texas gunfighter by the name of Ben Thompson jumped into the middle of it to protect Bat. But that's only backed up by one writer's version. The fact remains that Bat and Ben Thompson were very close friends.

SO BAT WAS A LOYAL FRIEND?

Bat held friendship very dear. He took good care of his friends. Doc Holiday was arrested once in Denver by a man who claimed to be an authority in Arizona. Bat, who was the Marshal of Trinidad, Colorado at the time, got a warrant sworn out against Doc on some minor charge. He went to the governor and said, "You can't extradite him to

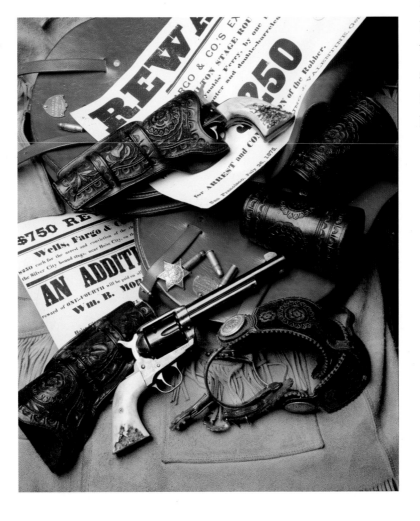

Arizona, he's got to face this charge in Colorado first." Every time Doc showed up for his court date, Bat would think up some other reason to continue the case for another two or three months. One time the Arizona Rangers were late for court. When they didn't show, Bat said, "Your Honor, we are going to have to dismiss the charges. We can't find our witnesses." And the Judge said, "Return this man's bond" and sent Doc out the door. About ten minutes later, the Arizona Rangers walked in, but it was too late. Well, long story short, Bat actually hated Doc Holiday. But he loved Wyatt Earp like a brother, and he would do anything for a friend, even save the life of a man he didn't like.

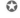

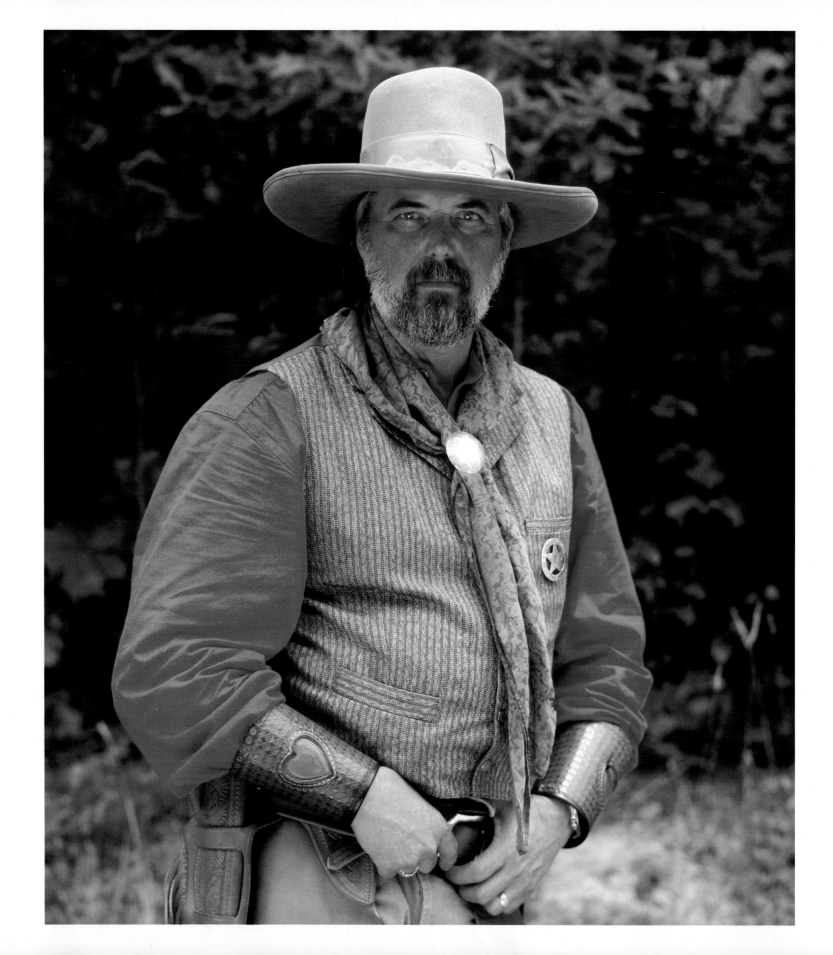

"Ninety percent of the people here don't know my real name. Probably ninety-five percent."

HIPSHOT

Founding member of SASS

WHAT IS THE "CODE OF THE WEST"?

You never speak ill of others, you treat women like ladies. And truth, virtue—you don't lie, you don't cheat, you don't steal. It's kind of a lifestyle, it really is, for so many of these people. They eat and breathe this stuff. They go to work to make a living, but everything else revolves around this. Your handshake and word is worth more than a contract to these people. . . even if they're attorneys in real life. You know, it's a fantasy. What would you really want to be in the Old West if you could be anybody? The school marm or the bartender or the banker or the hooker or the cowboy or the drover? I am Hipshot! Ninety percent of the people here don't know my real name. Probably ninety-five percent. It doesn't matter when I'm out here. I met Charlton Heston at the NRA convention two years ago because I was Hipshot. And he knew that. If I'd told him my real name, I'd never have gotten through.

HOW OFTEN DO YOU DO THIS?

At least once a month. We have a home club; it's been something that my wife and daughter and I have all done together for over 12 years. In fact, on Christmas and birthdays we even exchange gifts under our real names and our aliases!

DOES YOUR DAUGHTER SHOOT?

Yeah. She started at 13, she's now 26 and she's getting married next month.

IS HER FIANCE IN IT?

(laughs) He is now. He really had no shooting background or experience but he decided he better get with it if he is going to be in this family. He was just like a kid in a candy store.

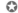

"In America, the cowboy represents a sense of freedom that most people don't really have today."

JIM DUNHAM

Western entertainer and motion picture consultant

WHAT DID HOLLYWOOD GET WRONG?

A common question people ask was "Who was the fastest gun in the Old West?" The whole concept of facing down in the street is based on fiction and not reality. There were a few times that people shot at each other. The closest historical gunfight took place in Springfield, Missouri, between James Butler Hickock, who was called "Wild Bill," and a fellow named Dave Tutt. But Tutt wasn't a "bad guy" and wasn't being arrested—it was a personal gambling argument that went bad. This led to them both coming out and pulling weapons, firing at each other. Hickock won and Dave Tutt fell down. That IS an actual gunfight in the Old West. But almost every other situation involved brothers and families and people running around hiding behind things, more typical of what battles are like today. What I usually say is, human nature hasn't changed that much in the last 100 years. And so just assume what's true today was true then. If you're going to go after somebody for some reason, criminal or whatever, you're going to want every advantage on your side. That's just common sense. You would never say "Well, any time you're ready to go for your gun, go ahead and start first."

WHAT DID HOLLYWOOD GET RIGHT?

America has this attitude about "manifest destiny," about moving west and conquering the land, even at the expense of the existing population. Americans have always felt that God gave them the North American continent to subdue, so all the movies that are "western ho the wagons" show pretty well what the attitude was toward the frontier, toward the land, toward western expansion. Especially movies like *Red River* about moving the cattle up to the railheads. That was pretty much how it happened.

WAS THE SHERIFF REALLY ON HIS OWN WHEN THE BAD GUYS CAME, LIKE IN HIGH NOON?

Not really. The legal structure was pretty elaborate. At any

given time you had a Town Marshal, same as the modern Chief of Police. You had county law, which was the Sheriff. You also had federal law, the Marshals. These overlapped and existed at the same time. When somebody was shot, or when somebody fired a gun, they went to court. When the gunfight at the OK Corral took place, there was a 30-day court trial where the Earps were charged with police brutality and had to prove what they did was legal. So even though the courts were few and far between, even though the vast open spaces meant there were only a few people around, it wasn't much different from today. You look at the Constitution—it's a very sophisticated document. And the original way our legal structure was set up was very sophisticated as well. It didn't just fall apart during the 1800's. It was still there.

SO THEY HAD LAWYERS?

Absolutely. If you were in Indian territory and you got arrested, good legal advice and the right lawyers might be hard to come by, but when somebody got arrested, they got a lawyer. There were lawyers in Dodge City and Tombstone. When Wyatt Earp was charged with murder and police brutality, he hired Thomas Fitch, one of the best lawyers of the day. He had legal representation when he went into court before Judge Spicer. Movies simplify that process. Good guys shoot bad guys and ride into the sunset, like in *OK Corral*. Burt Lancaster and Kurt Douglas have this big shootout, lots of guys killed. At the end of the movie they're sitting in a bar having a drink and Wyatt says, "Well, Doc, whaddya gonna do?" And Doc says, "I think I'll go up to Colorado and play some cards." And Wyatt says, "I think I'm going to California to visit my family." And they both get on horses and ride out of town. So you say, "Wait a minute! They just killed three men! Where are the ramifications?" Just because you were on the police force doesn't mean you can just ride out of town. So the movie people have condensed the legal structure. But some of the historical inaccuracies are put in because of "theater." Not because they don't know the difference.

IN THE MOVIE TOMBSTONE, YOU WEREN'T ALLOWED TO CARRY A GUN IN THE CITY LIMITS. . .

You weren't allowed to carry a gun within the city limits during the 1880s, although you actually can today. They had much stricter laws then than we do now. That's interesting. But to understand, you have to say, "In the year 2001, of the 4,000 people you see in the streets of the town, how many are carrying guns?" Probably nobody. Most gunowners have them in their cars, but they don't "go heeled." They don't go armed wherever they go. On the other hand, in 1880, everybody on the frontier had guns. They all carried guns for a number of reasons, not the least of which is if you got bucked off your horse and had to walk to town, it might be 50-60 miles and you'd need a gun for protection, hunting, signaling. Most everybody who traveled in the frontier carried firearms and what you didn't want is everybody wearing a gun, standing at the bar, drinking.

WHAT DID THEY DO WITH THE GUNS?

The towns had really good checking systems. The police department and hotels and saloons and livery stables all had tokens, like a hat check. So you'd ride into town and head for the livery stable. As soon as you took care of your horse, checked it into a corral, the person who ran the livery stable would take your gun, hang it on a peg, and hand you a token that you could redeem when you left town.

DO MOVIE HATS PARALLEL THE ACTUAL HATS COWBOYS WORE?

Hollywood hats are just the most bizarre things I've ever seen. You go back to a few of the movies in the 1930s earlier than Tom Mix before you see really authentic hats. Every once in a while you can find a movie that has some authentic hats. And most of them are worn by real cowboys hired to be extras who brought their own costumes. But what happened was, the costume people started looking around for hats to use. Maybe they grabbed some old fedoras from a gangster movie and just curled up the brims. Some of the hats, like the 1950's cowboy hats on TV, are just horrible. The hats from *Bonanza*, *Big Valley*, *The Virginian*, most of the weekly shows had terrible hats, although Matt Dillon on *Gunsmoke* had a pretty good one. Nobody checked the photographs for historical accuracy—they looked at other movies. I think the costume designers are supposed to be creative, so the last thing they want to do is copy pictures from history. If they're a creative person, you couldn't give them a worse assignment. They put their "signature" on the look of the costumes. As

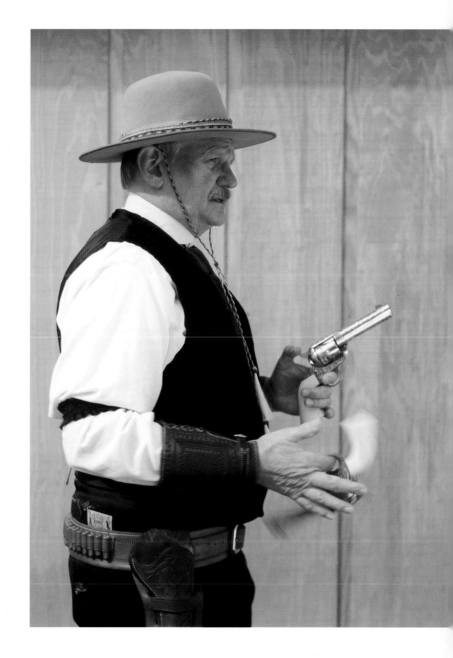

long as it looks flashy and clever, you can get away with it. The early silent films were pretty good, because they hired consultants who actually lived during the Old West. When the entertainer Tom Mix started in the movies, he went to the Stetson Hat Company and ordered a big hat, pure white, so it would set him apart from the rest of the cowboy actors in the field. And he was the first to establish the idea that good guys wore white hats.

WHAT'S THE DEAL WITH BAD GUYS IN BLACK HATS?

Well, it wasn't so much the idea that bad guys always wore black hats. Usually the bad guys were townspeople: the industrialists, bankers, conniving real estate people trying to "steal the ranch from the poor widow." Those people wore suits and ties and matching dark hats. If you had gone back earlier than Tom Mix and said "What color hats do good guys wear?", the answer would have been "brown." And if you asked what color hats the bad guys wear, the answer would have been, "Well, they wore brown, too."

SO THE VILLIANS IN EARLY WESTERNS REPRESENTED "THE ESTABLISHMENT"?

Oh, yeah! That was very much part of the "cowboy lore." Billy the Kid was the most famous historical example of that. The real "bad guys" were the money people, the established bankers, lawyers, and real estate people trying to cheat the poor people out of their ranches, like the Murphy Dolan fac-

tion. So Billy the Kid befriends the small Mexican farmers and he becomes the hero. Legally, he was the criminal; he shot and killed evil people. And that's against the law.

DID THEY REALLY HAVE RANGE WARS LIKE IN JOHN WAYNE'S CHISOLM?

There were a few real-life ones. One was the Lincoln County Range War, when the big ranchers tried to steal the land from the little ranchers. The Murphy Dolan faction was trying to steal from the small landholders, trying to control the price of goods . . . sort of the Mafia of the Old West. Another one was the Pleasant Valley Range War that took place in Arizona from the late 1800's up until the turn of the century. That was the cattlemen against the sheepherders, fought over the rights of rangelands. Cattlemen hated the sheep because they ate the grass too close to the ground, leaving nothing for their cows. It was a family against family thing, Tewksburys against Grahams. The two families fought for years.

WHICH WESTERN HERO OR VILLIAN HAS HOLLYWOOD MOST DEPICTED?

No question, Billy the Kid has had more movies made about him than anyone else. Quite a few on Wyatt Earp and Jesse James, but not as many as Billy the Kid. His story fits the classic definition of Greek tragedy: he's the character we identify with, but we know that fate is going to take him down in the end. There are good comedies, good melodramas, but of all the characters in the frontier, the best tragedy is Billy the Kid. ✪

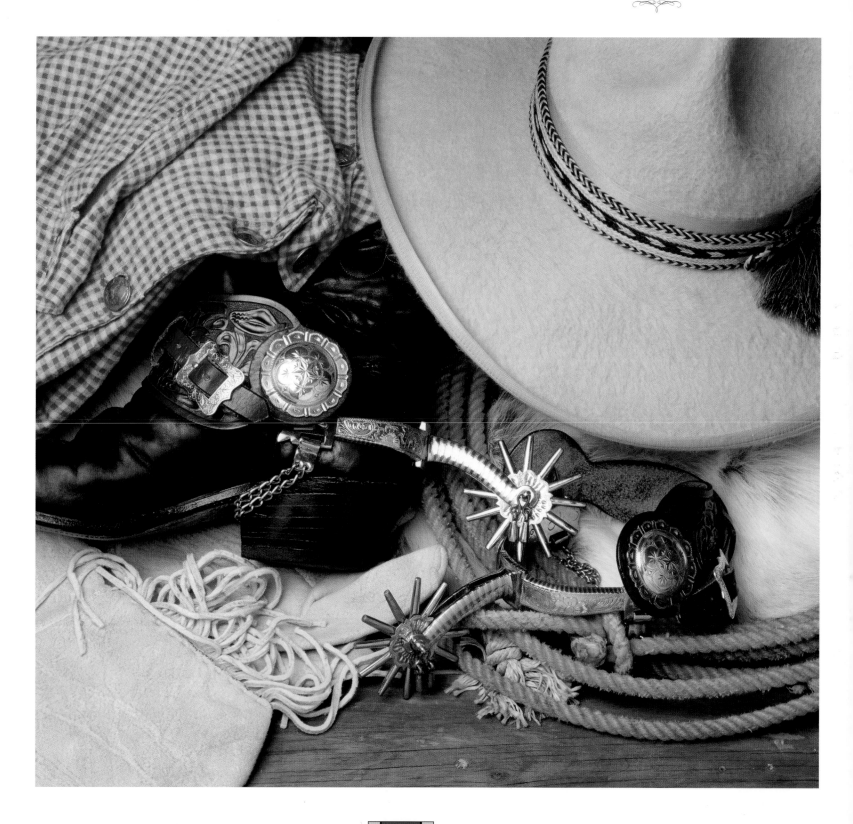

"I want to strap those guns on, and I want to start throwing lead."

JUSTICE LILLY KATE

Cowboy Shooter

Growing up on a West Texas ranch, I played 'cowboy' a lot and guns were always around the house. I never thought of them as instruments of violence—they were tools of protection, or more importantly, tools to secure food. We were very poor and that's the way we put meat on the table, so respect and love of guns came naturally for me.

It has occurred to me more than once that I am using the type of guns my great-grandmothers and grandmothers used to defend their homestead. And I'm passing that heritage down to my younger son, Chris, who shoots with me. We want to keep the sport alive and well for years to come.

I think most of us have the same love affair with our guns. I'm proud of them and take good care of them. That way, when I go to shoot, I want to get out there, I want to strap those guns on, and I want to start throwing lead." ✪

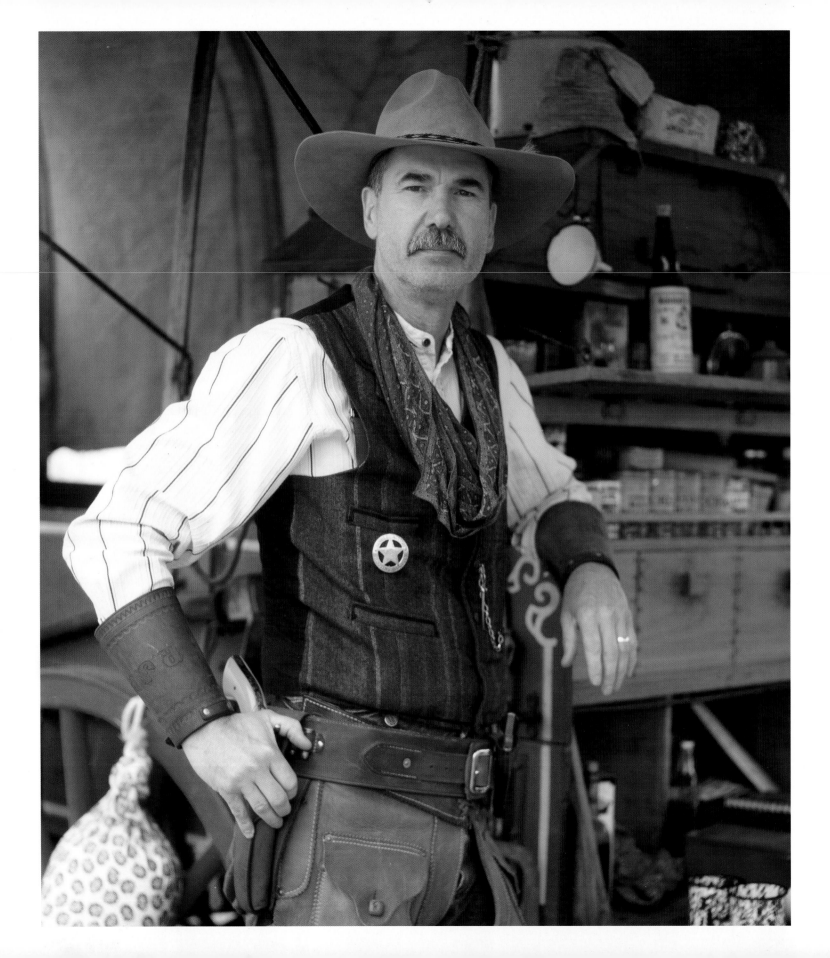

"Out here at End of Trail there are three things that you have to do: you have to meet new people, you have to have fun, and you have to be safe."

RJ POTEET

Founding Member

HOW DOES SASS DIFFER FROM OTHER SHOOTING SPORTS?

None of the other shooting sports require of the individual the change in mindset that cowboy action shooting does. You cannot shoot under your own name—you have to leave behind your day-to-day personality and adopt a new character. You have to dress in period clothing. I don't know where else in the shooting world you're likely to round the corner and find three or four guys standing around talking about where they got their cowboy shirts, or how they made this piece of leather tack, or "Wow, that's a great hat, where'd ya find that?" For most of the people involved, it's not about the competition. It's about the lifestyle, about socializing and networking with a group of folks who share a common interest.

EVER ANY PROBLEMS WITH HOTHEADED COWBOYS?

This is our 20th End of Trail that I've been involved in. In all that time, we've never even had a fight. This huge encampment exists for a whole week and we've never even had a drunk who had to be ejected from a party. In my experience, there's never been anything more serious here than some guys passing a few hot words, and that blows over quickly. It's really remarkable. There's a level of integrity.

TELL US ABOUT SAFETY.

Safety is our number-one concern. Fancy dress aside, it's a shooting competition, it's live ammunition, and it can kill you. In the history of our club, we've never had a fatality, never even a life-threatening injury. Everybody within line of sight of the shooting area is required to wear glasses for eye protection. Hearing protection is not required, but you need to wear it. The type of ammunition is controlled; you have to use an all-lead projectile that minimizes the splash or backsplatter you might get in ricochets off a jacketed bullet. Muzzle velocities are controlled so you're not shooting "over-hot" rounds. The firearms are carefully checked and inspected by a third party of designated Range Officers to ensure that they're clear and empty. Gun handling is non-existent off the range; you're welcome to walk around with your side arms, but they stay in holsters. Long gun actions have to be open when they're out of your hands. So there's a lot of attention to safety. There has to be. It's the first and last rule. Out here at End of Trail there are three things you have to do: you have to meet new people, you have to have fun, and you have to be safe. ✪

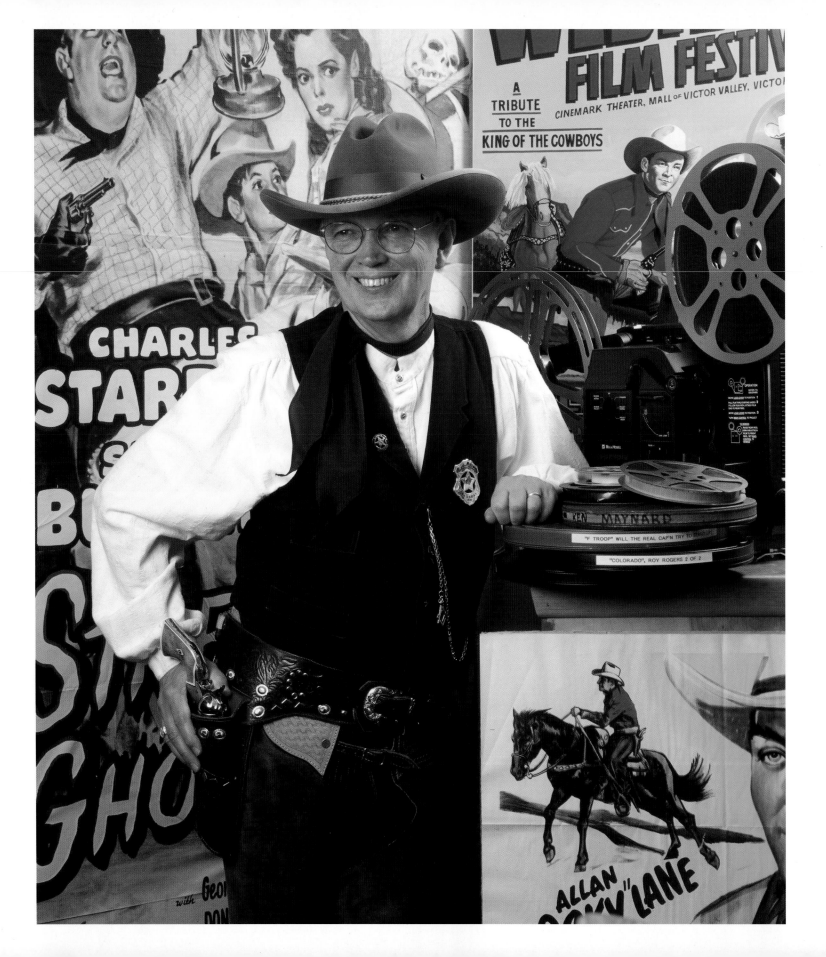

"B Westerns ... represent a lost art."

LARRY BLANKS

Film buff

WHAT IS A "B WESTERN"?

The "B" stands for "budget." Low budget, specifically. They started in the late twenties, early thirties, when sound pictures first came out. Companies like Mascot Pictures had this singing cowboy named Gene Autry starring in a serial called *The Phantom Empire*. It was a Sci-fi/ B Western. That was Gene Autry's first starring role. Those guys could crank out a movie in two weeks for ten or fifteen thousand dollars. It was fantastic. They had a good story, maybe wrapped around a Zane Gray novel, but it was always a good flick. B Westerns are unique. It's too bad that they're not still around, because they represent a lost art.

WHEN DID THE B WESTERN "RIDE INTO THE SUNSET"?

Probably in the early to mid-fifties, when television replaced the Saturday morning matinee. Gene Autry and Roy Rogers were out of Republic Studios and were able to buy out the rights to their films. They positioned themselves to move into the television realm. William Boyd (Hopalong Cassidy) also bought the rights to his series and all of his films, and he even started making thirty-minute TV programs in the late forties, early fifties. From there, westerns transitioned into adult TV westerns, like *Gunsmoke* and *The Rifleman,* that really came into their own in the mid to late-fifties.

GIVE US SOME TERRIBLE B WESTERNS.

Well, in the late fifties, when TV really got started, the production companies started rolling them out. Roger Corman, the guy who did all the horror flicks, started making movies like "Frankenstein Meets Jesse James." Dennis Hopper started in films like that. Also Robert Vaughn, who later became *The Man From Uncle*, did a few of that ilk. They were bad!

WHO WERE THE MOST FAMOUS SIDEKICKS?

Well, you have to start off with George Gabby Hayes, who dates back to the John Wayne B Westerns in the

early thirties. He played Windy Holiday. When Republic Studios started out, Gabby moved over there and became Gabby Hayes, working with Roy Rogers. Smiley Burnett really started off in the business with Gene Autry and later on moved over and did some films with Roy

too. And if you're talking about sidekicks, you have to talk about Andy Devine. He was fantastic.

DID THESE ACTORS HAVE SIGNATURE "GIMMICKS?"

Every cowboy star had his own "schtick." A good example is Andy Devine. In the fifties, on the Wild Bill Hickock series with Guy Madison, Andy played Jingles Jones. And even in the early films, he'd always "throw" his bullets—throw that gun out there every time. Of course that looks kind of silly now to people who know better, but so do some of the Kevin Costner tricks that Hollywood tries to pull these days. When they try and do their little cool thing, it looks really silly.

WHAT ABOUT THE FIGHT SCENES?

In the beginning they were real phony. Mainly it was wrestling and pushing. Then the famous stuntman Yakima Canutt and John Wayne began doing early B Westerns in the thirties—*Texas Cyclone, The Big Stampede, Haunted Gold, Blue Steel, West of the Divide.* John Wayne was making seven or eight of these little things a year. They only took about two weeks to produce back in those days. So anyway, John Wayne and Yakima decided that they needed to make the fights look better. So they started staging and choreographing the fights, throwing punches and ducking, working with the camera angles . . . that was all Yakima's idea.

HOW DID THEY MAKE THE HORSES FALL?

Before the ASPCA got into the picture, they used trip wires. In the early days, Yakima came up with trip wires that could be triggered by the rider. He would pull it and the horse's front hooves would come out from under him. He could actually predict which way the horse would fall, because he'd set the wire on the particular leg that he needed to pull out. So the stunt guys could do their flip and get off without getting hurt, but the horse often got hurt. They stopped that in the mid to late thirties. After that they started doing coordinated stuff where the horses weren't hurt.

THEY WERE PRETTY ROUGH ON THEIR HORSES.

Actually, if you were one of the big star horses, you had a pretty good life. All the cowboy stars had favorite horses. They were almost like their co-stars: Ken Maynard had Tarzan, Gene Autry had Champion, Rex Allen had Koko and, of course, Roy Rogers had Trigger. Their horses actually got gobs of fan mail. Trigger and Champion showed up at personal appearances with their stars—they were part of that actor's image. Roy Rogers once said, "I never made a picture without Trigger." And he didn't. In 1936, on his first film, he spotted Trigger in the string of extras' horses. He picked him out and later on, bought him for $2,500 as his personal horse. And he was with him from then on. Trigger eventually retired, died of old age and Roy had him mounted and put on display in the Roy Rogers Museum, where he still stands today. ✪

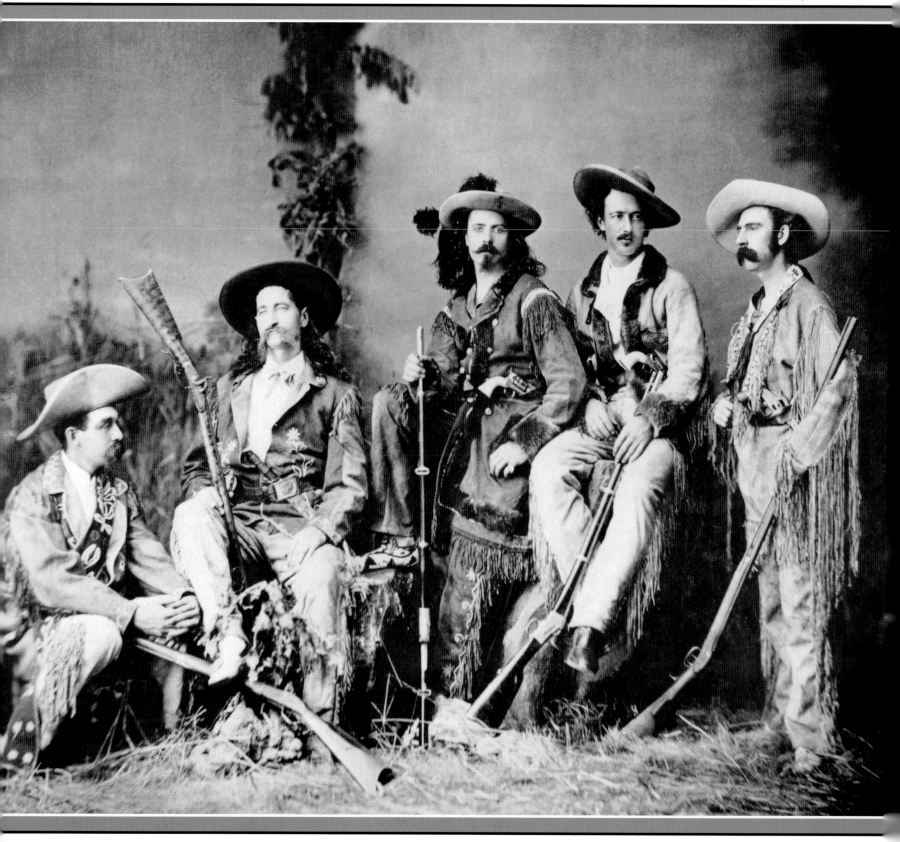

— (l to r) Eugene Overton, Wild Bill Hickock, Buffalo Bill, Texas Jack Omohundro, Elisha Green, 1873 —

A few more words about SASS

THE CHISELER

Marketing Director of SASS

SO SASS HAS BEEN GROWING?

Well, in the last eight years we've gone from fifteen hundred members to over forty thousand. Basically, starting about seven or eight years ago, we've doubled every year. We sign between eight hundred to a thousand new members every month.

DESCRIBE A TYPICAL SASS MEMBER.

Well, from a demographic standpoint, they're in their 40's. They are outdoor-minded. They have a warm spot in their hearts for the Old West. They strongly identify with Western history and cowboy movies. They are friendly people who are looking for a simpler way of life, where their handshake, their word, still means something. Who plays this sport? It's a person who wants to live in simpler times and uses SASS as a vehicle to achieve that. ✪

Chapter Two
GUNS & GUNSMITHS

BEADLE'S

Dime

New York Library

Copyrighted, 1893, by Beadle and Adams. Entered as Second Class Matter at the New York, N. Y., Post Office. January 18, 1893.

No. 743. Published Every Wednesday. *Beadle & Adams, Publishers,* 98 WILLIAM STREET, NEW YORK. Ten Cents a Copy. $5.00 a Year. Vol. LVIII.

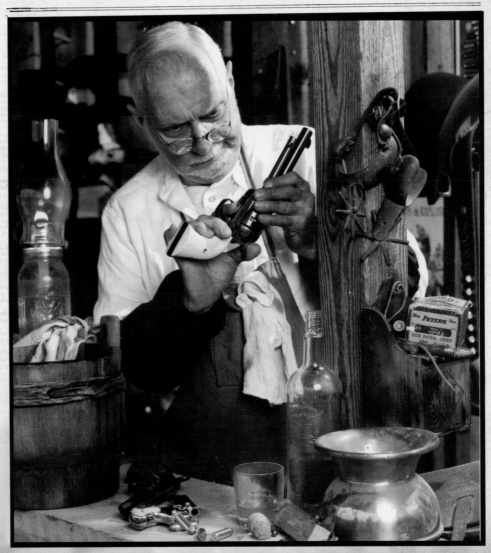

The old man watched through bleary eyes as the Bounty Hunter stalked out the door. Peering through the streaked window, he tracked the tattered shadow back down the street. The killer was gone. The old Gunsmith swallowed thickly; his mouth was dry as dust. And the gun was still in his hand. Stumbling across his dirty shop, he latched the door, quickly pulling down the yellowed shade. He was soused, as usual, but somehow he had managed to give just five dollars for the piece. This fine revolver, hidden beneath its careless patina of dust, would easily pay off his gambling debts and keep him in whiskey for a month.

The Gunsmith felt like celebrating, but the Saloon wouldn't open for an hour, so he set about reviving his new investment. His hands shook as he took her apart, pulling the pin, dropping the cylinder on his dusty counter. Slowly he cleaned her, oiling away months of hard use and leaving the gun with a dull, deadly shine. Reaching under the counter, he fished around and pulled out a scrap of worn red velvet, faded by the sun and thread-bare at the edges. Using it for a backdrop, he put the gun in his shop window, propping it up with a wooden dowel. Stepping outside his streaked, dingy door, he took a look back inside. Rubbing the dirty window with his shirtsleeve, he steadied himself and admired the new display. "It shouldn't take but a couple of days to sell this old girl" he thought, "and I'll be sittin' in high cotton."

But the weeks passed and the tin bell that announced his customers remained silent. His ivory-gripped pot of gold still sat in its dingy velvet nest, waiting for a rich man to happen past. "Even if there was a rich man in Brownsville, he wouldn't be coming down here," the old Gunsmith groused. "Never been anything worth seeing in my window." Besides, folks were wary of a drunk working on their guns. Still worse, he'd been acting like Diamond Jim Brady at the saloon, blowing a roll he didn't have yet, buying drinks for the house. Now those same folks were baying at his heels, just as thirsty to be paid back for the money he owed them.

The revolver was bad luck. That was clear

to him. And now he'd have to sell it to the first yahoo who walked into his shop, just to get his five bucks back.

Speak of the devil and it rained pitchforks. There was a figure peering through the glass window, trying to pierce the gloom of his shop. It was a lad not a whisker older than 16, with big ears and wide eyes. His rust red hair showed like old blood against his new white hat. His thin hips were hung with an empty gun belt. The Gunsmith glared with his bleary, red eyes, reading the boy's new hat and too-short sleeves like a preacher reads a Bible.

This kid is ripe for the picking, the old man said to himself, and he felt his mouth water for the drink that would soon be coming. He stood there, waiting for the kid to get brave enough to come inside. The Gunsmith stood behind the counter, but his mind was already at the saloon, slugging back a shot of rank red whiskey. Just the thought of that burning drink made his eyes water like he was going to be reunited with his own true love. ✍

GUNS & GUNSMITHS

"Be not afraid of any man,
No matter what his size;
When in danger call on me
And I will equalize!"

When you're talking about the firearms of the Old West, this little slogan, written about the Colt .45 Equalizer, sums things up nicely. In the 1880's, the western part of the United States was a difficult place to live. Hostile indigenous peoples warred against the invading eastern horde. The western states and territories were "uncivilized." They were less populated, and the concentration of lawmen was far less than it had been in the states back east. This meant every man was responsible for his own safety, and the safety of his family.

Necessity has always been the mother of invention, so this increased need for personal safety sired an amazing advance in firearm technology. In the early 1800's, when per-cussion caps began to replace old-style flint as the means to ignite firearms, gunsmiths like Sam Colt started producing multi-shot revolving-chamber weapons. The brilliant inventions of Colt, B. Tyler Henry, and other innovative gunsmiths, such as six shooters, repeating rifles, and double-action revolvers, soon showed up across the western landscape.

Today on a Single Action Shooting range, you can see many of these old-style guns. But with forty thousand SASS members, it's impossible that all of them are equipped with original firearms that have survived from the Old West period. So where do you go to get a classic western six-shooter? Let's meet some of the craftsmen who make them and some of the artisans who keep them looking good. ✪

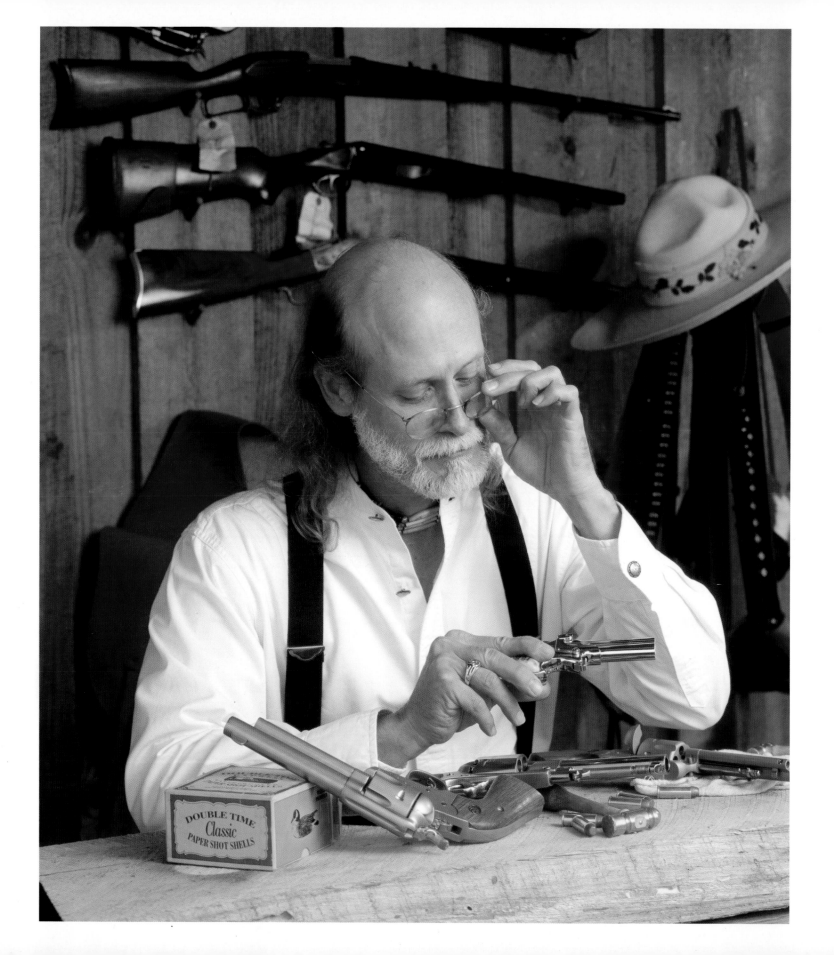

"The gunsmith of the Old West had to be very self-sufficient. Guys like me are spoiled."

HOG LEG SMITH

Gunsmith

WHAT KIND OF SET UP DID YOU SEE IN AN OLD WEST GUNSMITH'S SHOP?

Well, he would have had a furnace, so that he could heat parts and make springs. He probably had an anvil and a series of hammers, so he could work heated metal into various forms. Files, of course screwdrivers, various clamping devices, really basic stuff. The gunsmith of the Old West had to be very self-sufficient. Guys like me are spoiled. I can pick up a gun and order just about anything that I want, but in the Old West they needed to make it.

WHAT KIND OF TRAINING DID A GUNSMITH HAVE?

An older gentleman would take in a younger man who would typically work for "room and board." And the older man would teach the younger man the art of gunsmithing. You had apprenticeships in all the major trades during that era. It would take them 3-5 years, sometimes longer, depending on the ability of the apprentice. Quite often gunsmiths, just as in modern times, had to have more than one profession. The town blacksmith also could have been the town gunsmith, because of the common traits of working metal.

HOW MUCH DID IT COST IN THE 1800S TO GET A GUN "TRICKED OUT"?

Two or three dollars. That was good money back then. It entailed going through and refining the "fit and finish," making sure everything works "in time," the way that it should. As far as the aesthetics of the gun, it really depended on the personality of the shooter. A lot of people liked a gun that was flashy. Some of them wanted something very subtle.

WHAT KIND OF FIREARM DID THE AVERAGE CITIZEN CARRY?

It really depends on the era. For so long the farmer primarily had a muzzle-loading rifle. Then in the 1800s, as cartridge rifles became cheaper and more available, he might have a new Winchester that cost him all of five to seven dollars, which was a lot of money back then. And he always longed to own a Colt.

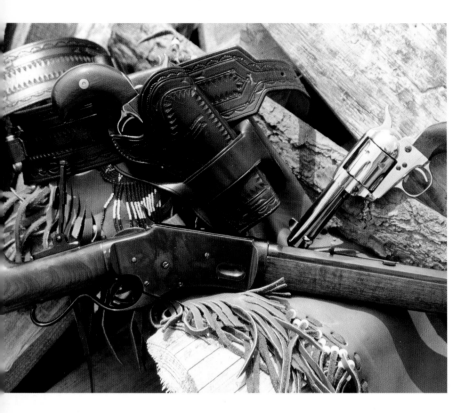

HOW DO THE GUNS SASS USES RESEMBLE THE GUNS OF THE OLD WEST?

A lot of people that compete in SASS events really like the older stuff. They like the feel of the older Colts. In competition today you see people shooting weapons in modern calibers, not so much because they are NOT trying to be historically correct, but because of the expense. It's cheaper to shoot a modern cartridge and it's cheaper to re-load a modern cartridge. People that are truly competitive shoot a lot, so ammunition costs enter into the equation.

HOW DO THEY DIFFER?

In the olden days, manufacturers didn't produce guns the way they do now. For the most part, parts were produced and then individual artisans "fitted" or assembled the guns. So a gun that was produced during that era was truly a reflection of a gunsmith's talents. Nowadays, with production costs and the higher grades of machinery, we're relying more so on machines to produce a gun. That, quite often, doesn't produce a finished product with the finesse that an older gun would have had.

SO WOULD YOU PICK YOUR GUNSMITH DEPENDING ON YOUR TASTE IN GUNS?

To a certain degree. Styles developed over the years. . .particular designers had a specific flair for particular firearms, a type of finish. And people either came to him and gave him business or not. And you flourished relative to your ability to fit and finish. And that's pretty much true today, as well. There are a lot of people out there "smithing" guns that are very good at fitting parts and very good mechanics, but they may not have an eye for the aesthetic—they may not have a feel for the "smooth."

WHAT DO YOU MEAN BY "FIT AND FINISH"?

Well, different finishes have been popular at different times in history. Color case hardened covers in a receiver were popular then and are even popular now, but fewer and fewer people accomplish that because it's so time consuming and expensive. The types and grades and styles of woods. . .checkering patterns and finishing techniques. Some were very functional and certainly

served the purpose. Some were quite beautiful. And the individual artisan would almost "sign" his work by how he finished his goods.

DID THE CARVING ON THE GRIP MAKE A DIFFERENCE IN THE SPEED OF THE DRAW?

Well, it certainly increased your ability to hold onto it in wet, rainy conditions. And in our sport it certainly helps you control your pistol in hot weather, when you're sweating or when your palms are damp from the nerves of competition. But different strokes. Some people like a checkered or engraved grip strap and some people like it smooth.

WHAT GUNS DID SOLDIERS USE DURING THE "WILD WEST"?

Unlike today, where a modern day soldier is issued "A, B, and C" weapons, frontiersmen and cavalry men of that era quite often "shot what they brung." So you had a mixed bag of armament in the field and in the cavalry. You'd see anything from muzzle loading muskets and rifles to lever action rifles, to the trap door Springfields. There was not a lot of uniformity.

WHAT OTHER KINDS OF CITIZENS CARRIED FIREARMS?

Shop keepers, just as they do today, to protect their shop and inventory. They would have used a revolver, probably a Colt, possibly a Smith and Wesson. The rest of the public was primarily unarmed. The homesteaders would have had a mixed bag. . . MuzzleLoaders, Lever Action rifles, Trap Door Springfields, for protection. They would have used a smaller bore rifle to harvest small game and a shotgun for harvesting fowl. They might have a bigger caliber Lever Action or Single Shotgun for harvesting larger game, just like today.

WHERE WOULD YOU HAVE GONE TO PURCHASE A GUN?

Normally a Mercantile or General Store. They would have a catalogue, and you could drool over the catalogue and order it. And most of the weapons were special ordered and pretty much hand built. Sears and Roebuck carried quite a selection.

WHO'S YOUR FAVORITE OLD WEST GUNFIGHTER?

Doc Holiday. . .I like his style. ✪

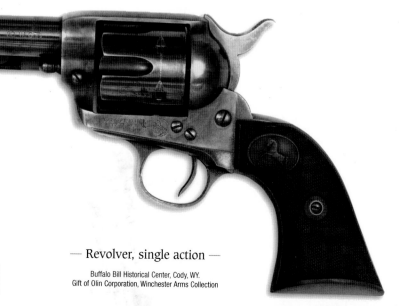

— Revolver, single action —

Buffalo Bill Historical Center, Cody, WY.
Gift of Olin Corporation, Winchester Arms Collection

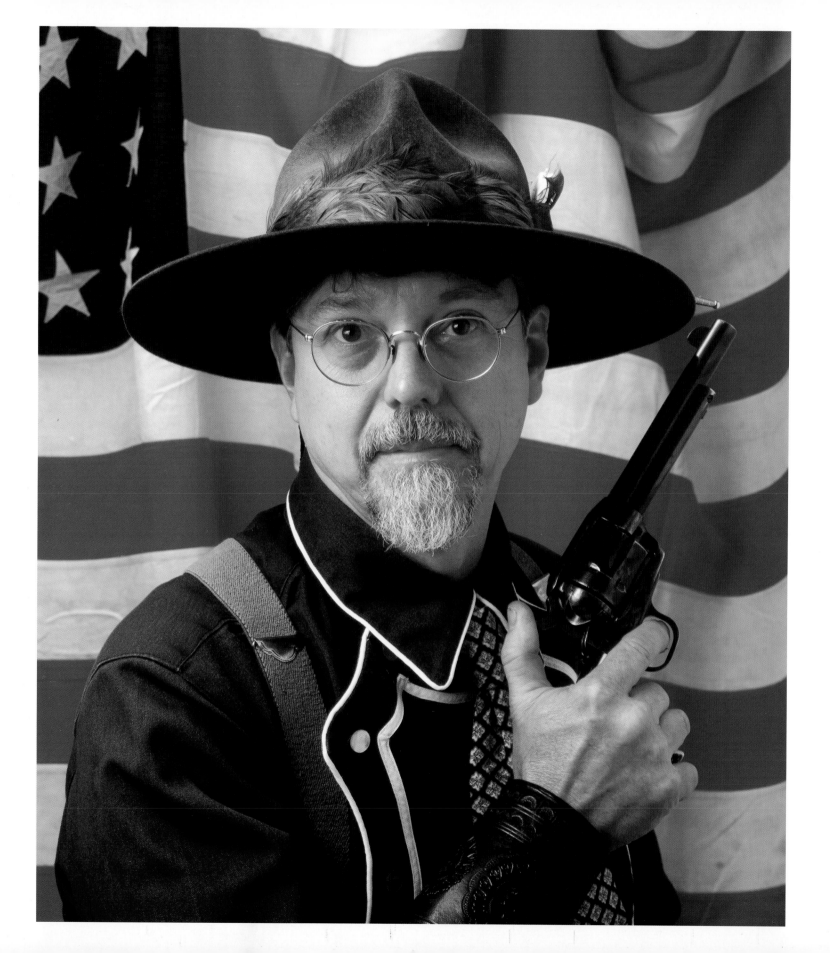

"We are actually taking up a step that is no longer done in the manufacturing of guns: we try and make them into what they 'should have been.'"

JOE WEST

Gunsmith

HOW HAVE GUNS EVOLVED IN SASS SINCE YOU'VE BEEN AROUND?

Here in Georgia, we had gotten the idea from SASS in California to do cowboy shooting, but we were just shooting what we could find, trying to make it as authentic as possible. But we started to compare ourselves with groups from other areas and we thought, "How could these guys be this fast?" A guy came down from Illinois who was a top shooter. We saw him shoot his heavily customized, modified gun and he just whipped us into a frazzle. We'd been using hammer guns that the shells wouldn't come out of, lever guns that had never been adjusted so it took all your strength just to open and close them, revolvers that had never been "point of aimed," never been adjusted in any way. Now we started to think about it. Lots of us shot in other competitive shooting sports, so we started to apply these same methods to make the guns more reliable.

ARE THESE THE SAME TECHNIQUES THAT SMITHS OF THE OLD WEST USED?

Some of the things we do are the same, some are not. See, our game is a total fantasy. And in this fantasy world, all our guns work all the time. We're the best shooters. Nobody is shooting at us. No misfires. We are like the TV gunfighters. Never have a problem. In the real Old West, their guns didn't work. Their ammo misfired all the time. The shells wouldn't come out of their shotguns without being pried out. They operated their lever guns by dropping them off their shoulders, cranking them, then picking it back up to shoot it. They didn't have a gun smooth enough to just hold up to their shoulder to shoot. They didn't have a gun reliable enough to shoot six thousand rounds a year without falling apart. So we are actually taking up a step that is no longer done in the manufacturing of guns. When we work on them, we try and make them into what they "should have been."

WHY DIDN'T THEY DO THAT IN THE OLD WEST?

They just didn't shoot that much. Maybe there were a few hundred people that were actual gunfighters. Everybody else just carried a gun for self-defense. There weren't that many people that were good with a pistol. See, they didn't get the chance to practice like we do. They didn't have the luxury of firearms made from modern steel and almost unlimited ammunition supply, so it was a much more "real" shooting environment. Not like our shooting fantasy.

WHICH WAS THE GUN THAT WON THE WEST?

Probably the Winchester 73 or the Double Barrel Shotgun, the two most common powerful guns. Handy and easy to buy. The thing is, there was no one gun that

really won the West. People back then are like they are now: expedient. So whatever they had at hand was what they used. A lot of people used cap and ball long after it was "extinct," just because they had it and it was cheap. They could buy an old used cap and ball for a few cents whereas a modern cartridge revolver of the day was expensive. It would cost you several dollars and that was a huge cost for the average person.

WHAT DO YOU LIKE ABOUT FIXING GUNS?

It's tangible. It's a positive thing that you can put your hand on and say, "I did this. It's now working beautifully. I have made it better than it was." You can take your gun out and show it to somebody and say "try that." And they'll try it and they'll say, "Wow, that's great!" The appreciation that you get. . .people calling you from different states so they can send you their stuff to work on. . .e-mails from other countries asking you how you did a certain thing. . .it's very rewarding. ✪

— Winchester Model 1866 rifle, c.1875 —

Buffalo Bill Historical Center, Cody, WY. Gift of Olin Corporation, Winchester Arms Collection

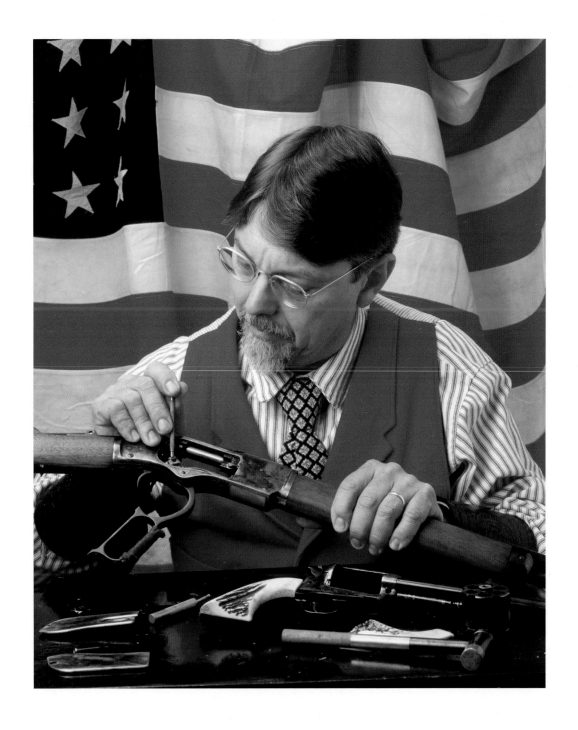

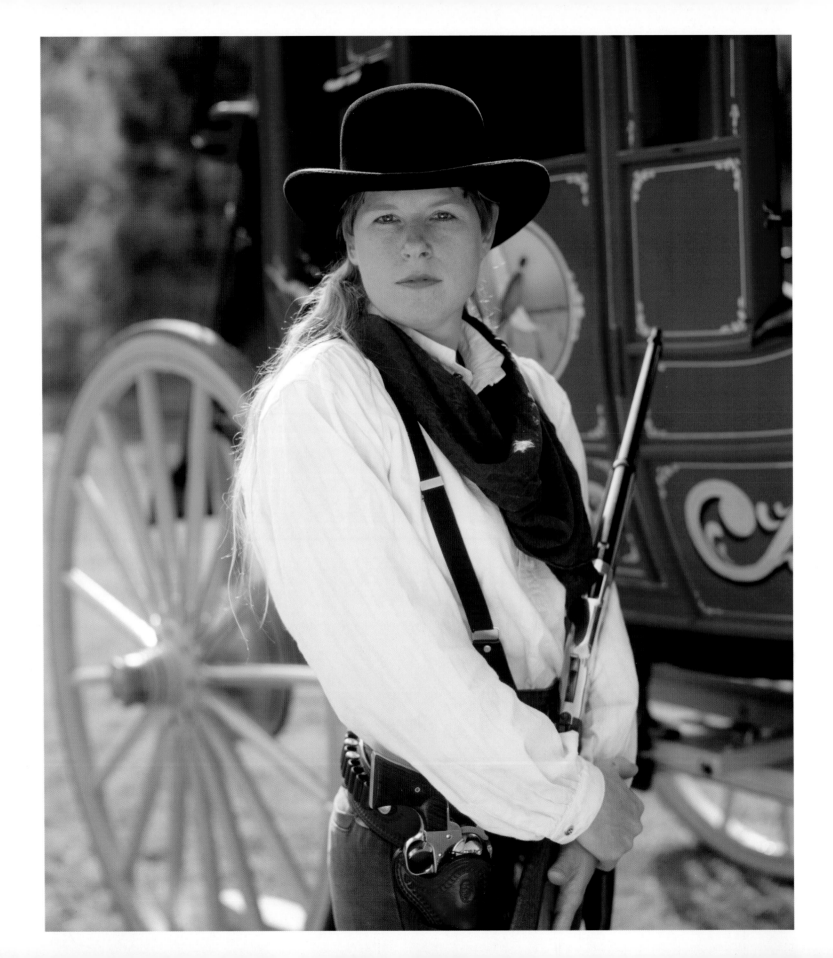

"When you get smooth, then you get the speed"

Cowboy shooter

I think women have an edge. They don't usually go out there for speed. The men go out and try and shoot as fast as they can. Miss things. The women go out with a little more grace. They hit the targets and they're smooth and when you get smooth, then you get the speed. And that's usually how I can come in higher up, because I'm smooth.

My first goal was to beat my husband. I did that this year. My second goal is to become 'top gun,' which I also did this year. In the future, I would like to actually win 'End of Trail' and 'Mule Camp,' and some day I'll do it. It'll just take time. Time and practice." ✪

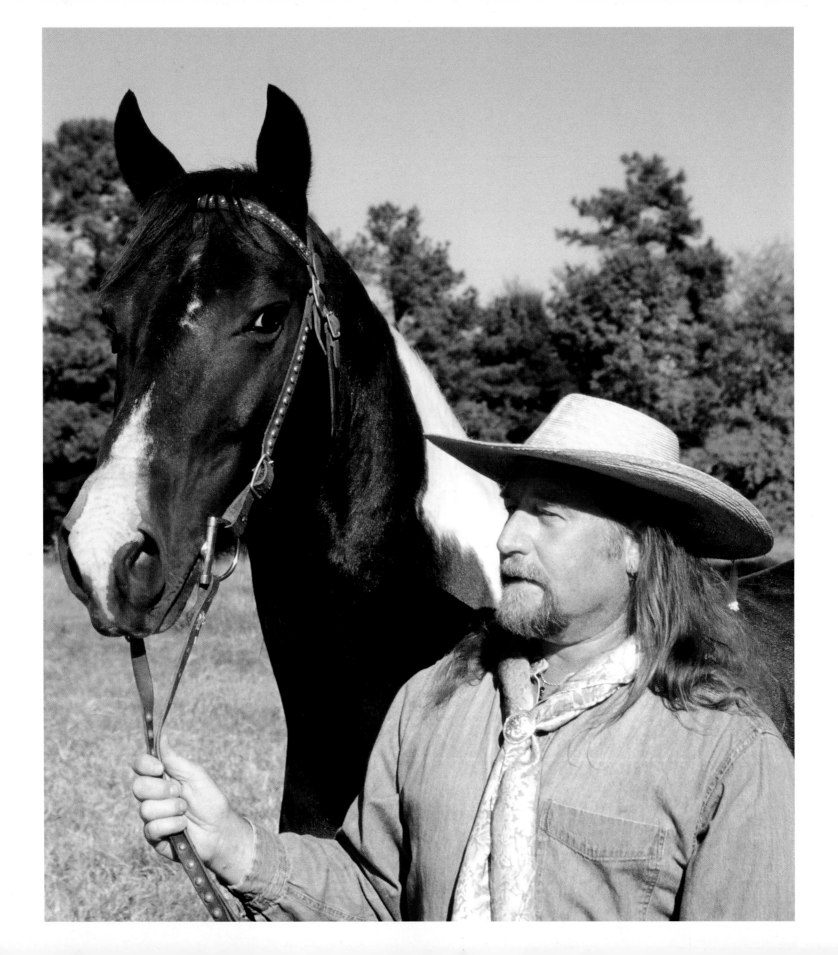

"If a guy has a gun and he's fired up all his ammunition, the last thing he wants to do is throw away his last line of defense."

Atlanta Cutlery/Museum Replicas
Designer/Prototypes

TELL US ABOUT BOWIE KNIVES.

Well, of course they're named after the great Jim Bowie. In the [early?] 1800's, he brought the large knife back into fashion. During the Civil War, the Bowie knife became popular with the southern troops. Lots of the knives were homemade, rather rustic, made in a primitive blacksmith's forge. The guy who was carrying it would often "finish" it himself. Many of these Civil War Bowies had a "D" type hand guard and could have blades as much as 16" to 18" long. They were really short swords with a Bowie-shaped blade. But after the Civil War, the large knives started falling out of favor. Why? War tends to advance weapon technology. The guns made by Mr. Colt and the like after the war were far more reliable. When you have six sure shots at your disposal, you don't need a knife as much for self-defense. So after the Civil War, the Bowie knife was still carried, but it became less and less a primary weapon and was used more and more for utilitarian purposes.

IN THE OLD WEST, WHERE DID THEY WEAR THEIR KNIVES?

Usually at the waist, on their belt. The location—left, right, back—was usually determined by the individual. Most favored a cross draw. For riding, a cross draw was usually more comfortable and if you were wearing it with a six shooter, you'd need to wear it on your "off-hand" so you were free to draw your gun more easily. People who wore two guns would carry it in the middle of their back or even carry a smaller knife in the top of their boot.

TELL US ABOUT KNIFE THROWING.

Well, back in the Civil War, that was one of the "big time" entertainments. The Yankees were playing baseball and the Confederates were throwing their outlandish Bowie knives, trying to make them stick. So knife throwing has been around for a long time. But as far as self-defense, if a guy has a gun and he's used up all his ammunition, the last thing he wants to do is throw away his last line of defense.

You throw a knife and miss, you're in bad shape. So as a combat technique, knives weren't thrown very often. But as far as just playing "mumbly peg" on the wooden steps, I think it was a pretty common entertainment. ✪

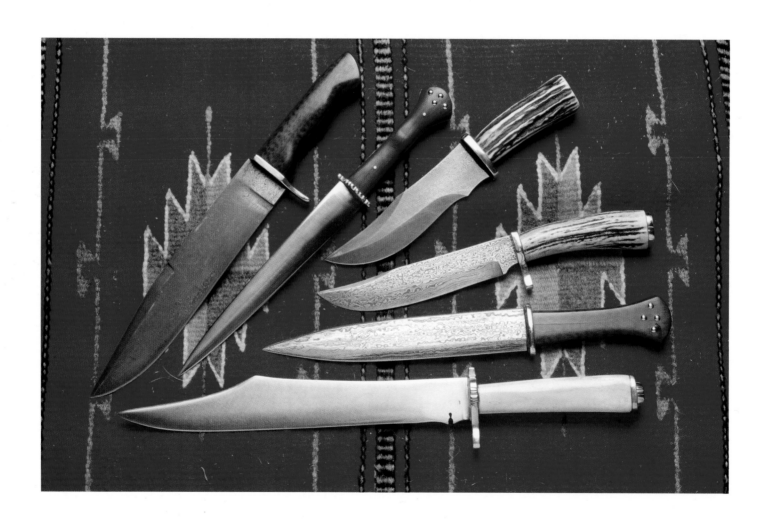

Jim Stephens

"This little window of time in the late 1880's is probably the most romantic period in the history of the United States . . ."

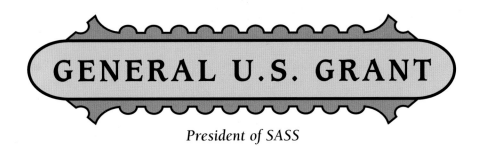

GENERAL U.S. GRANT

President of SASS

HOW DID SASS GET STARTED?

We were part of the Orange County Practical Pistol Club down in Coto de Caza, California, in the late 1970's and it started attracting paramilitary types with intense competition and it just wasn't a lot of fun. So a bunch of us started our own group, using sets such as barbershops or saloons or a mine. We set up scenarios where the game was to pick off the "bad guys" who came into town to wreak havoc on the good, just like in the old cowboy movies. We issued badges and everyone had to have an alias.

We decided to send out a lot of invitations to shooters we knew who might enjoy our game, the first "End of Trail." When I think about what it is today, a national and worldwide organization with almost forty thousand members, it boggles the mind. This little window of time in the late 1880s is probably the most romantic period in the history of the United States. That's probably why SASS caught on and grew like wildfire. It's a fantasy: putting on the outfit, the gun belt, the hat, taking on the whole aura of a time

past but far from forgotten.

Dave Britton, aka R.J. Poteet, was the motivating party, getting all this going, setting up the organization. His wife Roz, aka Sarasota, ran the association out of her back bedroom. SASS just kept getting bigger and bigger, so we rented quarters, adding more rooms and offices as we grew. In 1990, we were renting spaces in three different buildings. And we also found ourselves in the publishing business with the *Cowboy Chronicle*, our now-monthly newspaper. About a year and a half ago, we acquired a ten thousand square foot building in Yorba Linda, so SASS now has an official home.

WHY THE TREMENDOUS GROWTH?

The friendliness of the members, the fun, meeting new people. It's a family event. The wives and kids love the costuming. Those who travel around the country to attend shooting events meet a fine, upright brand of people. When I went to South Carolina last year, I heard a fellow

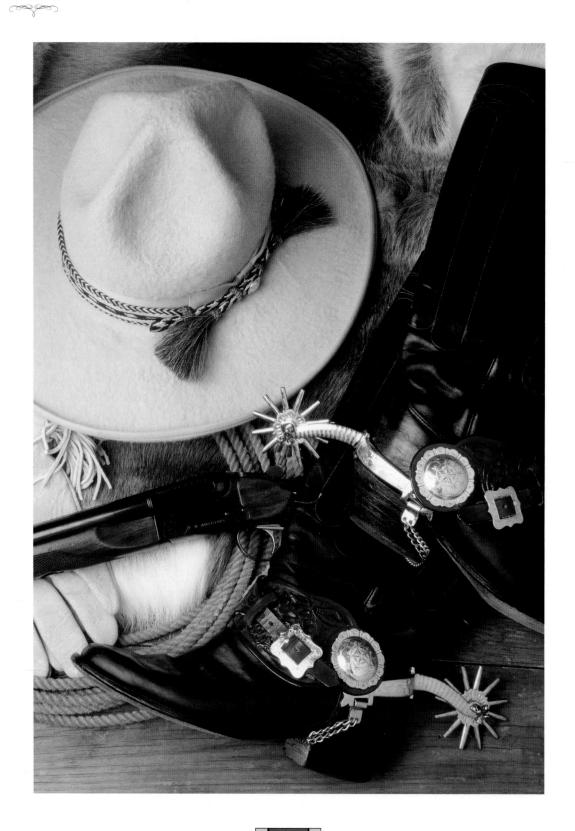

say; "It's like going to a family reunion, only you like everyone!" It goes far beyond the shooting competition or a weekend event. It's like entering a whole new world . . .or should I say a "whole *old* world."

WHO RUNS SASS?

We have a board of directors called the "Wild Bunch." I am President, SASS badge #2. I'm also in charge of tents and toilets and food concessions at "End of Trail." Each member has his area of participation. We have a board meeting about once a week. Judge Roy Bean, SASS badge #1, is our "Icon." He travels all over the U. S. to attend meets, dispense wisdom and handle public relations. Most of the board members try to travel to some of the monthly shoots and particularly the regional shoots, when all the clubs in the area get together to compete.

I HEAR YOU HAVE GREAT PRIZES.

Actually the prizes are not for the top shooter. He gets the bragging rights and all the glory, but the prizes are spread among all the shooters in a prize drawing. It's the luck of the draw. He (or she) may get a shirt, some ammo, and a gun or belt buckle. Nothing is valued less than about 60 dollars. At the beginning, I provided most of the prizes since I was in the business of importing cowboy guns. Later a prize committee was set up to solicit sponsors and prizes.

HOW DO THE GROUPS DIFFER FROM REGION TO REGION?

They don't differ a lot. You meet the same great people everywhere, decent law-abiding citizens and their families. They all play by the same SASS standards. There are about 350 clubs in the U. S. now who get together each month to compete. There are seven regional shoots a year, which are smaller scale "End of Trail"-type shoots. I must say, however, that in the south the emphasis is on the Civil War. I was really going into enemy territory as "General U. S. Grant" in North and South Carolina and Georgia! ✪

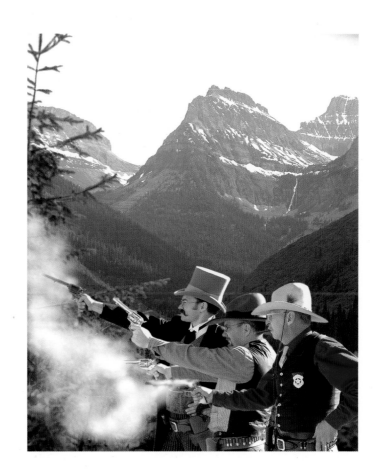

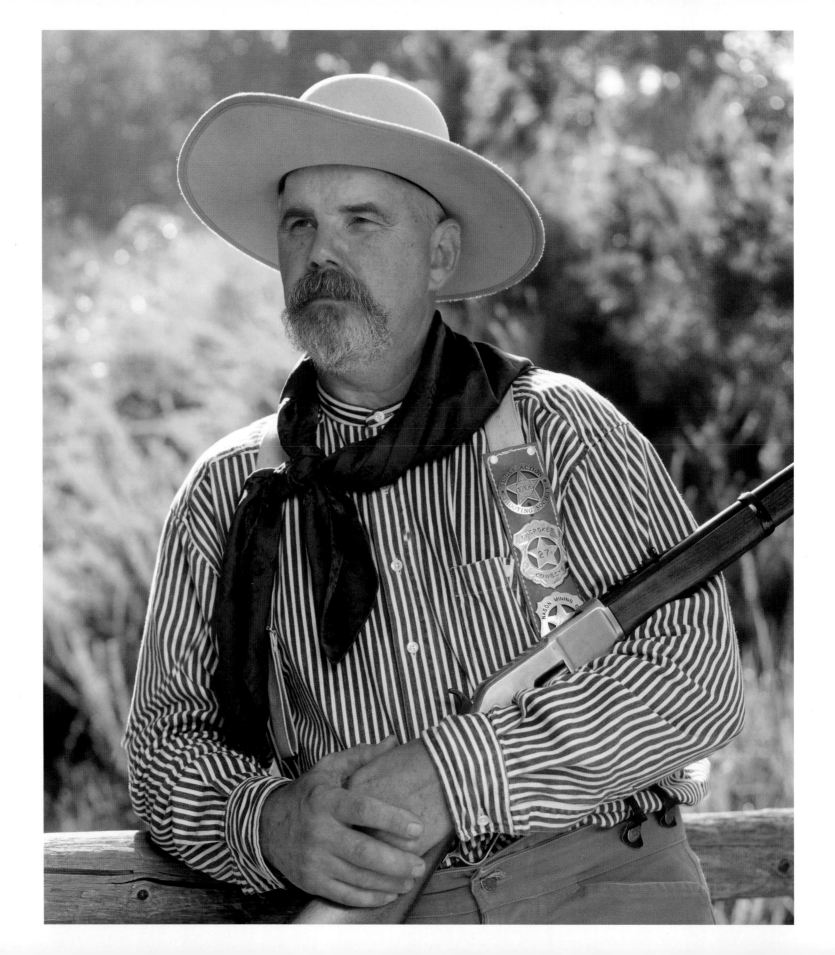

"A man's pistol represented a substantial investment, and he wanted to put it into suitable leather."

ROD KIBLER

Saddlemaker

WHERE DID YOU BUY HOLSTERS IN THE OLD WEST?

In the old days, saddleries made a good selection of gun leather in their shops. Some of the makers became better known for their gun leather than for their saddles. Most gun shops would have a selection of mail-order leather in stock from factories back East. But most often the customer would prefer to have his outfit made to order, so he'd go to a saddlery. A man's pistol represented a substantial investment, and he wanted to put it into suitable leather.

DID SADDLERIES MAKE MATCHING SETS?

That was very uncommon, because a lot of times they'd replace either the belt or the holster and not replace the whole rig. Too expensive. The early belts and holsters were strictly functional. There were no embellishments . . .no gee-gaws or doo-dads. It was just a way to carry the pistol and ammunition. That's one reason the money belt got so popular. Your belt carried your money, your ammunition, and the holster carried your pistol. They were a lot like the modern-day carpenter's tool belt.

SO WHEN DID ORNAMENTAL CARVING COME INTO PLAY?

Incise carving, fancy stitching, and silver trim were seen on some early examples, but didn't become common until the very end of the 19th century. The highly decorated and ornate rigs weren't really seen until the movie cowboy era. That's where the embellishments really came into their own.

WHAT KIND OF FOLKS WORE WHAT KIND OF RIGS?

True cowboys, most of the time, didn't carry a sidearm "day in, day out, all day long." Unless danger was at hand, the gun and rig were in his bedroll in the wagon. The men

of the town, the gamblers and businessmen, would more likely carry a small pocket pistol or derringer, concealed. Maybe in a pocket or sleeve hideout, or vest.

WHO WORE THE VISIBLE HOLSTERS?

Probably just the working cowboys. They weren't likely going to wear their rigs when they were out working, but when they were in town, going on a "hoo-rah," then they'd have their sidearms on.

TELL US ABOUT THE FIRST WESTERN HOLSTERS.

The traditional western holster, as we usually recognize it, wasn't developed until Sam Colt introduced the Single Action Army Pistol in the early 1870's. Originally sidearms were carried in the belt or sash. Early short barrels were carried in a pocket. The earliest forms were known as California styles. These holsters were usually very deep pocketed, to protect the weapon's internal parts, as well as to keep the powder dry. They were made of fairly lightweight leather and were carried by means of

a simple loop sewn or riveted to the back of the pouch, usually on a narrow belt. The next major design innovation appeared sometime in the 1870's, closely following the introduction of the cartridge firearms. This design became known as the Mexican Loop. It was cut from a single piece of leather. That formed the pouch. The backflap or skirt was folded over and slotted. The pouch was then put through these loops to secure it. Practically every holster popular then and today is derived from these two basic designs. Things like the Cheyenne Toe Plug and Texas Jock Strap—those were regional names for embellishments.

TEXAS JOCK STRAP?

That name apparently originated with the Myres Saddle Company in El Paso. And how they came to give that moniker to it, I'm not absolutely sure. But if you've ever seen that piece of equipment, the similarities are obvious.

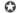

"Engravers don't retire. They just get better. You might get crippled, blind, but you don't ever retire."

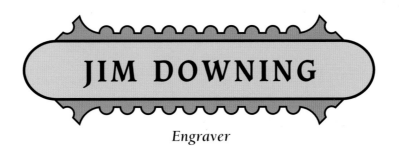

JIM DOWNING

Engraver

SO WHAT EXACTLY IS ENGRAVING?

It's the art of cutting metal with a chisel, rather than with a rotary tool or by using acid etching or the laser process. Even though people might call those techniques engraving, they're actually etching. A lot of cheaper guns nowadays are etched. That makes them more flat, more dull—the gun has no shape or style, let alone any uniqueness, because it's one of a million. Engraving is done with a sharp chisel, so that you get a two-sided cut. Both sides reflect light. And that's what gives the engraving its flair.

WHERE DID MOST OF THE ENGRAVING HAPPEN IN THE OLD WEST?

Colt, Winchester and the factory guys did most of the engraving at the factories. Very few engravers back then were "after market," like I am. Factory engravers did things the "Colt" way or the "Winchester" way, got paid next to nothing. . .standard designs: "A, B, or C." But then each factory might have one or two really good guys, master engravers, who would do the presentation pieces that would be given to the Secretary of State, or Secretary of War, or a foreign potentate. That master engraver would be capable of doing very unique work—dragons, fantasy, naked ladies, or whatever that foreign potentate was "into." He might do the customized part, the scene, and then hand it off to a secondary engraver to do the scroll. In the factory system you could do that.

THERE'S A LOT OF FOLKS DROPPING OFF GUNS TODAY.

At these SASS shows, I'll work twelve to thirteen hours a day. I average about a gun a week at home. A backstrap takes me about an hour. It's physically tough on your body, which is why there are so few engravers. Also, to learn to engrave, you have to do it all the time—it's not just a hobby that you can pick up when the mood strikes you. You have to jump in with two feet and work on it for years just to become proficient at it, let alone good. Engravers don't retire. They just get better. You might get crippled, blind, but you don't ever retire. I see myself doing this when I'm seventy. ✪

Chapter Three
COWBOYS

BEADLE'S
Dime
New York Library

Copyrighted, 1893, by Beadle and Adams. Entered as Second Class Matter at the New York, N. Y., Post Office. January 18, 1893.

No. 743. Published Every Wednesday. *Beadle & Adams, Publishers,* 98 WILLIAM STREET, NEW YORK. Ten Cents a Copy. $5.00 a Year. Vol. LVIII.

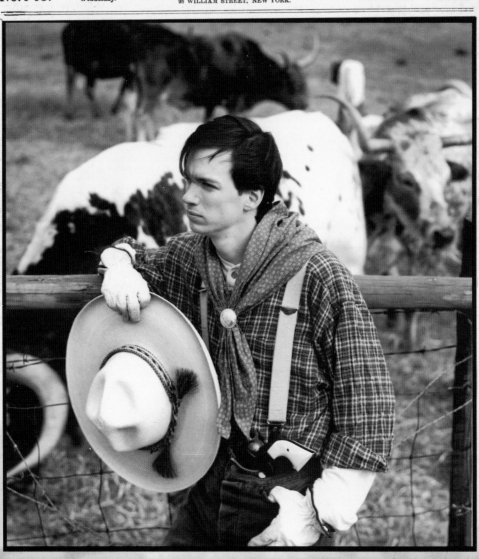

The old Gunsmith was slick. He could smell the silver in the lanky greenhorn's pocket. And it smelled like whiskey. He was bound to have it, every cent, before the kid walked out the door. "My name's Will Fergus," the boy blurted, his voice cracking right down the middle like Mama's Sunday china. "I hired on with the Double G drive and I need a side iron. . .the best you got."

Crossing to his window display, the Gunsmith picked up the Peacemaker and polished it carefully, thinking about the debts he owed at the saloon. He looked at the lad and decided to take what he offered. "This one just come in. Bounty hunter's gun. . .killed 12 men. Shoots nice and easy." He spun the chamber with a well-oiled blur and aimed the empty piece out the dirty window. His liver-spotted hand shook from want of whiskey. Pulling back the hammer, he released the trigger slowly. "About a 2-pound pull on the trigger." The old man's voice was as greasy as his polish rag. "But I don't think it's too much gun for an able trail-hand like yourself."

The peach-faced boy left the shop, whistling "Sweet Betsy from Pike." His purse was five bucks lighter, he'd spent more of his Mama's butter and egg money than he should have, but his hip hung heavy with killin' iron.

⁓⁂⁓

Will Fergus was qualified for many things—a store clerk, maybe a telegraph officer—but he wasn't cut out to be a cowboy. And every single hard-riding day the Trail Boss reminded him. The other men called him "Apron Strings" and he had begun to wish that's where he had stayed. It had taken many hard days in the saddle before his legs stopped aching, and sleeping on the cold, hard ground was keeping rest at bay. Even the Colt 45 had lost her beauty to him, and he rued the day he crossed the threshold of that Gunsmith's filthy shop.

He had suffered through almost two whole sore-tailed weeks. The herd was bedded down a dozen days' hard ride outside Brownsville and Will had pulled the graveyard shift. His

third turn in the barrel this week. Turning his collar up and pulling his hat down, he mounted up for the late-night ride. His job was to keep 994 wild-eyed longhorns calm and quiet. The Trail Boss never let him sing to them, though. Said his squeaky voice scared the cows.

Will spurred his mustang up the hill, cresting the ridge that looked over the resting herd. Just then he felt it. . .the air turned weird. Will smelled the storm coming first, on the wet-sage wind sneaking in from the west. He rode down the ridge, talking low and soothing to the uneasy cattle.

Then lightning started up, snaking out of the black, rolling clouds, making eerie day out of night. The longhorns started moaning and shifting on the ground with dread. Will faced the renegade storm. It came blowing in across the flat plains, turning the sky against them. The hail came next, blistering the ground like angry rain. Just then, God's wide and fiery finger shot down, splitting the sky like a rotten melon and blasting matchsticks out of an old cottonwood tree. The herd started running blind.

Will's horse, as bad and sly as the lad was green, started bucking stiff-legged. The lanky boy tried to hang on, but hard rain was making for a slippery seat. He sailed between the crafty mustang's ears onto the boiling ground beneath the grinding stampede. He landed hard, fell on his side. The Peacemaker was still strapped in his holster, useless against Heaven's thundering wrath.

Will Fergus knew he was done. Knew he'd never see his Mama's dear face again. He'd be stomped into the churning mud and buried on the lonely plains in an unmarked grave. But before he could take a breath for his last prayer, a meaty hand grabbed the back of his collar, jerking him by the scruff of his neck onto the seat of the bouncing chuck wagon. Will gaped through the blowing curtains of rain into the face of his unlikely angel, snaggle-toothed Cookie. The old camp cook cracked his whip against the roar of the storm.

"Good thing you're only half-growed," yelled Cookie over the rising wind, "else I'd've never got you off the ground."

Will gawked down from the island of the wagon into the milling sea of bellowing cows and flashing horns. Gulping, he stuttered, "Thanks, Cookie" through chattering teeth.

"OK, Apron Strings," Cookie growled, "but you owe me."

They came from all walks of life. . . misplaced veterans of the War Between the States, Mexican vaqueros, freed slaves, immigrants from the East who had come to the United States to seek a better life. These were the men who lived and worked out on the western range, moving millions of half-wild cattle to the rail yards of our nation. They were poor men, for the most part barely educated, and tough as nails.

The big cattle drives began in Texas, but they soon spread as far as grass would grow, as far north as Idaho and Montana. And before long, even the president of our nation was eating steak raised and run on those hard western plains.

A man didn't have to meet many qualifications to be a cowboy: be able to stay in a saddle, withstand difficult conditions without complaint. But a particular kind of man was attracted to this lifestyle, a man who desired freedom more than comfort.

Eventually, if he stayed at it long enough, if the work didn't break him and the cold didn't kill him, he became skilled. And skills like roping, riding, and working the cattle made him a marketable commodity in a world where beef per pound was worth almost as much as the men who drove it.

The wilder the country they rode, the greater the danger became. But cowboys hardly ever carried a firearm when they were working on the range. Blizzards and gopher holes posed much more of a danger than rattlesnakes and "hostiles," so they generally left their guns in the wagon. But when the drive was over, and they headed into town, they brushed the trail dirt off their hats, polished their guns, and became the pistol-toting buckaroos that we all recognize today.

The cowboy persona is probably the most popular one that Single Action shooters strap on when they step out of their everyday lives. They love the simple tenacity of that character. They admire the unbreakable fortitude that made the cowboy survive unimaginable hardships. Let's take a look at some of those men and find out just what it is that makes them want to walk the cowboy way. ✪

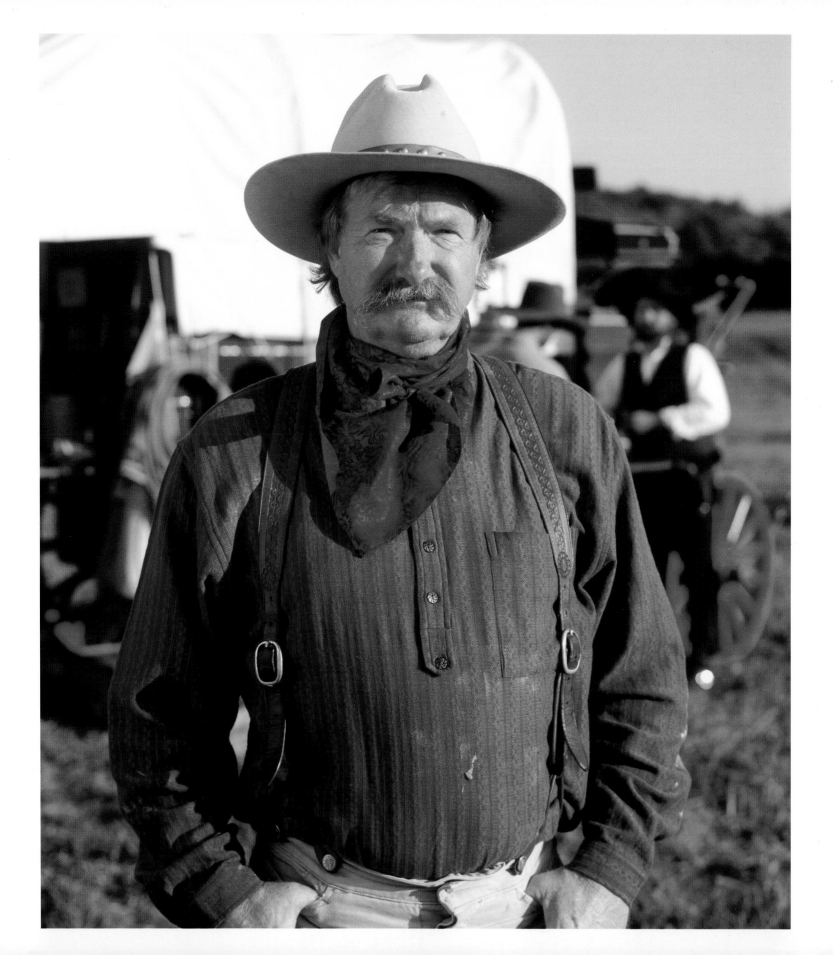

"I just can't imagine men being that tough."

LAMAR GREEN

Coosie

WHAT'S THE PROFILE OF A COWBOY?
They'd be kids, 11 or 12 years old. You had to be a hard worker and a good rider. And these boys worked hard. Lots of them came out of boarding schools. . .they didn't have anything and they'd want to be a cowboy. So that's how they got started. I guess it was kind of exciting, too. They'd get to travel on a horse to these cow camps. Most people don't realize it, but most of the old cowboys came from the south. After the Civil War, when the carpetbaggers started coming through, these boys had a hard time, so they loaded up and moved west.

I don't see how the cowboys did it. I really don't see how. They'd be out there for weeks, looking for water. If they lived to be 35, 36 years old, they were considered OLD. In the blizzard of 1890, in Montana or Wyoming, they had 100,000 cattle freeze to death. It snowed so deep that they couldn't move—just stood there and froze to death. In fact, the blizzards in Montana almost wiped the cattle business out. The men thought they had found glory land when they got up into that rich grassland, but they didn't understand how cold it got.

WHAT KIND OF GEAR DID YOU NEED?
Well, their saddle was their pride. It was like our car is today. They wanted a good, custom hand-made saddle. And a good horse. They took pride in their horses, too. Even though the ranch would keep a gang of horses, in case they had some that got sick or killed, the real cowboys, the hard-working ranch cowboys, had their own horse.

BESIDES COWPUNCHING, WHAT OTHER KINDS OF WORK DID THEY DO?
Well, that was pretty much it. They'd drive cattle all day long. They didn't really have time to do anything else. They got up way before sunup, ate, and started gathering cattle just as soon as there was light to see them. The cows would wander off during the night maybe eight or ten miles, and they'd have to round them all back in. By

then, the chuckwagon was on his way and they'd go and push them forward.

WHY DO YOU ADMIRE THEM SO MUCH?

It amazes me. I'm flabbergasted every time I think about it. I just can't imagine men being that tough. I've read stories where they'd sleep under nothing but an old buffalo robe and they'd get up and have three feet of snow on the ground. And all their clothes soaking wet. I've read stories about some of those big rains coming up and they'd be out driving cattle in the pouring rain for a week. And then, at night, there still wasn't any place to go get dry. These boys had it rough. Some of them wouldn't take a bath for a year. They wouldn't take one in the wintertime, cause they'd freeze to death. And in the summertime, they'd find a creek somewhere, and take a bath, and that might be the only one they'd get that year. It was a hard, hard life. ★

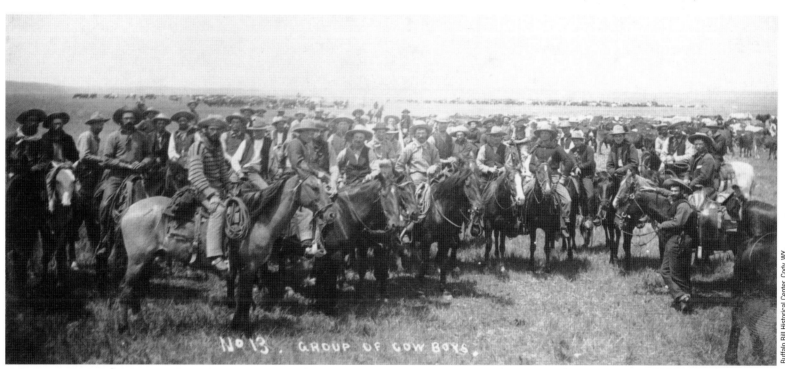

Buffalo Bill Historical Center, Cody, WY.

— Group of cowboys, c.1880 —

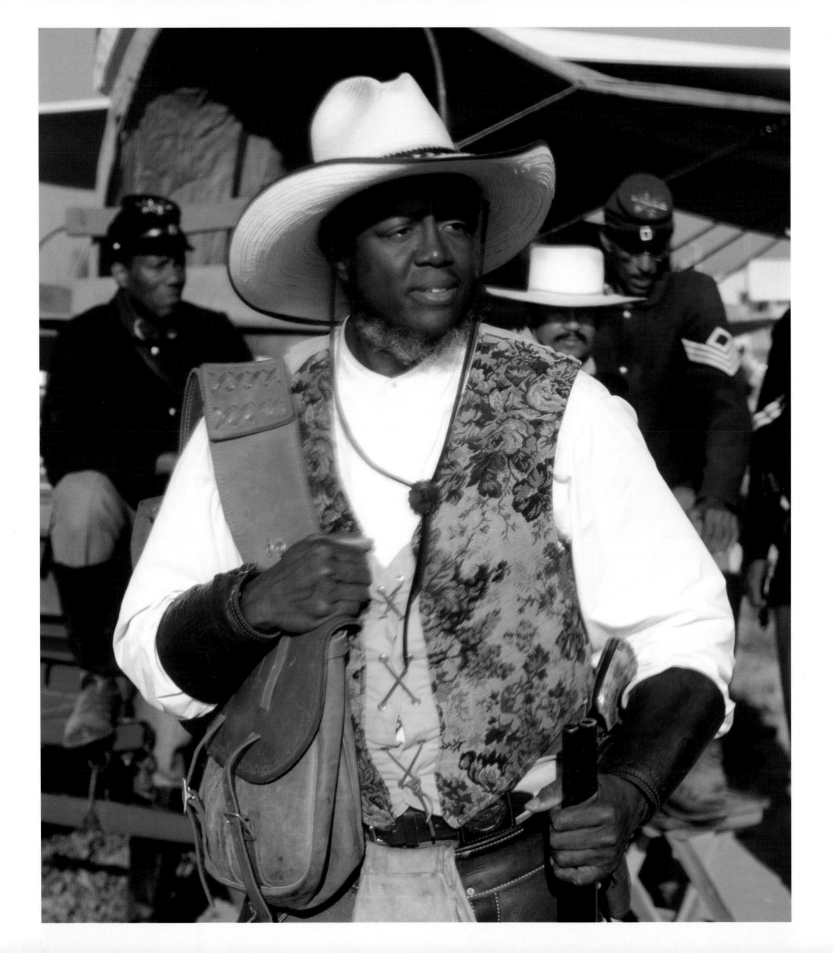

"They were out to survive, to live their lives, provide for their families, strengthen their communities, and that makes them true Americans."

NAT LOVE

Cowboy Shooter/Western Storyteller

TELL US ABOUT THE REAL NAT LOVE.

I've always been an avid fan of studying history. I concentrated on the study of African-Americans in the West. Every now and again, I'd find a story. One of the stories was about this African-American cowboy by the name of Nat Love. He was published in 1907 in the Los Angeles public library. I got a copy of his book and read it from cover to cover. He starts out explaining that cowboys are "the greatest thing in the world and I'm so glad to be among them." Now, he doesn't say, "even though they treated me bad because I'd been a slave . . ." He doesn't go there. He provides a historical perspective, but you don't get a sense of bitterness because of the condition of servitude that he'd been forced to endure. He talks about his fantastic adventures. Eventually you wonder if he's pulling your leg, because he's having too much fun. Coming out of the Civil War, he wanted to strike out and explore his desire for becoming a cowboy. He goes out to cattle country. He wins his spurs by riding the worst horse around.

And he does it in fine fashion, because when he was young, he trained horses on the plantation where he lived. So, when I read this story, I said, "I knew it! I knew there were African-Americans who were cowboys!"

DID MANY AFRICAN-AMERICANS GO INTO LAW ENFORCEMENT?

There was a marshal who had been a slave. He couldn't read the warrants, so he'd have somebody read them to him and he'd memorize the details. He'd ride into the Indian nations and find the people who were on the warrants, bring them out alive, or sometimes strapped over a saddle. His name was Bass Reeves. And he had a faithful companion who was a black Indian. Prior to becoming a marshal, Bass had been a fugitive slave who hid out in the Indian Nation, so he knew the badlands. He was an able agent for Judge Parker's hanging court out of Fort Smith, Arkansas. Bass and his partner rode long and hard, and his horse took on this gray-white chalky color. Now, you have

to remember, he was black, his face was black. Inmates in the Detroit Federal Penitentiary in the 20's told of a black-faced man who brought them to justice. And they told these stories to a Jewish producer who started developing this series of stories for radio that talked about the mysterious masked man who rode a white horse and had an Indian side-kick. The rest is history.

SO HOLLYWOOD LEFT THE COLOR OUT OF THEIR CHARACTERS?

In the movie "The Searchers," John Wayne portrayed a man, a tracker, whose family was stolen by the Indians. And he tracks them down and becomes a member of the tribe in order to win their confidence so he could steal his family back. When he steals them back, the Indians swear that they will pay him back, and they track him again. And when they find him, there is a confrontation and he's eventually killed, but not before he has a good accounting and kills 75 natives who were trying to get him. Now, the moviemakers played loose with the facts. They changed the unit he was in from the Tenth Cavalry to the Third Cavalry. Why? Because the Tenth Cavalry was an all-black unit and our hero, whose real name was Brit Johnson, was a black man. When I tell that story, boy, I get some jaws dropping!

TELL US ABOUT THE BUFFALO SOLDIERS.

Remember when Billy the Kid was in New Mexico and having that confrontation with the army? Those were Buffalo Soldiers. Now, how do we cover that up? We say there was an element of the cavalry there, an Officer Kinkaid, a good old Irish boy, right? Up until the late 1880s, all the officers of the Buffalo Soldiers were white. So you had regiments of black troops involved in important history, but nobody knows it. They left that important qualifier out because they wanted to sell their stories to newspapers and publishing houses, and at the turn of the century, those places didn't print stories about black people.

The beauty of all of this is that Nat Love and all these black individuals didn't end up being bitter about their life situations. They operated in the true sense of being Americans, of being citizens. They were out to survive, to live their lives, provide for their families, strengthen their communities, and that makes them true Americans. ★

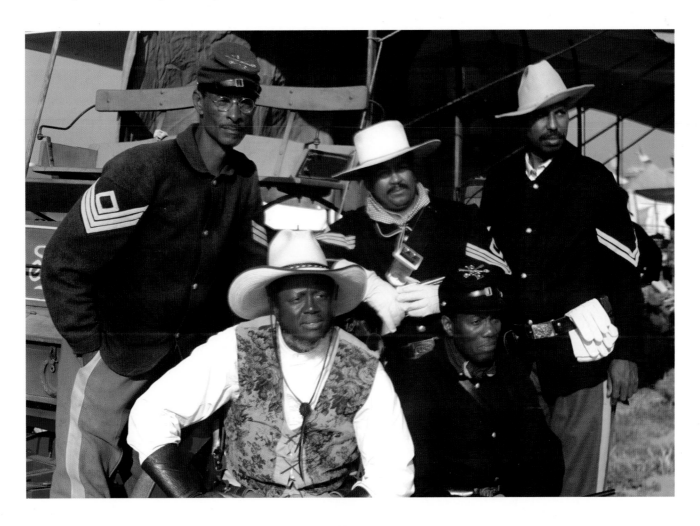

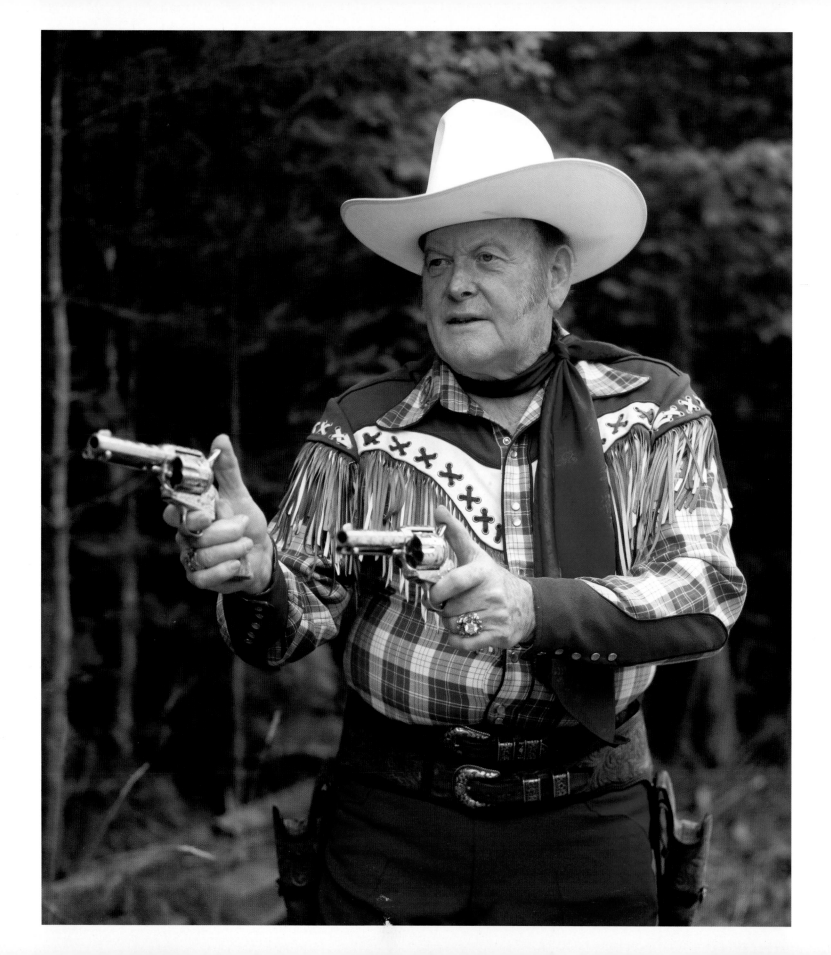

"Earlier Westerns . . . those were morality plays."

JOE BOWMAN

*Actor and Western movie consultant,
master of "Triggernometry"*

If you look at the earlier Westerns, you could tell good guys and bad guys. That's where they talk about the black and white hats. Those were morality plays, really. Back then there was kind of a formula. The bad guys were trying to take something that didn't belong to them, whether it was robbing an oil field or a bank or a stagecoach. You had *High Noon*—now *that* was good vs. evil. Nowadays the movies are all garbled up to where being bad is good. It's a terrible sight when everybody is in it for themselves. ✪

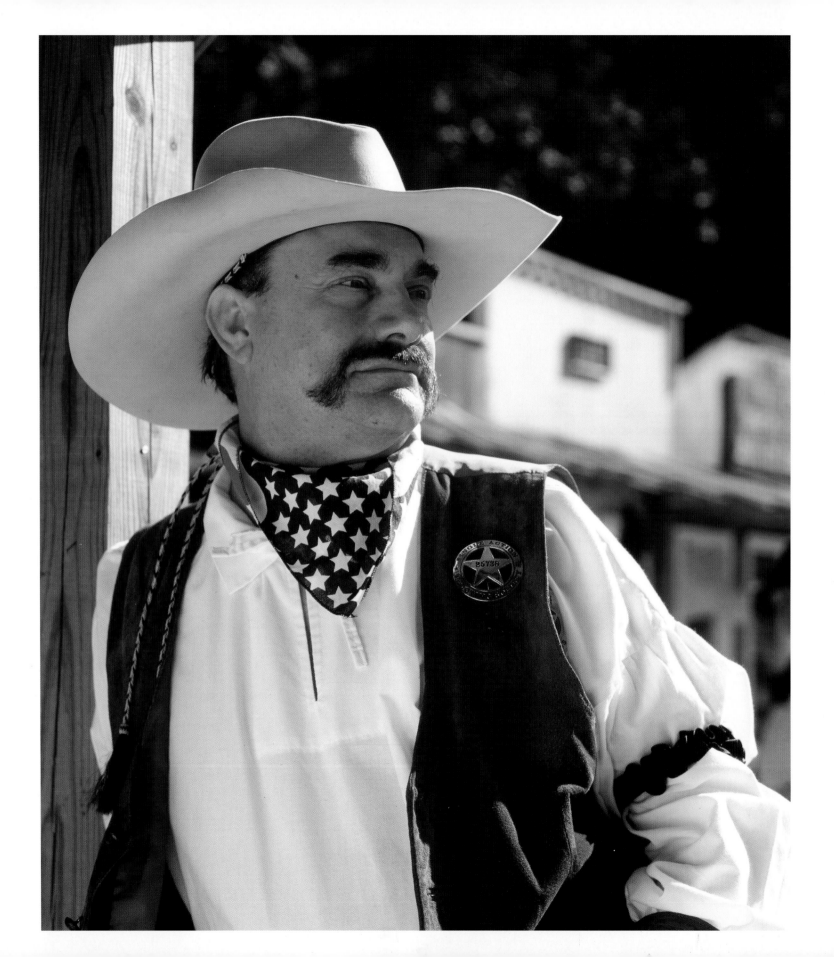

"It's all about fun. Fun for everybody, so we try and make it as fair as we can."

Cowboy shooter

WHAT MAKES SASS DIFFERENT FROM OTHER SHOOTING SPORTS?

Most other shooting sports, particularly handgun or rifle, are very competitive. Our sport is designed strictly for fun. We're not there to win any trophies to take home. The most you get is a piece of paper that you can show off. It allows us to be kids again. And, except for the safety aspect, it's not to be taken too seriously. We set our stages up so that ninety percent of the cowboys hit ninety percent of the targets, ninety percent of the time.

WHAT'S A SCENARIO?

It's the basic story behind each shoot. A scenario is set up to depict something from the history of the Old West, like the shootout at the OK Corral or the great Northfield, Montana raid when the Youngers and the James Brothers attempted to rob the bank. Or, it could be the capture and killing of Billy the Kid. It can be fact or fiction so long as it's based on the lore or myth of the Old West. Once you

have the scenario, you set the stage.

MEANWHILE, BACK AT THE RANCH. . .

(Laughs) Meanwhile, the Posse Leader—who is in charge of each group of shooters—reads the scenario to the cowboys, then they announce the "round count." That's how many rounds you're going to take with each pistol, rifle, and shotgun. They also tell you where the weapons will be staged . . .on a haybale, out of a saddle scabbard, on a table, out of a gunrack. At this point, Posse Leader will go through the scenario and describe how the stage will be fired, or shot. For example, if there are five steel pistol targets out in the front, the scenario may be, "the competitor will stand with hands on hips, draw the first pistol at the sound of the buzzer and shoot at pistol targets left to right. Then (put the gun in the) holster and draw and shoot the second pistol targets right to left." The description is very specific.

Now, that's just one stage. They'll rotate through each stage before the day is done. And each stage has a different

walk down the boardwalk and shoot through doorways and windows at targets. At one shoot we had to go gather eggs out of hens' nests and put them into an egg basket before you could shoot. I've even seen them put you inside the outhouse, sitting on the "pot" and you had to say your line, open the door, come out and draw your pistol and shoot at targets.

ANY SPECIAL SAFETY PROCEDURES?

At all cowboy action shoots we operate cold ranges. That means nobody can load a weapon unless they are observed at the loading table. There are some basic safety procedures about how to carry guns out on the firing line. Guns should always be carried pointed down range, or up in the air, down range. SASS requires that when you're moving from the loading table to the stage where you're going to shoot, the muzzle be pointed down range, away from the firing line. Also, when we shoot a scenario, we move laterally along the firing line. We never go forward of any staged gun, so all movement is done behind the staged guns.

scenario story, or all (the stages) could be connected to the same story. Like "the Life and Times of Tom Horn," or Jesse James. We did a state shoot a couple of years ago and all the scenarios were from John Wayne movies. Did another one that was taken from Clint Eastwood movies. Those were a lot of fun.

TELL US ABOUT THE PROPS YOU USE IN SCENARIOS.

We use lots of different kinds of props. Really, anything that you can think of to enhance the game. We use everything from actual buckboard wagons, to fake mules and horses. We stage our guns on their saddles or in scabbards. We even have saddles on them so we jump on them and shoot from "horseback." I've seen a mock town where you

YOU USE VINTAGE GUN REPRODUCTIONS. DO YOU HAVE SPECIAL SAFETY ISSUES WITH THEM?

Most of the rifles and shotguns do have safety features on them. But the pistols don't have any safety features. To make sure the pistols are safe, we only load five rounds. Never load the sixth. So we never have a hammer down on a live round in a holstered pistol.

LET'S TALK A LITTLE BIT ABOUT SCORING.

Scoring is done in two different ways. They either use just a "raw time" score, where the fastest time wins, or there's a system called "rank scoring." Rank scoring considers each stage as a separate event. Because stages differ in time required to shoot, firing positions, and movement, some shooters can have a physical edge over others. If you have someone with a "trick knee" and they can't squat down, it's hard for them to shoot against a twenty-two year old who's in perfect physical shape. It wouldn't be a fair competition at all. But rank scoring allows for that and gives more equality. Even so, there's lots of controversy over rank scoring. The really good, really fast shooters don't like it. They just want to go out there and shoot the stage as fast as they can. But it's all about fun. Fun for everybody, so we try and make it as fair as we can. ✪

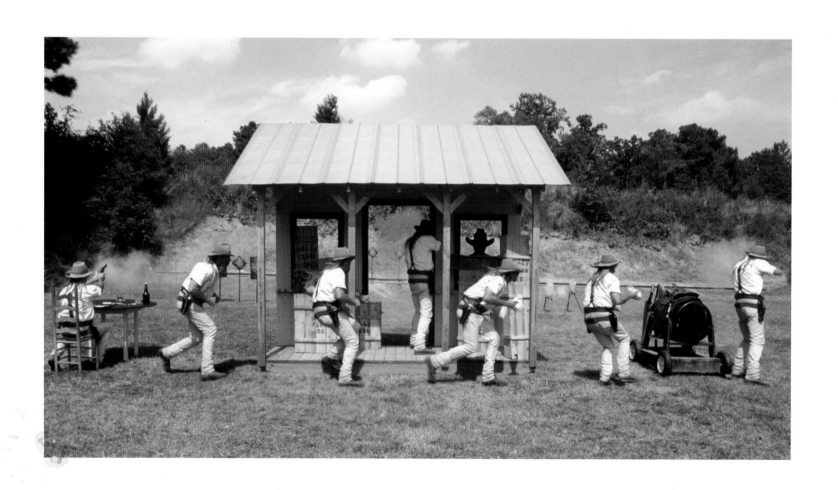

"OSO GRANDE COMES TO TOWN"
(TIMED SCENARIO)

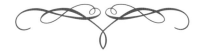

— STORY —

You'd been at the table for a couple of hours. There is a mean slug of tequila in your fist and an over-painted floozie on your knee. But your cards are bad. Just plain lousy. Looks like Lady Luck has gone for a long ride and you're not going to be waiting for her at the station. It doesn't matter, though. You're not sitting in this dumpy saloon for the game. There's a Wells Fargo office in the building next door, and you know there's a big, fat shipment of gold coming in from Frisco on the next stage. So you're stuck here until the thunder of the four o'clock stage draws you out of your hole.

Over the bar hangs a long, dim mirror. You glance that way and catch your reflection in the streaked, dusty surface. You scratch your thick, black stubble and flash yourself that new gold tooth. It glints as bright as the gold on the table and you think about the gold next door. Your gold.

Your eyes shift toward the door. The slatted doors swing wide, and the sun comes streaming in. You can see three silhouettes—one is holding what seems to be a wanted poster, two have side arms drawn—and they're coming in fast. You're not sure they're coming for you, but with a thousand-dollar bounty on your head, you're not taking any chances.

You stand up fast; your knee-sitting gal hits the ground like a sack of spuds. Coins and chips pelt down like prairie hail. You take the two deputies in the door out first. The dealer is pulling out a belly gun. You let him have it double, because he was cheating. The Sheriff with the wanted poster is running out the back door because he's yellow and you're Oso

Grande. So you take a quick look around at the smarter gents in the bar. They politely put their hands up, so you let them stand. Taking the last swig of your rotgut tequila, you head for the Wells Fargo office. You've already shot the law in this town. You might as well go ahead and rob the bank, too.

You thunder down the plank sidewalk, pounding past crates and bags piled high outside the station. There's a rifle lying outside on a Wells Fargo box, so you snag it and get to work. The women getting off the stage start cackling like a coop full of hens. Two guards swarm out, and you plug them quick. You spot a too-slow, slick-haired gent reaching for his piece, so you plug him, too. But then your borrowed rifle's dry. You drop it and grab those precious sacks of gold.

Finally you head for your horse, tied in the alley. All this shooting's got its blood pumping fast and you hear it snort. The gold burns hot in your hand and you know you're in the clear. Suddenly you hear them running up the alley, bellowing like a pair of longhorns. It's the sheriff and his three deputies, finally shamed out of hiding. Two Pinkerton detectives in their black frock coats follow like sporting dogs, close behind. They are all firing at you, shooting wide because of their fear. You pull your shotgun from your fringed scabbard and load them full of lead like a flock of Thanksgiving turkeys. Home free.

As you jump on the horse, you pray that this only took a minute. If it took you any longer, you can expect to see a fire-breathing lynch mob rounding the corner, and you're about to wear your first necktie. ✑

— STAGE SET UP —

PISTOLS — five rounds each and staged on the table.
RIFLE — 9 rounds and staged on a Wells Fargo box by the door.
SHOTGUN — staged on the horse, 6 rounds minimum on your person.

— SCENARIO —

⭐ Start seated at the table. Say a line of your choice, something becoming to a card cheat. At the beep, double tap the pistol targets in any order, all targets must be engaged at least twice. Return pistols to table.

⭐ Move to the Wells Fargo Doorway. Rifle is staged, lying on Wells Fargo box. With your rifle, triple tap the rifle targets. Return rifle to box.

⭐ Move to the horse and, with your shotgun, engage the six shotgun targets in any order.

PISTOL	RIFLE	SHOTGUN
10 Rounds – holstered	6 Rounds – In Scabbard	6 Rounds – Horse

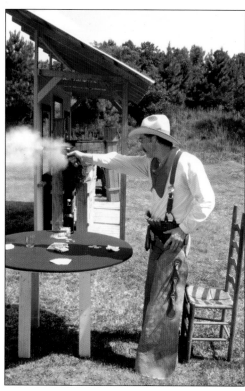
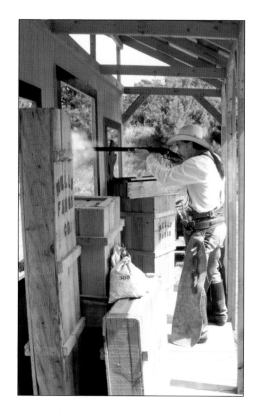

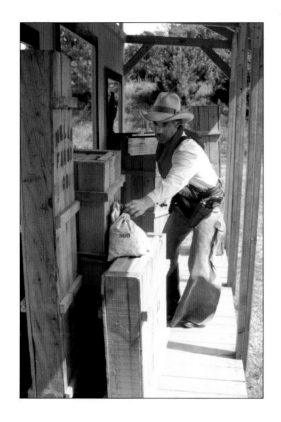

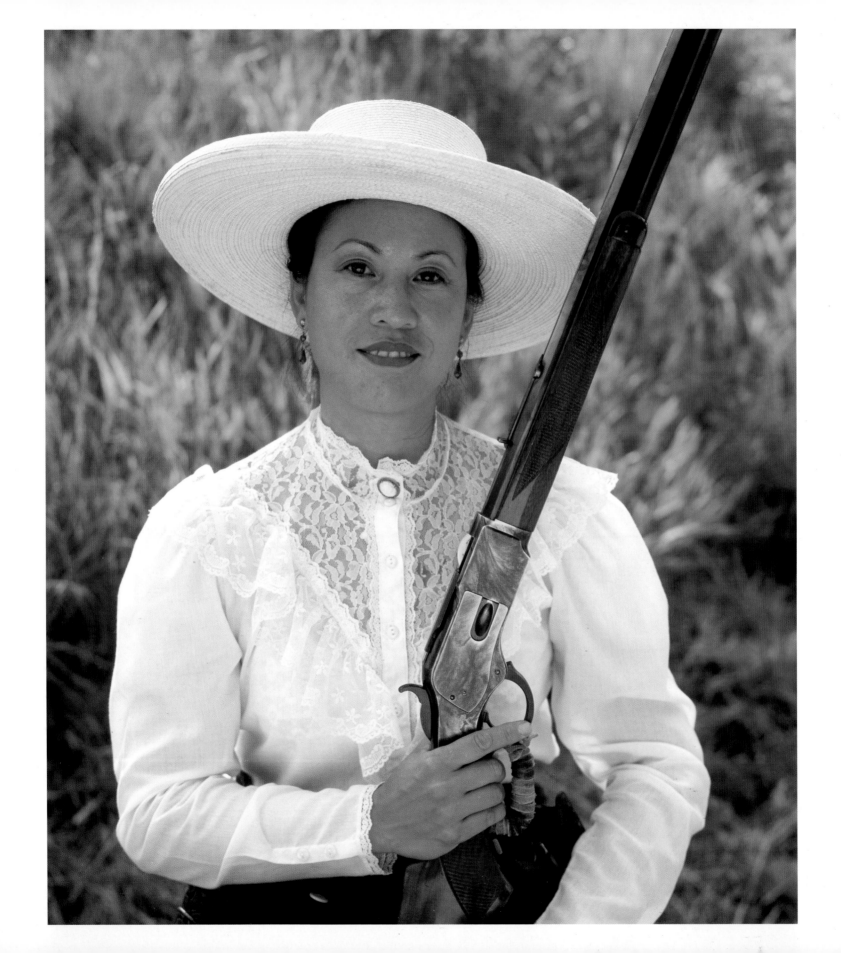

"When we play this game, we're all equal."

ISLAND GIRL

Cowboy Shooter

HOW LONG HAVE YOU BEEN A PART OF SASS?

I've been doing this for nine years.

FROM WHAT I HEAR, YOU ARE "MISS THANG" OF SINGLE ACTION SHOOTING. HOW OFTEN DO YOU HAVE TO PRACTICE?

Fortunately in California, we have cowboy matches each weekend and I try to go as much as I can. That's how I practice. . . I go every Saturday and Sunday.

WHY DO YOU DO THIS EVERY WEEK?

Oh, I've never met such a good group of people. Everybody is so nice. I have friends all over the world. From Germany, Australia, Spain—I can't believe it. And when we play this game, we're all equal. I could be talking to a judge, or a lawyer, or a doctor, but we are all shooters. That's one thing I like about it. The camaraderie is just overwhelming.

SOME AMERICAN WOMEN PROTEST AGAINST CERTAIN ASPECTS OF THE SECOND AMENDMENT. HOW DO YOU FEEL ABOUT THAT?

Well, maybe they have had a bad personal experience. I myself have a personal story about guns in my past. So when I met Logan, my husband, I thought, "Great. Here's one of those gun freaks again." (laughs) But he re-educated me about guns and, seeing that women were so comfortable shooting here, I got a different perspective. Coming from a different country, the Philippines, I have experienced things that you just don't see here. A lot of countries don't have what we have, the right to bear arms. Where I come from, we don't have those rights. Our forefathers in America had to fight for freedom. That's why they created the Constitution, to keep our freedom alive.

✪

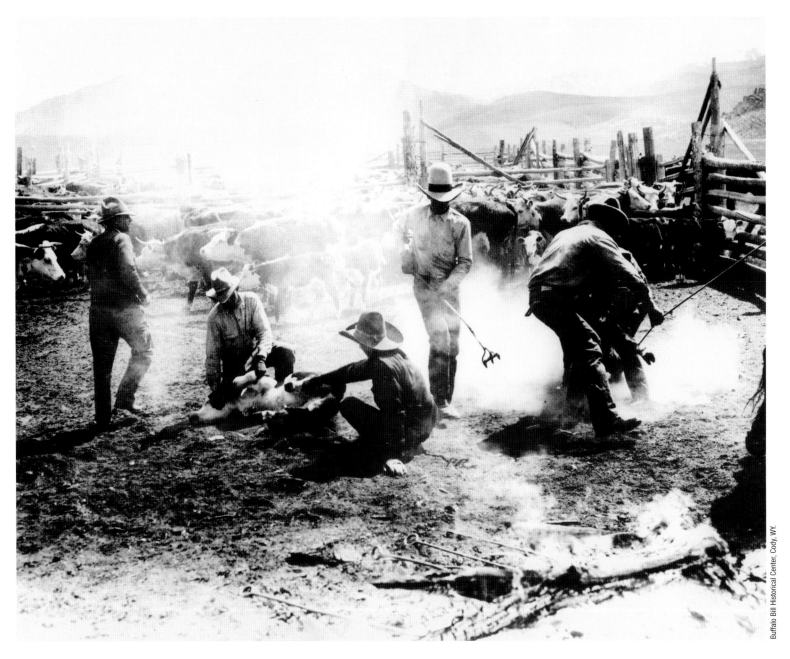

— Branding scene at Timber Creek corrals —

A few words about Longhorns

JIM STEPHENS

The great cattle drives actually started shortly after the Civil War. Of course, the Longhorn breed is an offshoot of the cattle that were brought into the southwestern part of the United States and Mexico by the original Spanish settlers. Now, in Texas they had large ranches even before the Civil War, but when the war came along, most of the people who ran the ranches either went away and served in the Confederate Army, or were in the Texas Rangers to try and keep peace during the war. And the cattle ran wild all over Texas, multiplying like crazy. So, at the end of the Civil War, you had several million longhorn cattle that were totally wild and were there for the taking. They hadn't been branded. So when the ranchers came back from the war, they went out and began to round them up and brand them.

Now, beef was practically worthless in the Southwest, so they started driving the herds north to railheads for shipment back east. Also, for purchase by the government to feed the Indians on various reservations. So driving the herds to the railheads brought the cattlemen eight to ten times the price as they would have gotten in Texas. ✪

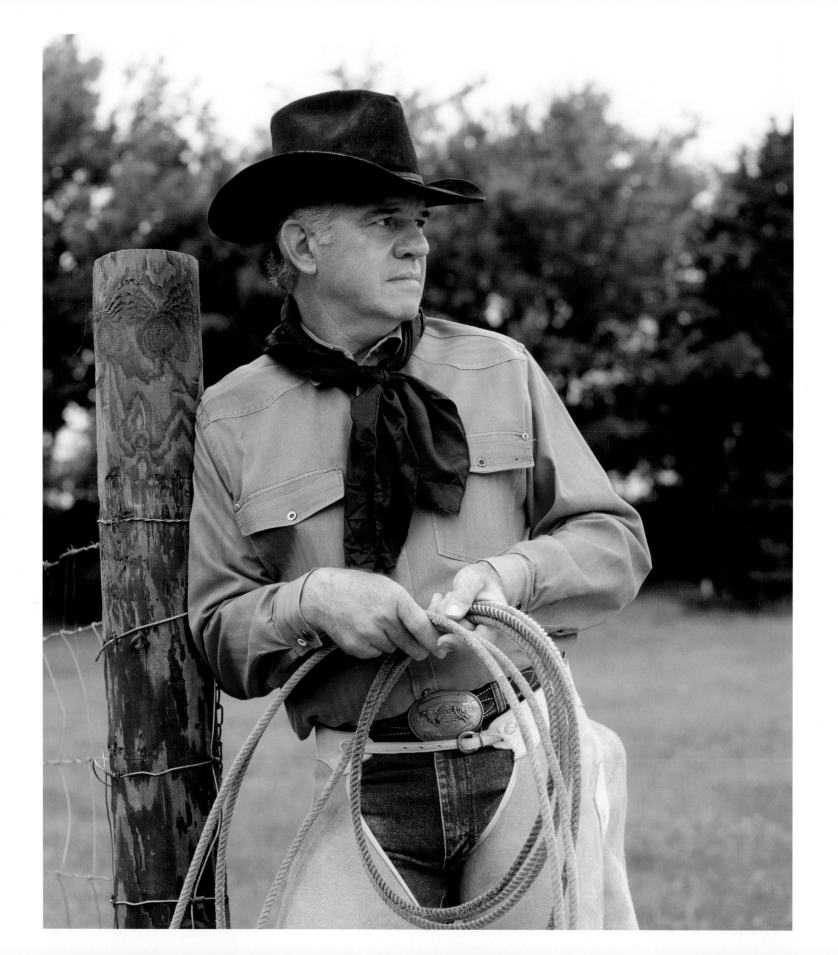

"To love that [nomadic] lifestyle so much that you sacrifice to go live it, that fascinates me . . ."

JERRY WARREN

Philosopher and poet

I HEAR YOU WERE IN THE RODEO.

I rode bareback horses when I was in college and roped calves. Then I began bulldogging steers. When I started rodeoing professionally, I dropped the barebacking and stayed with bulldogging and calf-roping. I really liked calf-roping. That was my best event because it's such an individual thing and it requires such precision. Plus the horse-training aspect of it comes into play. I trained calf-roping horses for several years.

TELL US ABOUT ROPING.

That Lariat is "the Equalizer." It allows you to reach out and touch things that you can't get your hands on otherwise. It lets me be in touch with animals that you can't control in pens. Today, ropers go on Saturday afternoon and compete with a stopwatch to display their roping skills. That's carrying on the tradition, but seldom does that animal ever leave that pen. But if you're out in wide-open spaces, it's an entirely different story. In the Ruby Mountain Range area, those guys will carry maybe sixty feet of nylon in their Lariat rope. In the Southwest they used the Spanish Riata, which is a rawhide and considerably longer than the ropes that we used here. But they don't have the fences out there that we have here.

LETS TALK ABOUT HISTORICAL COWBOYS.

Well, history says they came from Scotland, Ireland, the British Isles. Some folks say they got tired of growing potatoes over there. But I think the better cowboys came from long lines of cattle producers in those countries. I think when they came over here and started looking for work in the bigger cities, Boston, New York, places like that, it didn't take long to find out that they weren't suited for that kind of living. They couldn't stand the confines of the cities, cramped up in a factory or shipyard, so they started migrating to the open spaces, looking for the freedoms that they left their countries for. They dreamed of

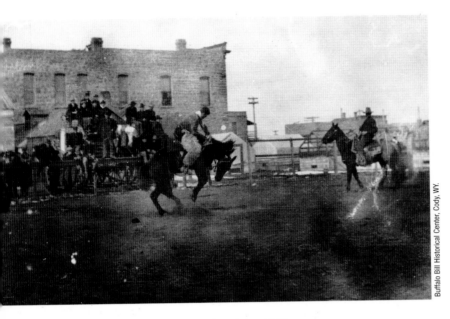

— Tim McCoy trying Star, 1908 —

Buffalo Bill Historical Center, Cody, WY.

working how they saw fit, worshiping as they saw fit. Fortunately, 150-200 years ago, those free places still existed out west, so they migrated there. At the same time, Scandinavians were coming from Canada and moving into the Dakotas, Montana, the northern part of Colorado. All of that, the North and the South, came together and formed the mix that settled in the buckaroo country of Idaho, Oregon, Nevada, and even Utah.

ARE THERE STILL ANY OF THOSE AROUND?

There are less than a thousand of them existing today. They still live a nomadic lifestyle in that desolate country. There's places there where you can still ride a horse seventy miles and not cut a fence. That's pretty unheard of in this day and age. To love that lifestyle so much that you sacrifice to

go live it, that fascinates me, and my hat's off to those guys. When we go to the cowboy gatherings at Reno and Elko, some of those old buckaroo cowboys come in and are stiff, and "stove up," hobbling along. They have crippled-up hands and fingers from too much hard work and too many winters with the discomfort that they can bring. But you have to respect them, because they choose that type of life in order to be free. And that's what Old Glory waving over this country is all about.

SO THE COWBOY WAS A BELIEVER?

He probably held, more privately than not, a belief in who he was and what he was capable of doing. First of all, he wasn't afraid to be alone. He had a pretty good sense of his relationship with his creator, although it might be the last thing you could get him to talk about. He wasn't afraid of work. Independent to a fault, but smart enough to offer a helping hand to those in need. He recognized his responsibility in the chain of existence on the face of the earth, to know that critters were in his care and keeping, but at the same time they offered a livelihood for him. He found great satisfaction in those endeavors. At the end of the day, although he was scarred, skint, and dirty, there was great satisfaction in knowing that he had tended those critters well, that they were going to be all right, and ultimately, so would he.

WHAT DO YOU ADMIRE MOST ABOUT THE COWBOY?

He was the kind of guy that drew a line in the sand. A lot of people don't know it, but there were probably more

Tenneseans that died at the Alamo than Texans, because they recognized that those boys needed some help, and it was their nature to go and help them. And did. And died there. They drew the line and stood on it. And I think we miss that today. In our business dealings, personal relationships, raising our children, so many aspects of our life, I think we've gotten away from that basic principle. That was really what made this country. We were a people that would say, "I'll tolerate this only to here, but no more and no further." And be willing to die to back that up. That was the spirit of the cowboy of yesteryear. ✪

Chapter Four

CAMP LIFE

Beadle's
Dime
New York Library

Copyrighted, 18 3, by Beadle and Adams. Entered as Second Class Matter at the New York, N. Y., Post Office. January 18, 1893.

No. 743. Published Every Wednesday. Beadle & Adams, Publishers, 98 WILLIAM STREET, NEW YORK. Ten Cents a Copy. $5.00 a Year. Vol. LVIII.

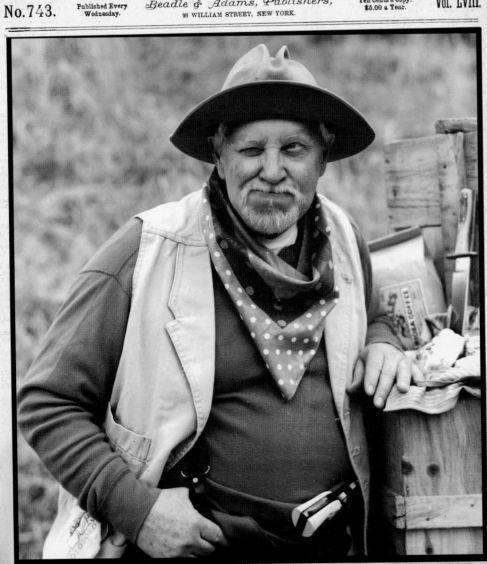

Cookie was tidying up after supper. He liked to run a tight camp, and that meant taking time for cleaning. He cooked two "squares" a day, breakfast and supper, and usually supplied the cowboys with a "riding lunch" that more often than not consisted of a piece of fat bacon on a cat's head biscuit. It was the cowboy's job to get this herd to Laredo, and it was Cookie's job to make sure they had enough biscuits and beans to keep them in the saddle.

Feeding a crew on the trail was always tough work, but this trip was worse than usual. There were a bunch of greenhorns with soft seats and they had gingerly chewed their way through his usual fare like horses eating barbed wire.

It was no surprise that beans and bacon hadn't been enough for them. He'd even cooked them Dutch oven apple pie. But one of the lads had come moping around with his half-eaten plate, complaining that the pork was too salty. The Trail Boss would hear about this.

Cookie wasn't the best cook this side of Laredo, but he surely wasn't the worst. A ride was only as good as its cook, and many an experienced cowpoke found out who was flipping the flapjacks before they signed on for a job. So he figured he had a little respect coming.

Nothing like a panty-waisted city slicker to put him in a foul mood. Now the end of his day was spoiled and he muttered while he scrubbed out his iron Dutch ovens with sand. He was still steaming when he put on a pot of Arbuckle's black for the first watch.

❧

The gals came riding into camp as the sun squatted down behind the skimpy Texas hills. Cookie would have called them ladies if he'd been feeling a little more charitable. Soiled prairie doves was what they really were, and they jostled on the wagon, their white ankles stemming from the bloom of their brightly colored silk petticoats. Their hair glowed yellow, like pollen, and their high, giggling shrieks could have cut glass all the way to Brownsville.

As soon as the trail hands spotted the girls, they moseyed to the edge of camp,

doffed their broad-brimmed hats, licked their hands, and slicked down their hair. There wasn't much improving to be done on a cowpoke in the middle of a trail ride, but they did their best, slapping their denim pants with their hats to knock off a little of the Texas trail. They preened and postured, whistling at the bright-haired girls, calling out greetings as the wagon closed in on the camp.

Cookie, an old hand at this game, just stayed with his wagon and watched the girls flouncing down off their buckboard. Some years ago he had lost the craving for "sweet young things" and preferred to hang onto his hard-earned cash. Instead the old man continued to check his dry-good staples for next week's trip into town. " I needed to stop in Rio Grande City," he rolled his eyes. "But it looks like town has come to me." He shook his head, scratching sand from his bristly chin.

The madam, a yellow-haired, fine figure of a woman, wandered by, waiting while her girls worked the camp. She wore a dress of purple and scarlet silk with a low-cut bodice. She looked a little bored until she spied the old cook, wiping down the gate on the back of his wagon.

"Hey, Cookie," she smiled sweetly. "How 'bout a game of chance?" Now, Cookie could resist a brainless girl, but this was a real woman. Red-blooded and round where she should have been. Besides, he never could say no to "Lady Luck." Glancing up at the dropdown pantry, he saw the ivory handle of the Peacemaker. It was stuck between his tin of coffee and the half-empty flour sack. Will Fergus had given it to him last month after Cookie "saved his bacon" during that bad stampede. The boy was a terrible tenderfoot. Went running home for Mama as soon as he stopped shaking, but before he went, he'd squared up his debt, and Cookie had to respect that. Seemed like a fair price for saving the life of a man.

Cookie picked it up off the shelf and laid it on the gate of the chuck wagon. "I wouldn't mind some company. . ." he ventured, his grin betraying his picket-fence teeth.

As she laid out the cards, he watched her. Her long, white fingers flew over the rough plank of the gate, strewing cards in an elegant dance. He was entranced by the long sweep of her ivory neck and hint of lemon verbena water that whispered to him below the thick stink of the longhorns. So entranced that he didn't notice when her eyes got shrewd and cold. She was a dove, all right. A lovely, carnivorous dove. ✐

Conquering fire was humankind's first victory over nature. It offered safety. It gave warmth. A flickering fire, no matter how small, represented humanity's courage against the darkness of a dangerous world.

Over the centuries, civilization evolved and fire was eventually replaced by more refined sources of heat. But to cowboys who were at the mercy of the elements, fire still meant home and hearth, no matter how far away from home they were.

Camp was the place where the home fire burned. Work stopped, bellies were filled, and elusive rest was granted, even if they did have to sleep wrapped up in thin blankets on the cold, hard ground. Stories were told there, lies were swapped and songs were sung.

Camp was where the cowboys kept the cold at bay.

Even more importantly, the fellowship that they shared there kept their loneliness in check.

The food was "three squares a day" regular. Sometimes that was the best thing the cowboys could say about it. But occasionally, if they were lucky and the cook was good, they enjoyed a hearty meal before they turned in for the night.

Some members of the Single Action Shooting Society have spent years researching camplife and perfecting their camp food. They've collected tales of cowboy leisure and obtained the secrets of cowboy cooking. And although these are still rough and tumble hombres, they aren't so sure that the West was won with a Colt .45. They think it had just as much to do with biscuits and beans that burned in the bellies of hard-living cowboys. ★

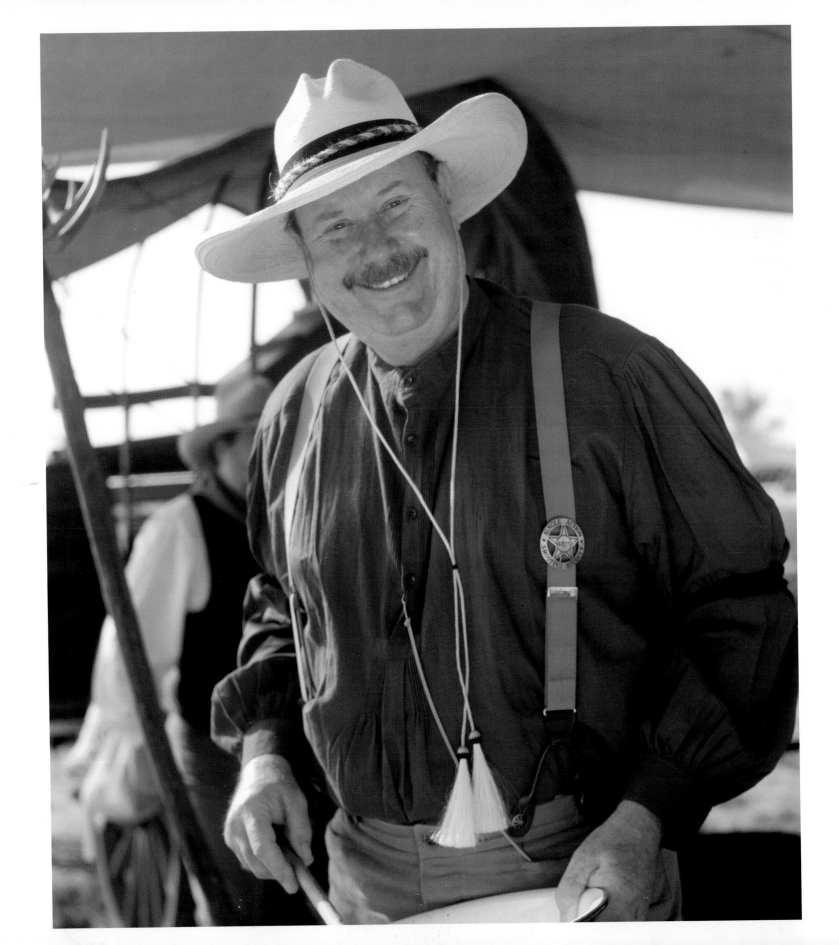

"The ranker the meat got, the more peppers got thrown into the stew."

CHILI KING

Chuck Wagon "Cookie"

CHILI. WHAT'S THE STORY?

I grew up in a little town called San Angelo, Texas. And I got fond of cowboy cooking because of being raised on a ranch. My grandfather, father, everybody that was around knew how to cook. Especially chili. In Texas, that's a primary dish. And primarily cooked by men. The other thing about chili is it's classified as the "only American food." About ten years ago I was invited to go to the US Senate by Pete Domenici, the Senator from New Mexico. He was sponsoring a bill to make chili the official American food. Any other dish we have can be traced to somewhere else. Apple pie came from German strudel, even hot dogs were invented somewhere else. But chili is pure American. It started on the trail drives in the 1860s, maybe a little earlier. Along the banks of the Rio Grande and the Red River, there grows a little wild plant called the "chilipiquines." When the camp cooks were feeding cowboys and the meat started to get a little rank on them, they'd take handfuls of these pepper pods, throw them in, and make a stew. And the ranker the meat got, the more peppers got thrown into the stew. And that's how chili got its start on the trail drives. Later on, in San Antonio, TX in the late 1880's, chili was being served in the prison there and—this is unofficial—but there is a story that prisoners would actually break back into jail to get chili. Maybe true, maybe not, but chili is a phenomenon.

HOW DID YOU END UP HERE TODAY?

About 21 years ago I started the Chili Company, and that's what I do for a living: make chili for supermarkets and grocery stores. Joining SASS fit in with the cowboy upbringing I had, but it dawned on me that nobody was paying attention to food. Everybody wanted to shoot. Everybody "talked" guns, loads, and ammo, but to a real working cowboy, that chuckwagon and that ranch cook was more important than any gun he ever carried. So when I got into SASS, the first thing I did was start paying attention to the cooking. I write cooking articles for the "Cowboy

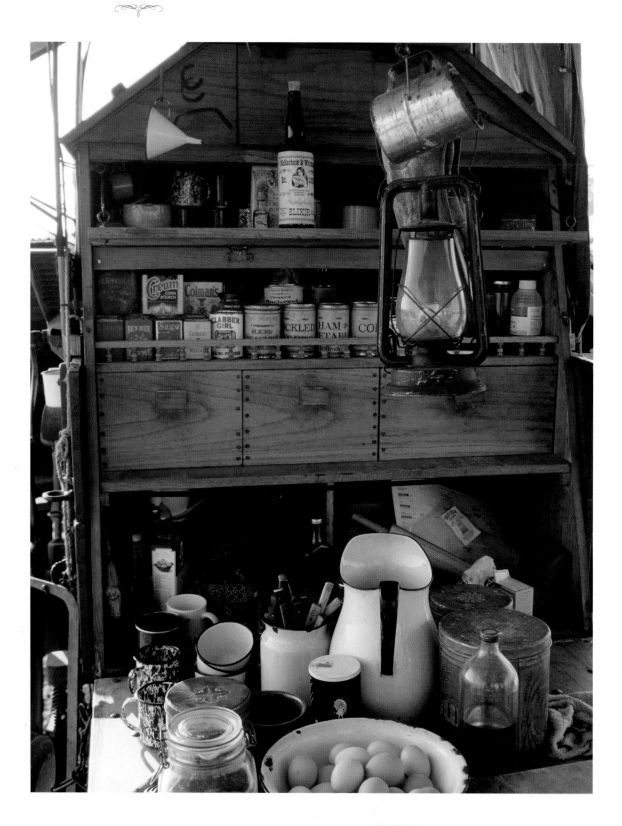

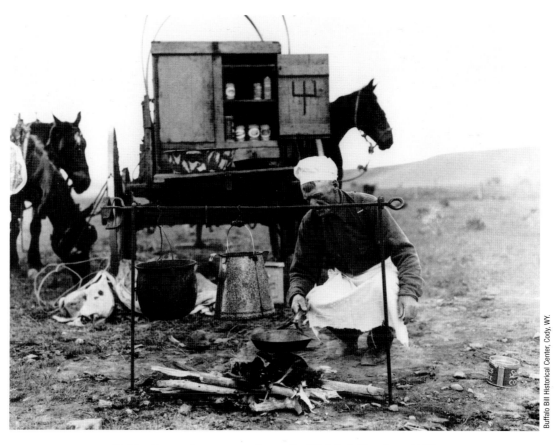

Buffalo Bill Historical Center, Cody, WY.

— Bobby Burns the mess cook, on the Pitchfork Ranch, c.1920 —

Chronicle" every month and I sponsor the Chuckwagon Cook-off for SASS at the End of Trail. To me, how you eat is an important part of the cowboy tradition. It's also an art. It's amazing to see these camp cooks make dishes you couldn't even get out of a restaurant, and they did it all over wood coals with a Dutch oven. That's amazing.

WHO HAD THE FIRST CHUCKWAGON?

The first recorded chuckwagon belonged to Charles Goodnight, who was known as the man who invented trail drives. He was driving beeves up the Red River in west Texas and he took an old Union cavalry wagon from the Civil War and built a chuck box on it so he could feed his hands. And from that point on, chuckwagons went with every herd.

On a trail drive, the chuckwagon cook served cowboy biscuits, salt pork, beans, and coffee. That was it. You had that any way you could serve it up, three times a day, every day you were on the drive. Occasionally, when a calf would die, they'd butcher it up and have

chuckwagon riding into camp. That kept the dust down. To this day in Texas, there are chuckwagon cook-offs where you may have as many as twenty wagons compete. Big prize money. These guys take a lot of pride in what they do.

DOES THIS ASPECT OF THE SPORT STILL APPEAL MOSTLY TO MEN?

Primarily in the old days it was men, but nowdays there are women cooks who are every bit as good, or better. Dianna Nett has a wagon here. Her husband is a blacksmith. And she runs that camp tight. One of her "hands" was saying, "If I burn anything, I'm minus teeth." And she's about four foot three, so when she swings, she'll put you down.

WHEN WAS THE LAST TRAIL DRIVE?

The last real trail drive was in the 1960s. There was a ranch in west Texas called the "Four Sixes" which was a huge spread, and Lyndon Johnson, Vice President at the time, brought a bunch of senators out from Washington. They flew them out in helicopters and landed them just so they could partake in this chuckwagon cooking. And he made his famous "sonnovabitch" stew, which was a special occasion dish on the trail.

THAT'S SOME NAME!

Well, when you go to chili cook-offs, everybody tries to gross each other out. You have "road-kill" chili, "arm-pit" chili—you never know what it is, anyway. Sometimes you just don't want to ask. (Laughs) ✪

fresh beef, but that wasn't normal. The cook also carried sacks of tobacco.

The cook was "the man." He was everything from the barber to the doctor, to the second in command. (Trail Boss was first.) Wagon cooks were known for having a great sense of humor. If they didn't, they were mad all the time. And you never crossed a cook. The one thing you learned early on, on the trail drive, is always stay downwind of the

COWBOY RECIPES

From the book *Cooking it up, On the Trail Part II*
by Tammy McDonald

EASY COBBLER

2 cups sugar
2 cups flour
4 tsp. baking powder
⅛ tsp. salt
1 tbsp. cinnamon
2 cups milk
1 tsp. vanilla
1-gallon can of fruit (boil and sweeten to taste)
1 stick of butter

Mix dry ingredients and add milk and vanilla. In a 12" or 14" Dutch oven, melt one stick of butter. Pour batter in first, then add fruit. Cook slowly with coals on top and bottom of oven until crust is golden brown.

DUTCH OVEN PORK CHOPS AND VEGETABLES

6 (1"-thick) pork chops
3 tbsp butter, melted
3 carrots, cut into ½" slices
1 cup fresh green beans, cut

3 potatoes, peeled and cubed
1 tsp. basil
6 (¼ oz) instant onion soup mix
2 cups water

Brown chops on both sides in butter in bottom of oven and drain. Place vegetables in bottom of oven garlic in Dutch oven, add water. Heat to boiling, reduce heat and simmer covered for 2½ hours. Add remaining ingredients. Cover and simmer until pork and vegetables are tender, about 30 minutes. Remove pork and vegetables. Cut pork into ¼" slices. Strain broth and serve with pork and vegetables.

SOURDOUGH STARTER

4 cups potato water (water from boiled potatoes)
4 tsp. sugar
1 tsp. salt
3 cups unsifted flour
1 package dry yeast

Mix ingredients well. Pour into a stone crock and set in warm, draft-free spot for 24 hours. It's then ready to use.

To keep starter working, store it in the refrigerator. When you use some, replace with equal amounts of flour and water and add a big pinch of sugar. Stir it up. This will keep your starter alive. While setting in the refrigerator, the starter will have a tendency to separate. Just stir it up before placing in the refrigerator, and it will keep indefinitely (my starter is several years old). You know it's good as long as it has a good yeasty smell. You can use a thermos to carry your starter to camp with no problem.

COWBOY REMEDIES

Here are some of the old cowboy remedies that old-time
chuckwagon cooks used to cure a sick, hurt or drunk cowboy

Kill or Cure Cough Syrup

Steam one large onion until tender. Put through a sieve and add to ½ cup
warm honey. Dosage is one Tsp per hour.

Toothache

Burn a piece of paper on an old plate, then with a small wad of cotton, wipe
up the brown sweat on the plate and plug it into the tooth.

Sore Throat

Pour a few drops of spirits of camphor on a lump of sugar, allow it to dissolve
in the mouth every hour. The third and fourth treatment
enables the cowboy to swallow easily.

Cure for Stomach Cramps

Ginger ale in half a glass of water into which a half-teaspoon of soda has been dissolved.

Cure for Poison Ivy

Five drops of carbolic acid dissolved in a tablespoon of water. Rub the affected parts.

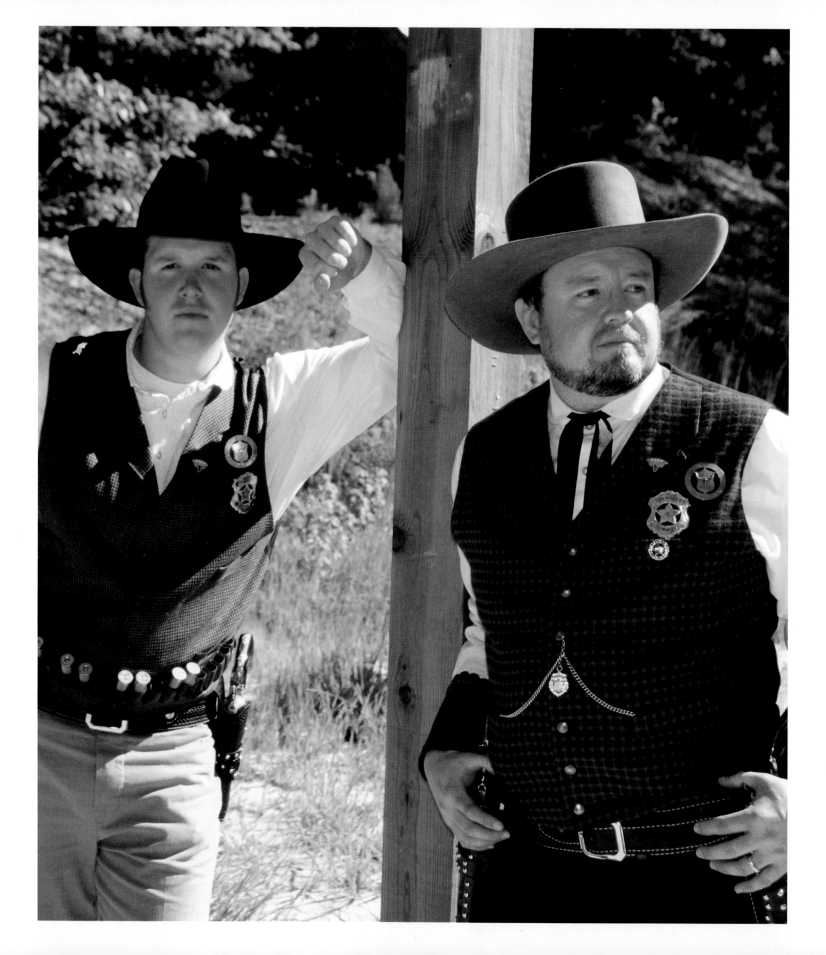

"SASS is a great way to teach basic gun safety to people of all ages."

SAN QUINTON

Cowboy Shooter/Territorial Governor

LET'S TALK ABOUT THE YOUNG PEOPLE IN THE SPORT.

When a young person wants to try their hand at Single Action Shooting, it's vitally important to teach them how to treat firearms responsibly. They have to learn a very high level of competency before they are ever allowed to handle a gun. That's just part of the training. And SASS is a great way to teach basic gun safety to people of all ages. At a SASS affiliated match, like a State, National, or International match, SASS rules require that a shooter be at least 12 years old to compete. At our monthly matches, a lot of our clubs allow younger shooters. They have their own local policies. For instance, we have some nine and ten year olds that shoot with us. "Juniors" in the sport are from age 12 to age 17. Most gun clubs consider you a junior until you're eighteen. Once I asked Judge Roy Bean why SASS has a different age division. He told me that he's of the opinion that if you're old enough to serve in the Marine Corps, you're old enough to shoot with the "big boys." So, that's how that rule came about, because at the age of seventeen you are eligible to join the Marines. By the way, the Judge is an ex-Marine.

TELL US ABOUT THE SASS SCHOLARSHIP PROGRAM.

The scholarship program started about three years ago in the year 2000. SASS and the Wild Bunch administer it. Because SASS is a non-profit organization, we're encouraged to participate in raising scholarship money for our kids. These young people must be a member of SASS for at least a year. They can only apply during their senior year in high school. Part of the application process entails having to write a 250-word essay on what the Second Amendment means to them. Based on the amount of money that's available in the scholarship foundation, we give out a two thousand-dollar, one time non-renewable scholarship to the applicant. The first year there were four of them; last year I think there were eight. My son Brock Holiday received one of those first scholarships.

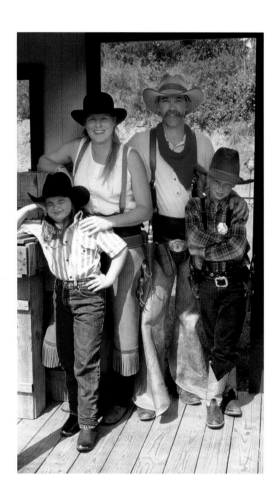

WHAT DO YOU THINK THE "COWBOY WAY" IS, AND HOW DO YOU APPLY IT IN YOUR DAILY LIFE?

Well, I'm a firm believer in the Golden Rule. You treat people like you want to be treated. And, bottom line, that's what the cowboy way means to me. I do that in my day-to-day life. It's just that important to me. It was also important for me to teach it to my kids. As John Wayne said in *The Shootist*, "I won't be laid a hand on, and I expect folks to do the same for me."

THERE'S LOTS OF JOHN WAYNE FANS IN THIS SPORT.

(Laughs) Yep. One of the most famous rules in our SASS handbook is our "John Wayne Rule." If John Wayne did it, it's ok. That's actually in the rulebook. John Wayne means a lot to us. ★

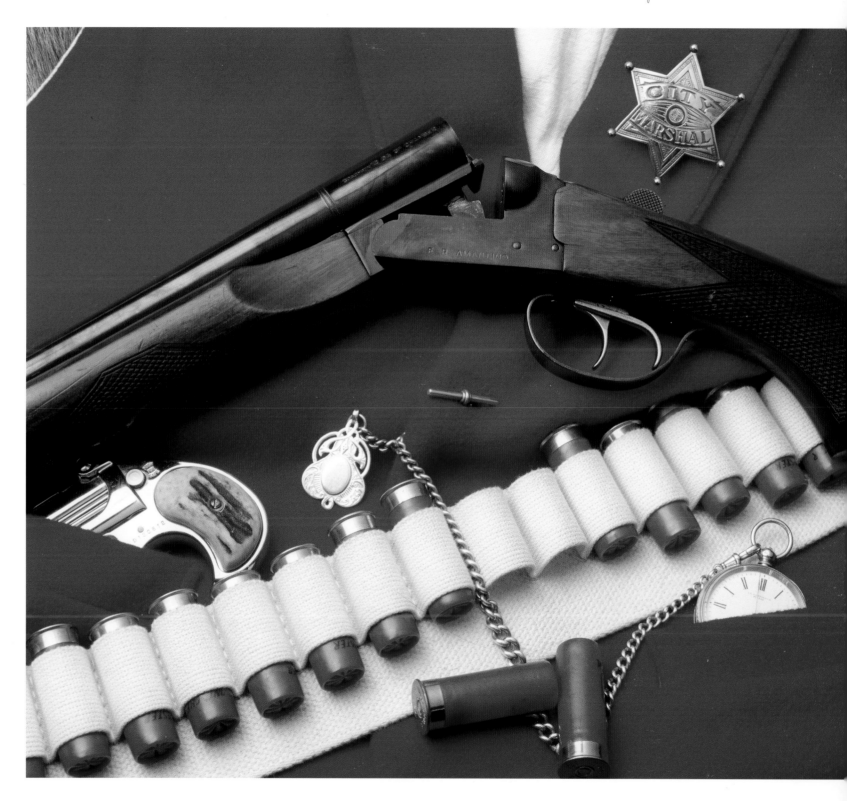

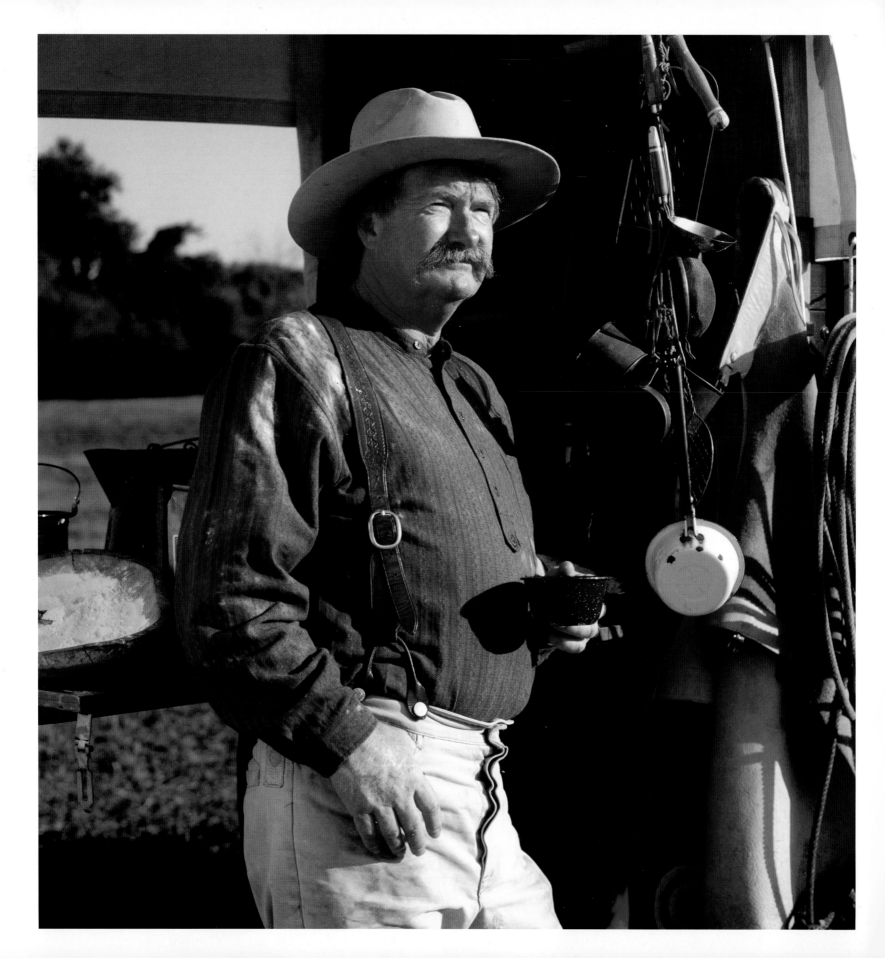

"The cow camps that had the best chuckwagon got the best cowboys."

LAMAR & SUSAN GREEN

Tumbleweed Ranch

Lamar: We did a lot of studying about chuckwagons when we were running our chuckwagon business. I can tell you this. . .if the outfit didn't have a real good "coosie" (that was what they called them then), then these cowboys just wouldn't go to work on the ranches. These cow camps had to have a good cook.

HOW DID SOMEONE GET TRAINED TO BE A COOSIE?

A lot of them really were old cowboys who were just worn out and couldn't ride on the range anymore. The cooks that came in were mostly from Germany, Italy, transplants. But according to everything I've read, most of the time what they'd do was get an old cowboy that was too old to do ranch work to apprentice under somebody and then set up their own cook camp.

DID COOSIES HAVE TO GET UP THEIR OWN KITS?

No. The wagon and all the fixins belonged to whatever ranch they were working with at the time. The cooks moved around a lot, and they always tried to get better and better themselves, like I said, because the cow camps that had the best chuckwagon got the best cowboys. And they really worked hard to get the best coosie they could find.

Susan: The chuckwagon was the center of life for the cowboy. Besides being the kitchen, it was also their home on long trail rides. That was where they went every night to eat, to socialize. If somebody was sick, they cared for them right there.

WHAT KIND OF ILLNESSES WOULD THE COOSIE HAVE TREATED?

They'd usually give the cowboys whiskey for colds. They used. . .pretty much. . . whiskey. Some of them were self-taught on how to pull teeth. If someone got a bad cut or something, they'd sew them up. Snakebite. They had to do veterinarian stuff, too. They had to do it all.

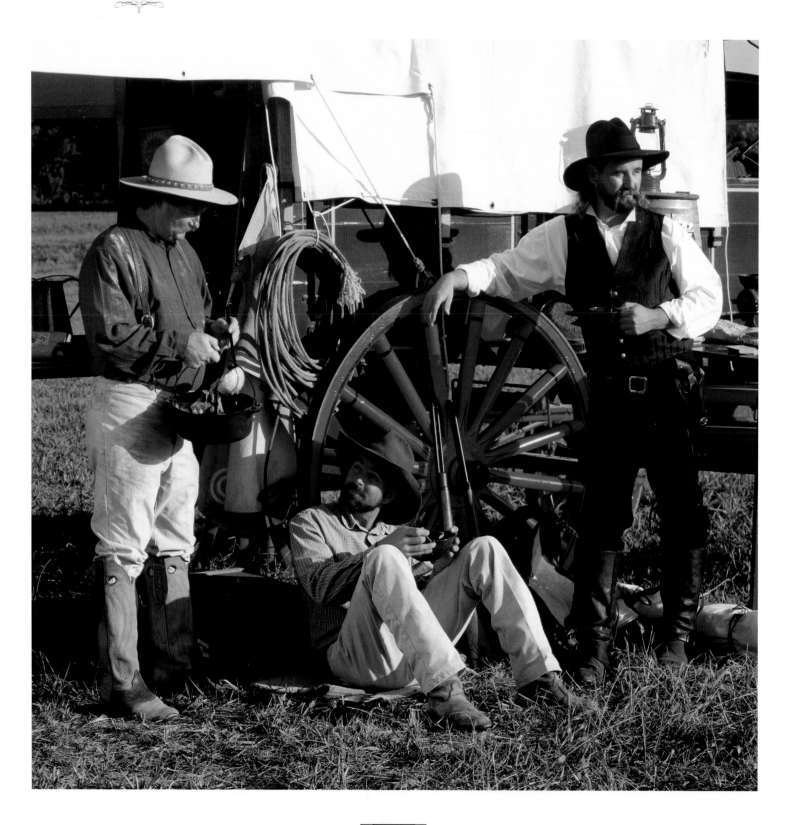

HOW ABOUT A FERRIER?

Yeah. From what I understand, the chuckwagon always had a few shoes and some ferrier equipment, but it's not like today. If a horse threw one shoe, they stuck one shoe back on and didn't worry about it too much. Also, their old horses weren't like they are now. They were pretty raw-boned back then. If you look at old pictures, you won't ever see a fat ranch horse. Lean. They didn't get much to eat out there.

WHAT WAS THE COOSIE'S
DAILY ROUTINE LIKE?

It was hard work. He got up every morning about 3 am to cook breakfast. After he fed all the crew and got his dishes and everything washed, he had to load all this stuff up and get ahead of the drive, and move to the lunch camp. He'd do the whole business again, and then move up to the dinner camp at night. The cowboys had to have that food. And this old man usually only had maybe one helper. Of course, the cowboys would be gathering cattle while he was going from one stop to the next, so he got ahead of them pretty easy.

One of the more famous chuckwagon stories you hear about is the Arbuckle brothers, who came out with some coffee and put a stick of peppermint in each bag. That encouraged whoever ground the coffee beans to do the job. Cook didn't have time to do it all, so he would designate one of the cowboys that he liked the best and say, "OK, you're going to be the one that grinds the coffee today, and you get the peppermint." And Arbuckle's still

does that. . .puts in a stick of peppermint.

But people don't understand really how hard that life was. And the chuckwagon was like sacred ground. You didn't just walk in and you never rode a horse into a chuckwagon camp. That was a big no-no because of the dust. About 50 feet all around was off limits—you had to ask the coosie for permission. Cooks would even take their dishwater at night and pour it under the chuckwagon to keep the cowboys from bedding down underneath it. If it was an old rainy night, they were right out there in the rain. The coosies didn't want you around the wagon.

WHAT KIND OF SALARY
DID THEY MAKE?

They didn't make much, about five and ten dollars a month. But they got room and board; they called it "found." They'd say "fifty cents and found." And that meant you got 50 cents and a place to stay.

WHAT KIND OF GEAR DID THEY
HAVE ON A CHUCK WAGON?

All the pots were cast iron and they had those old tin dinner plates. The reason they used cast iron was because there wasn't a lot of wood out west. They burned buffalo chips and said it made a really good heat. But the thing was, this cast iron, I don't know if you've ever cooked with it or not, but the heat dissipates so well that you can get it hot in one spot on the bottom and the heat spreads out all over. We've tried it on this chuckwagon here. You'd be surprised how well it cooks with charcoal. You

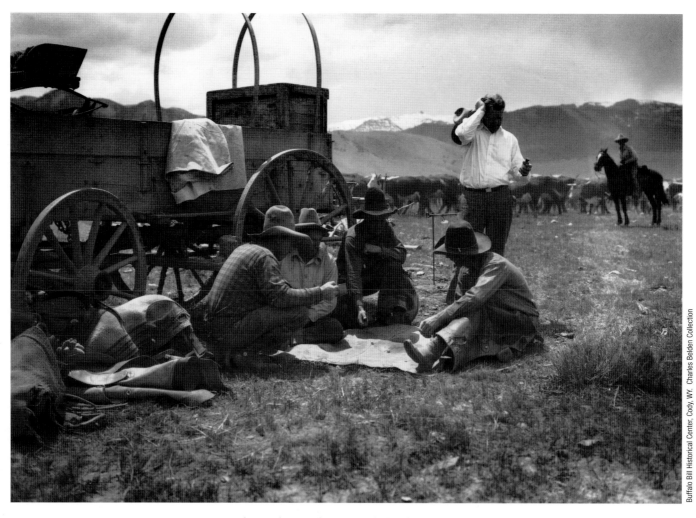

— Cowboys playing dice around the chuckwagon —

Buffalo Bill Historical Center, Cody, WY. Charles Belden Collection

could put ten briquettes under one of these 20-inch Dutch ovens, put eight on top, and you can cook biscuits in fifteen minutes. It's unbelievable. We've tried lots of different recipes. Sourdough biscuits were a big thing. And you know sourdough "starter"? There's starter that's still out there from the frontier days. There's still some going on from a hundred years ago.

WHAT DID THE MENU LOOK LIKE?

Well, they always had beef. There wasn't really much as far as steaks, more like roast, and biscuits and potatoes. And they always had dried beef. Their delicacy was canned peaches or apples, and they ate dried ones, too. They'd make pies and crisps in the Dutch oven. You'd put that in with your flour and sugar and butter and it's easy to make

a cobbler or something sweet. We made several of those. Boy, they turn out good! They served a lot of that for dessert. They always had dried beans, too, pintos in big old 50-pound bags.

Susan: And with beans, you could always add your leftovers to them and make a stew. When I served the shooters up in Gainesville, I just added pork and pork roast to the beans and it was good. You just cook it up in a big bean pot, put the meat in with the beans and let it cook down slowly. Serve a biscuit or cornbread with the beans and pork and that's a meal in itself.

HOW MANY FOLKS DID THE CHUCKWAGONS SERVE?

These cowcamps usually ran from 12-30. I know 30 people sounds like a lot, but the way they had their chuckwagon set up, 30 was easy to serve. We've fed 160 out of ours before and it went like clockwork. Of course, they had to prepare theirs from ground zero, but they stayed on top of things. They did everything with precision—they wanted the tarp in a certain place, every pot in its place. And that's how it was EVERY TIME. That way, when they got somewhere to set up, BAM, it was done.

WHERE DID THEY GET SUPPLIES?

Well, before they'd head out on the cattle drive, they'd have to go out and fill their wagons. They'd have a supply wagon that would go along with them and they'd fill both wagons full. And the next closest town they got to, when they started running low, they'd send one of the wagons out, or several cowboys, to get replenished. They'd get tobacco, too. Tobacco was a big thing on the cattle drive. Had to have it. If they weren't smoking it, they were chewing it. (Laughs) It wasn't bad for you then. ✪

"It wasn't necessary that you be a good singer, just as long as you could make some soothing noise."

TONY NORRIS

"Oh say, little doggies, why don't you lay down?
I've wandered and trampled all over the ground.
My horse is leg-weary, and I'm awful tired,
But if I let you get away, I'm sure to get fired.
Lay down, little doggies, lay down."

"The Night Herder's Song" by Harry Stephens

TELL ME ABOUT COWBOYS AND MUSIC.
Well, I think the cowboys liked music because it kept them company. Because of the nature of their work, they were often isolated and alone, and it helped to have songs to sing. Of course, the time they spent around campfires they were entertaining each other and music was a big part of that. I don't think their expectations of music were very great. I heard that a lot of the cowboys that would sing on night guard were more reciting songs in a singsong fashion than actually singing melody. They weren't trained singers and probably didn't have a big repertoire of music patterned for them. And it was just a steady sound, more than anything else.

WHY DID THEY NEED THAT STEADY SOUND?
For night herding, the purpose of singing was to kind of generate a background "white" noise. It told the cattle that everything was okay. That sound would also mask any sudden or unusual noises like a horse's hoof striking a

rock, or a coyote cutting loose close to the herd, maybe a slicker flapping in the wind. All these sounds might have spooked the longhorns. You have to keep in mind that the longhorns were not like your domestic Holsteins—they were wild animals and they spooked real easy. So the cowboys generated a comforting background noise as they rode around the herd. It also let the cattle know that the cowboys were approaching, gave them a little warning so they wouldn't spook. And it was a good way to occupy their heads with on those long, dark nights.

DID A REAL SINGING COWBOY GET ANY KIND OF EXTRA STATUS?

I've heard that cowboys were really proud of their good singers. Sometimes when groups from different ranches would get together, they would put forward their champions and have contests. Who knew the most songs. . .who knew the longest songs, so they were conscious of good singers and proud of them, although it wasn't necessary that you be a good singer, just as long as you could make some soothing noise. The old gospel songs were real popular with the cowboys. They sang most anything, like the popular songs of the day. Rather than a specific genre of songs, they'd sing anything that they knew.

TELL ME ABOUT THE INSTRUMENTS THEY USED ON THE TRAIL.

Well, the guitar was impractical. When things had to be carried on horseback, they had to be light, compact, and sturdy. So one instrument you were likely to find in a cowcamp or on a trail drive was the fiddle. If you were a decent player, you could talk the camp cook into tucking that underneath his bench seat on the chuckwagon. Also, the banjo mandolin. It looks like a miniature banjo with a short neck. . .12-16 inches long. It's strung with eight sets of strings like a mandolin. They also took "Jew's Harps," which were a bow or lyre-shaped piece of metal that had a steel spring that extended from the center of it. You could put it up against your teeth, with your teeth separated slightly, and if you plucked the metal spring, or tongue, with your finger, it would vibrate back and forth. Breathing out and in would amplify the sound and create a real distinctive sort of drone. It would fit into a vest pocket, so it was easy to carry. The harmonica was available, probably at the end of the period, but not as much as they show in the movies. ✪

Jim Stephens

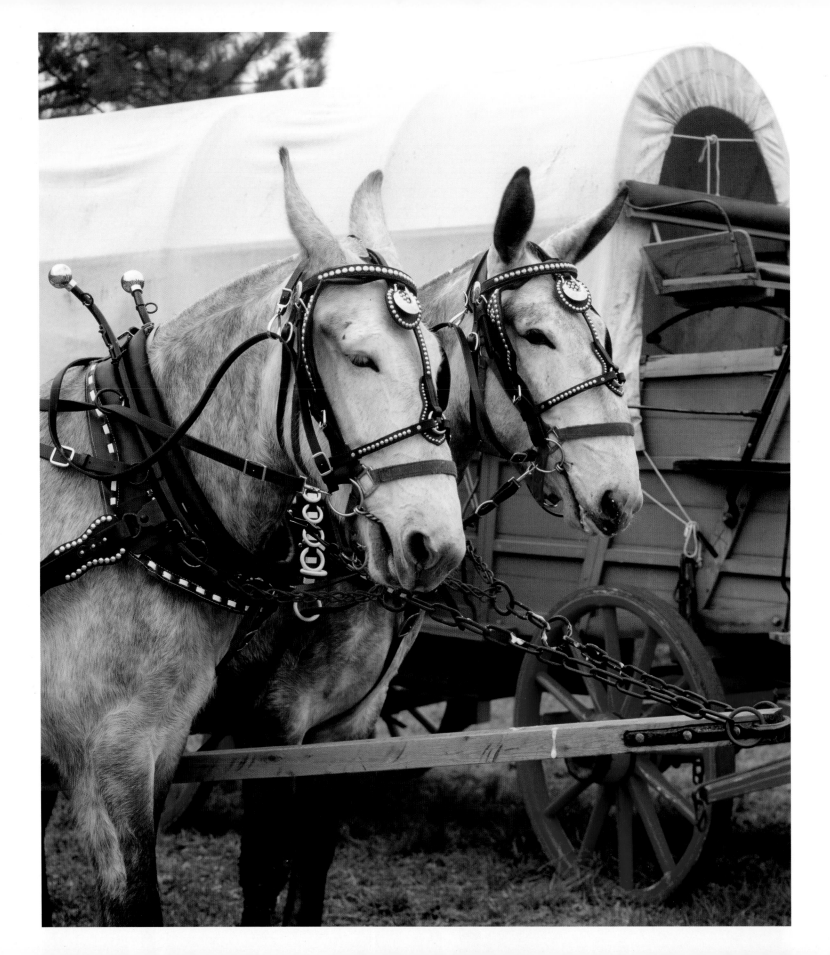

A few words about Mules

LAMAR GREEN

Mare mules can't breed because they're a hybrid, a combination of a horse and a Jack (donkey). These two are half Percheron. Stout. See the legs on those mules? Folks used to make a lot of money trading mules before the tractor was invented. Missouri was a big mule-breeding state. And Tennessee. When people went out West, that's were they got their mules. They didn't really use oxen that much because they were so slow. These boys here are quick, but they're strong. They could pull the house out from under you.

I'll tell you another thing they liked about mules: a mule won't hurt himself. A horse will work himself to death—he'll fall over dead before he'll quit. But a mule is smarter. They'll go as long as they can go, and then they'll just stop. You can take an old mule who gets his foot hung up in that fence over there, and he'll stand there a week, waiting for someone to come along and help him get it out. A horse will kill himself trying to get out of it. If you let horses into a grain bin, they will eat themselves to death. Mules will eat till they're full and then turn around and walk away.

These two mules eat about 2 gallons of feed twice a day. A bag of feed every two days for two mules. Imagine how much they'd have to carry on the trail to keep those mules fed. They fed corn to the mules they used in the cow-camps because it doesn't weigh as much as sweet feed. And oats were light, too. ✪

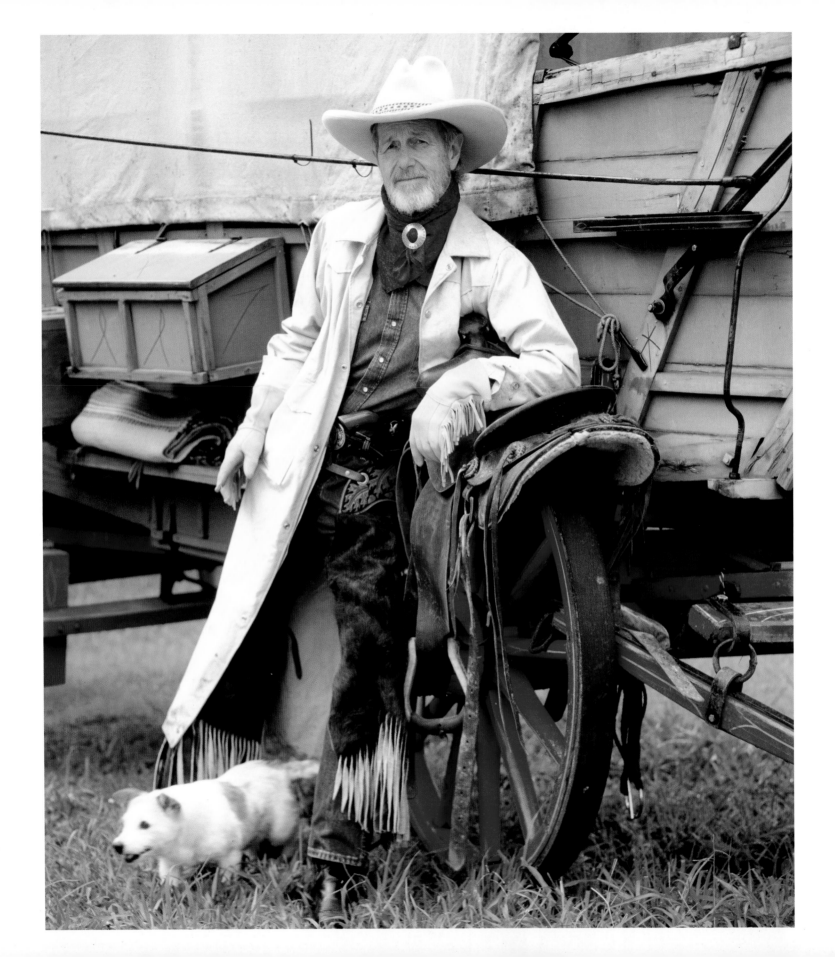

Cowboy Poet

BACK TO THE CAMPFIRE

The most welcome sight in the western lands was a campfire burning bright.
It boiled the coffee each morning and kept punchers warm at night.
Sometimes it was a beacon that could be seen for miles away,
A haven where cowboys gathered at the end of a long, hard day.
A stranger was never turned away as long as they acted right.
They were always invited to "light and sit: in that friendly circle of light.
It was a place for stories and yarns, some were lies, some were true.
By the time they were told and retold, we're not sure "who did what to who."

You could hear the sound of a trail herd, bedding down for the night,
You could feel the chill of evening as you watched the fading light.
There was bacon and beans and biscuits, and coffee that's black as sin,
And rest for a tired cowpuncher as he watched another day's end.
Sometimes the campfire was smaller when the cowboy rode alone.
It still meant just as much to him, it was home away from home.
Just a peaceful way to close the day when he was out on the trail.
There's just something about a campfire, when the day starts to fail.

Now the campfire is only a memory of another time and place,
It's like so much of our heritage, that progress has erased.
Take time to stop and remember the way it was back then,
Close your eyes and let memory take you, back to the campfire again.

Chapter Five
OLD WEST COW TOWNS

BEADLE'S

Dime

New York Library

Copyrighted, 18 3, by BEADLE AND ADAMS. ENTERED AS SECOND CLASS MATTER AT THE NEW YORK, N. Y., POST OFFICE. January 18, 1893.

No. 743. Published Every Wednesday. *Beadle & Adams, Publishers,* Ten Cents a Copy. Vol. LVIII.
98 WILLIAM STREET, NEW YORK. $5.00 a Year.

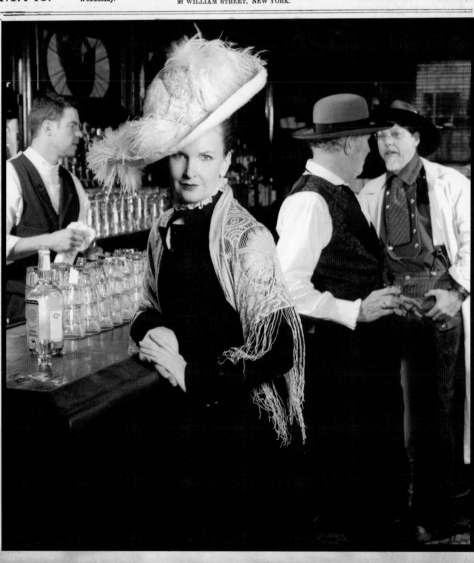

They rolled back into town as the baleful, rising sun rolled the songbirds out of bed. The girls jostled silently in back of the hay-strewn wagon, hot and tired after their all-night trip to the cowboy camp. With worn brakes complaining, the wagon finally pulled up in front of the Last Hope Saloon. Isabelle dabbed her throat with a moist linen hankie and took a lingering glance at the front of the place. It looked like she felt: a little worse for wear. The bright green paint had been faded long ago by the unkind sun and the roof sagged like all the sins of Rio Grande City were piled on top.

Isabelle remembered when she first came to this one-horse town on the two o'clock stage. The paint on the front of the Last Hope had been fresh and bright, like her future. But twenty years later she was still here and time had robbed her of her dreams.

Two townswomen carrying full-up market bags looked quickly away, crossing the street to avoid the Madam's direct gaze. They wore their purity like calico.

Walking into the bar, Isabelle silk-sashayed through the blue cloud of hand-rolled smoke. The place was hopping for a Tuesday night. Trail drivers and cowpokes were lined up like pigeons on a fence, laying down cash on the smooth polished bar. They'd all just been paid and were looking to wallow in some fiery red liquor.

Six men sat in the back, swilling warm beer and playing at table stakes. Some of them were rich, dressed in gray worsted wool and snow-white shirt-fronts. Some were poor, seduced and staking their baby's milk money on quick and easy gain. They sat at the round table, all of them equal like knights of old, in the eyes of Lady Luck.

But there was nothing noble about this round table. And the man who sat at the head was no king—he was a Gambler, sleek and shiny as a black crow, with bright, cheating eyes.
A boy barely old enough to drink sat at the table, cards clutched in his soft hands and his weak chin trembling. He was getting a hard trimming from the sly cardslinger.

Suddenly, the boy yelled, "Cheat!" and chairs scraped back across the rough plank floor. A beer bottle was thrown, almost hitting

the mirror that Isabelle had just shipped in from Laredo. She winced at the threat of seven more years of bad luck to add to the twenty she had already wasted in this worthless town.

Her piano player Chester stepped up. She had hired him for his big, wide shoulders and his mean left hook. . . certainly not for his command of the yellowed ivory keys. Grabbing the boy by his collar and belt, the big man danced him out the door. The boy's feet ran beneath him but never touched the ground. Watching as the youngster landed flat on his tail, the Madam threw back her head and laughed big. Isabelle liked to laugh. It was one pleasure that hard living had never stolen from her.

She climbed the stairs, rising out of the stink of smoke and booze. She made her way down the hall, past tightly closed doors, until she got to the end. Using a bright brass key, she unlocked her door and was greeted by the fresh scent of lemon verbena. Clean and white with sweet lace curtains and crisp sheets on the iron bed. It was peaceful here, just the opposite of the plush red in the rest of the garish upstairs rooms. This was Isabelle's room. Just for her. No dingy cowpoke had ever seen the inside of this place.

Throwing her valise on the bed, she unpacked the loot from the cowboy camp.

Sadly, there wasn't much money. The poor devils were usually broke until they reached pay-dirt at the end of the trail. But they had traded other things of value, a tin watch, a thin gold ring, an engraved set of Mexican silver spurs. . . strange the value that men put on the comforting arms of a woman.

When Isabelle came across the Peacemaker, she ran a manicured finger over the fine ivory grips. She could get some real cash for this pretty piece. But an idea came to her, an idea stronger than her greed. She would save this for her daughter Beka.

Although the "entertainment" business had been a better life for her than the eastern sweatshop and that dirty-handed foreman who almost broke her spirit, it was no place for her pretty daughter. Beka had started shooting early, almost as soon as she could walk, and had her heart set on running off and joining the Buffalo Bill show. This would be Beka's down payment on a new life. That and a handsome buckskin Colt that Isabelle had won in a game of Faroh from a rancher who couldn't keep his mind on his cards. And that dowry would take Beka away. . .far, far away from the faded satin and painted faces of Rio Grande City's Last Hope. ✑

OLD WEST COW TOWNS

The cattle drive had come to an end. The hardships and perils of the trail had been endured. The cattle had been delivered in a choking, dusty cloud to the railyard and now the cowboy was done. With hard money burning a hole in his pocket, he headed for town. If he was lucky, he had another set of clothes to change into. More than likely, though, the rangy young man stopped in at the dry goods store and bought an extra set. And after a steaming hot bath and a close shave, he burned the ripe set he'd been living in for the last three months.

Now he was ready to paint the town red. And town was ready for him. The cattle towns of the West were tailored to separate him from his hard-earned cash. They offered up anything that a young, pent-up man could possibly desire. Loose women, red whiskey, and games of chance waited to eat up his money as fast as he could pull it out of his new vest pocket.

But there was much more to these burgeoning Old West towns than gambling parlors and cat-house saloons. These settlements were filled with entrepreneurs, dreamers who had moved to the "uncivilized" territory to make a new start for themselves and their families. Craftsmen and merchants of all ages and talents made their way to a new market, supplying the increasing demand for "civilized" products.

With today's renewed curiosity about the history of the cowboy, there is also an interest in other important aspects of that western life. Without the infrastructure of towns, without the ready access of supplies and the demand for steak on the hoof, there would never have been any cowboys.

So let's head into a SASS town and take a look around. We'll hear what really went on behind those clapboard storefronts and take a look at some modern-day craftsmen who use their skill and knowledge to keep the history of the Old West alive. ✪

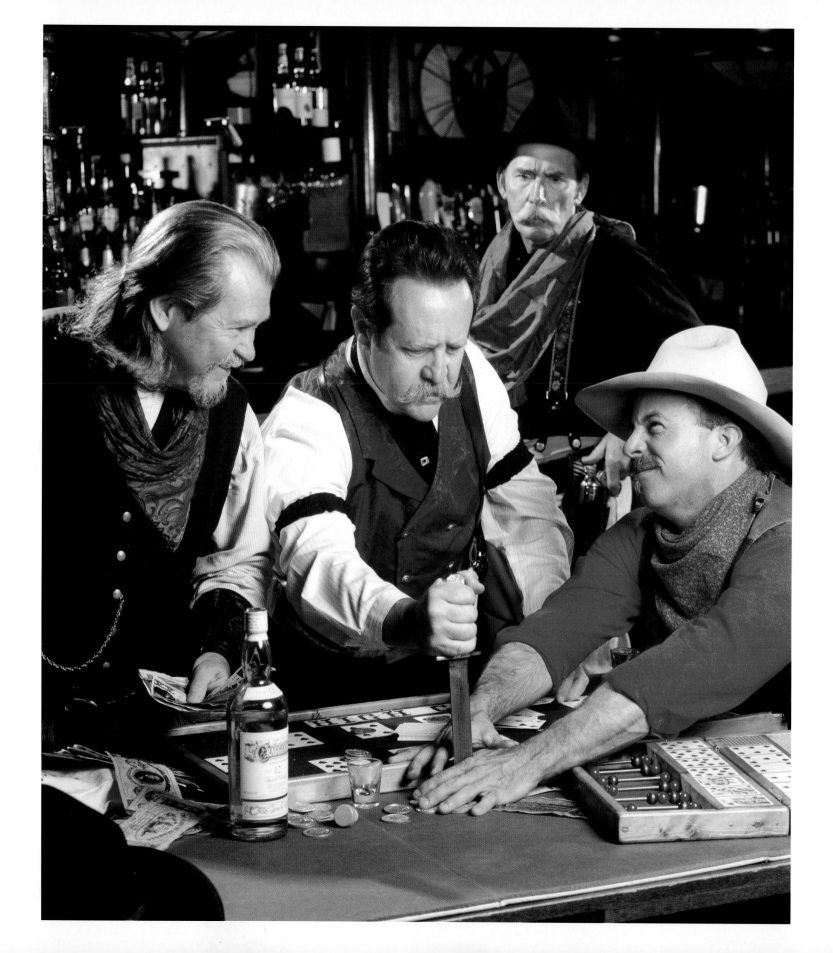

"The saloon was an easy way to make money."

TB BOSS

Cowboy Shooter/Mercantile

WE WALK INTO THE "LONE STAR" SALOON, THE DOORS SWING OPEN . . . WHAT DO WE SEE?

You'd see along one wall a bar. . .a lot of the saloons that you see in the movies are enormous things. Real saloons weren't that big. Even the larger ones tended to be long and narrow. You'd see a relatively long bar, depending on the length of the building. You'd see some tables, a pot-bellied stove, and there might be various and sundry things hanging on the walls: antlers, deer heads—one saloon was decorated entirely with taxidermed birds. It could be anything. But the key factor was a bar and some tables. A place to spend money.

WHAT DID THEY SPEND THEIR MONEY ON?

Well, whiskey was probably the biggest drink. And that was what made a lot of them mean. Because it wasn't good whiskey—it was rot-gut whiskey. And I've read some analysis on the stuff. It was the kind of thing that kills your brain cells and makes you crazy. It was high in lead and made them very cantankerous. But you could get whiskey anywhere. Nicer saloons would have different kinds of drinks, fancier drinks. You could probably get scotch some of the places in the West, some of the French wines. But you have to remember that in Tombstone, the closest train depot was in Tucson—which wouldn't be that far for us today, maybe 75-100 miles. But that was a pretty hard push in a wagon and that was the only way anything got to Tombstone: in a wagon.

DID THEY HAVE BORDELLOS IN SALOONS?

Not all of the saloons, of course. But they did have them. In Tombstone, in the Bird Cage Theatre, there were booths upstairs that people sat in and watched the show that did "double duty."

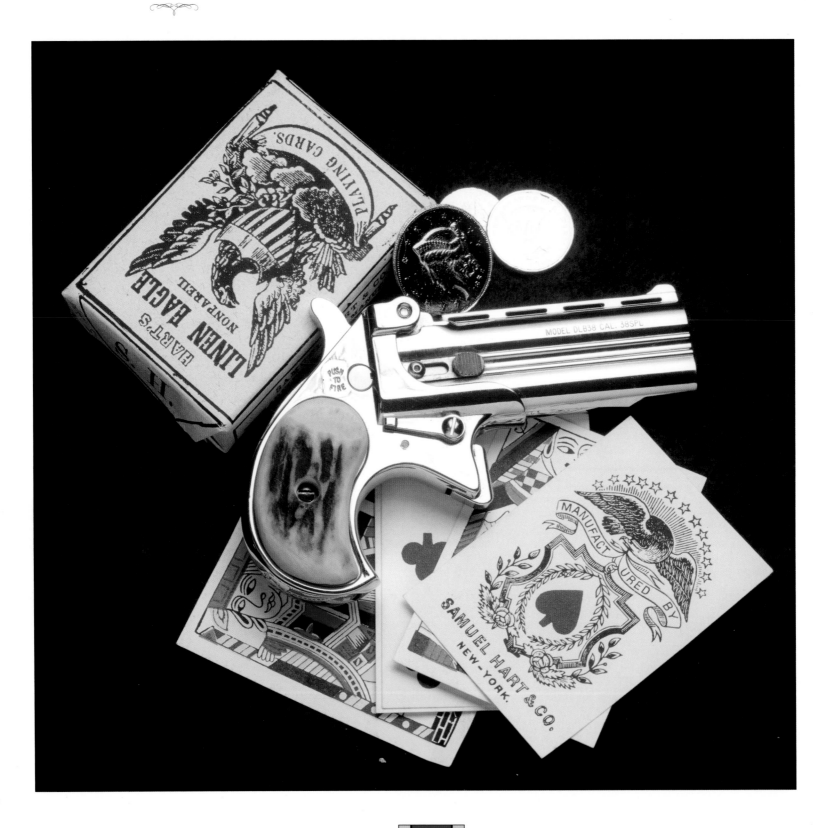

SO THE LAW ENFORCEMENT OFFICIALS PUT UP WITH THAT? IT WAS ILLEGAL, RIGHT?

Well, technically. But even Wyatt Earp, "living right and pure as the snow," was involved in prostitution and gambling. But there again, it wasn't looked down upon. There weren't many women out west, so they were very respected and well treated. Bear in mind that even though this was the Wild West, it was also the Victorian era. You didn't have drunken cowboys chasing respectable women down the street—that just wasn't done. Kate Elder, who was Doc Holliday's traveling companion, was a prostitute. She came with her mother and father from Hungary, I guess in the late 1860's. Apparently her parents both died, never any record of how. But she wound up being passed around from home to home and a lot of the prostitutes came from that kind of situation. They didn't have anywhere else to go.

WHAT KIND OF FOLKS CAME INTO THE SALOON?

Well, you're going to have the banker, the doctor. . .he's going to come in and have a drink. Probably everybody but the preacher and the respectable women come in there.

SO IF I WERE AFTER MY HUSBAND, HOW WOULD I GET HIM OUT OF THERE?

I don't know. . .I'm sure some of the wives went in and drug them out. But you wouldn't go in just to have a drink.

If you wanted that, you'd have a drink at home. But anybody and everybody would be in the saloon.

DID EVERY TOWN HAVE A SALOON?

I think west of the Mississippi, every town had several. Of course the suffrage movement tried to cut a lot of that out. And it worked in some places. But that's the kind of thing that's hard to get rid of. You might try to drive it out of town, you might try to drive it underground, but you don't really stop it. A lot of the towns had a "dead line," maybe where the railroad came through. So on that side of town, you had the bawdy houses, the saloons. On this side of the tracks you might have a saloon, but it's the one visited by the banker and the doctor. They tried to separate out the "rough crowd."

WERE THEY DANGEROUS?

Probably the dangerous times would have been during the real "cowboy era" when cowboys were moving cows from Texas to Kansas. These guys would leave Texas with 5,000-10,000 head of cattle, going to Dodge City to the railhead; it would take them three months to get there. All they had were the clothes on their backs, usually. But when they hit Dodge City, they got paid off and that was the most money they'd ever had in their lives. The smart ones went and took a bath, got a haircut, got new clothes and threw away the ones they had worn into town. They got a good meal, then went to the saloon and had a drink. But all of them weren't smart. Some hit the saloon first. Which meant some of them never got the bath or the new clothes—they got rid of their money.

SO WHAT KIND OF GAMES WOULD WE SEE IN THE SALOON?

You're going to see Poker, which is a pretty even-money game. You'd also see Faroh, which had a reputation. People would say, "If you play Faroh, you're bucking the tiger." I think that was a misconception, because Faroh is also a pretty even-money game, which is why you don't see it anymore in modern casinos. Casinos don't play even money. They want a house edge. In Doc Holliday's case, he'd go either way. He would buck the tiger, or he would run the game and be the bank. He didn't care. He could play from either side of the deck.

WHAT ABOUT MUSIC? HONKY TONK PIANO?

A lot of the saloons didn't have any music, didn't feel they had a need for it. In Tombstone, they had saloons up and down the street, but you also had the Birdcage Theater which had music and plays. . .a lot of pretty high-class entertainment, really. So piano was not necessary for a saloon. If the saloon was big enough, had enough stuff going on, they might put a piano player in there.

WHO USUALLY OWNED THE SALOON?

Doc Holliday supposedly owned a saloon for some time. Wyatt also. The entrepreneurs. If you went West and wanted to make money, it was a moneymaking deal. Another option was actually to go out in the hills and dig for gold, but you got your hands dirty. When Wild Bill was in Deadwood, he told his wife when he left that he was going "prospecting." Well, he got to Deadwood and would write his wife, saying, "Well, I'm going out into the fields today." He didn't go—he went to the saloon and gambled. The saloon was an easy way to make money. ✪

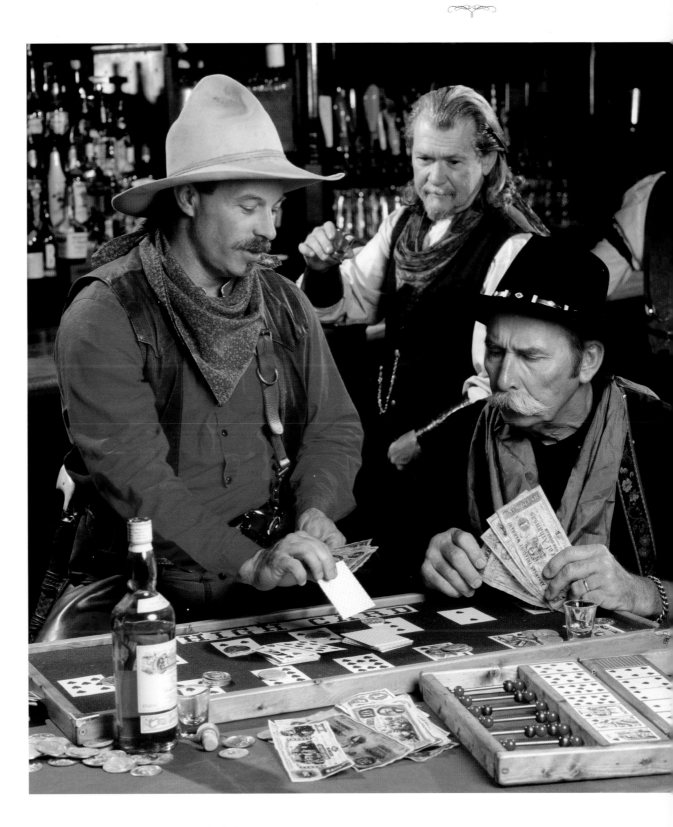

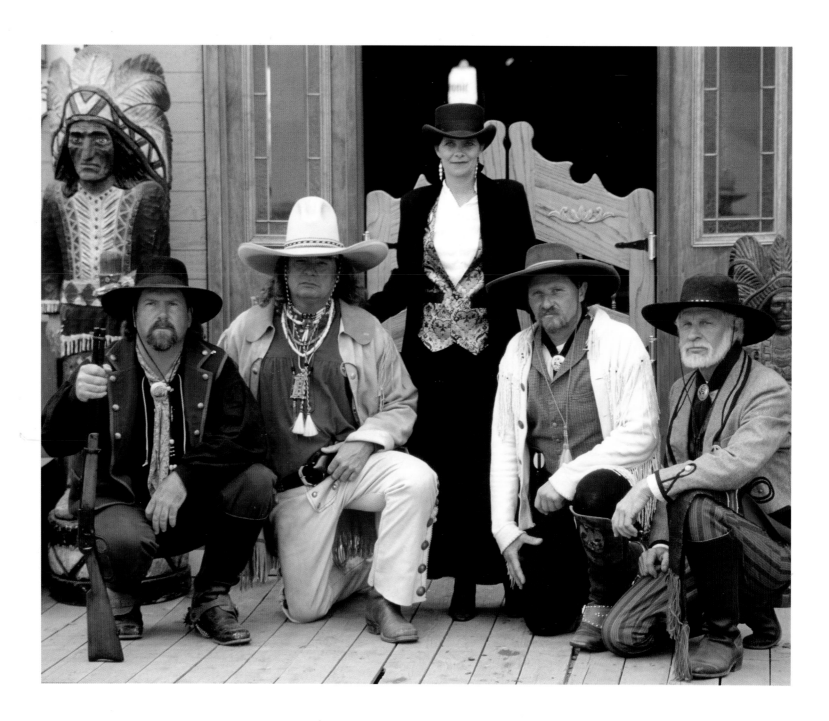

A few more words about Sheriffs and Saloons

JIM STEPHENS

Normally in western towns from the 1870's until the turn on the century, the sheriff—and sometimes his deputies—would be sold "pieces" of different saloons in town, and they would be there at night dealing cards. There were a couple of reasons for it. First, it kept the saloon a lot more peaceful and calm if the sheriff was sitting there with his badge and guns on. He was also considered to be a much fairer dealer than the average gambler who would go into town and deal cards at the table. People didn't readily believe that the sheriff would cheat them. That didn't mean he DIDN'T—it just meant that he was viewed as someone who would not do that. There's a long list of them. Wyatt Earp, almost every town he served as a lawman in, he bought into the saloons there. Bat Masterson is another well-known one. As a matter of fact, Bat and his brothers were lawmen in Dodge City and owned chunks of various saloons in town. ✪

"The closest thing we have today would be military towns. Just think of what a military town is like on payday."

JIM DUNHAM

Trick Shooter/Western Historian

LET'S TALK ABOUT KANSAS COW TOWNS.

The beginning of the Kansas cow towns was at the end of the Civil War. Joe McCoy, who was a businessman from Illinois, convinced the Kansas Pacific Railroad to build deep into Kansas and wound up going to Abilene. Abilene was chosen because there was lots of grass and water available for the cattle to eat and get fat before shipping. Then he convinced people from Texas to put together herds of 2000-3000 head at a time and go up the Texas Trail. As the railroad began to push west, the cow towns tended to go further west. You had Abilene, Wichita, Ellsworth, Hayes, Ogallala, Dodge City. . . whatever town was the farthest west tended to be the most popular one for that year. Basically, everything was torn down and moved from year to year. In fact, the Abilene Hotel where Joe McCoy put his people, called the Drover's Cottage, was completely disassembled, all the wood was marked, and it was taken and put on the railroad and shipped over to Dodge City. Then they rebuilt it, so it was possible to stay in Room 10 in Abilene in 1871 and then in 1875-76 you would be in the same room, but in a different town. The phrase "hell on wheels" came from those cow towns because you moved hell wherever you went. The closest thing we have today would be military towns. Just think of what a military town is like on payday.

HOW DO YOU CONTROL THINGS?

You bring in marshals and police officers. And, the law has rules and the rules are simple: What's good for business is legal. That isn't quite true, but it works out that way. There were always laws against prostitution and gambling on the books. So what you do is, you arrest the prostitute and take her before the judge. The judge would charge the prostitute $25 and tell her to get back on the street where she belonged.

SO IT'S LIKE A USER'S FEE.

Exactly. And the prostitutes and gamblers paid money, which then provided income for the town counsel and the police department and everything else. It's kind of like if people stopped speeding and drove the speed limit, we would be in trouble because they need the speeders to pay the salaries. So this is something they didn't want to put an end to it, they just wanted to make sure it paid the bills.

WHAT KIND OF ENTERTAINMENT WERE "RESPECTABLE" PEOPLE INTERESTED IN?

Music was very popular in those days, as it is today, but of course you didn't have recorded music or TV and movies back then. So live bands were very, very popular. There would always be concerts – everything from John Phillip Sousa to Mozart and Beethoven. On any given day, just like people today would say "let's go to the movies," you could say, "let's go the concert hall and hear the band play John Phillip Sousa." So from small musical groups to large orchestras, there was always music. The other thing is theatre. You had everything from Shakespeare to Gilbert and Sullivan musical comedy. You had melodramas and light comedy.

WHAT TRAVELING ENTERTAINMENTS CAME TO TOWN?

Eddie Foy was very popular. If you look up entertainment in any kind of reference book, you will find stuff on Eddie Foy and his family. I think there was movie based on his life with Bob Hope called *Eddie and the Little Foys*, or something like that. Eddie was very big in the cow towns and knew Wyatt Earp. He would do basic vaudeville. He later wrote a biography called *Clowning Through Life*. They also had singers, women such as Lilly Langtree, Lotta Crabtree and women who were well featured. They loved to have women singers all dressed up in their big skirts and outfits. They sang everything from light opera to popular songs. ✪

Jim Stephens

"Her mother said she wasn't ever going to get a husband if she didn't wear a corset."

Cowboy Shooter

IF A LADY WANTS TO INDULGE IN THIS SASS SPORT, WHAT DOES SHE WEAR?

I personally wear skirts. . . with one exception: if we go to a shoot on a motorcycle, I wear pants. Other than that, I wear skirts all the time. The costuming varies from the prairie dresses — the wrapper style with the pinafore and the apron on it—to the walking skirt or even a riding skirt with the knee-high boots. It just varies depending on what you want.

HISTORICALLY, WHAT KIND OF VARIATION DID YOU SEE IN LADIES' CLOTHING?

Lots, actually. Women that lived in the towns probably made more effort to dress like women back east. So you would see more of the Victorian costumes: the corsets and bustles. The women who were out on the farms and ranches were much less likely to wear that kind of thing. First of all, there was the economic issue: they could only use what was readily available, like flour sacks or the inexpensive calico. And they didn't usually wear corsets because they were just too hard to work in. Those ladies did a lot of very serious physical labor, so they had to be a little more practical about their clothes.

TELL US ABOUT THE HOMESTEADER'S CLOTHES.

Women on the ranches wore a lot of aprons and outer garments to protect their dresses because they only washed them once a week. And with no automatic washers and dryers, it was a big deal. When the bottom of the dress got frayed, they turned it and sewed a ruffle; they replaced the cuffs so that they could get more wear out of it. And then, when a dress got to the point that they couldn't do anything else with it, they would use it to make a child's dress or even use it for quilting scraps. They had to make use of whatever they had. They'd have maybe one or two dresses for warm weather and one or two for cold weather, and

that would be it. That's why you started seeing the skirt and blouse combinations—it gave you a little more flexibility in your wardrobe.

WHAT WOULD THE RESIDENT SOILED DOVES HAVE WORN?

Showing a bosom back then was not nearly as risqué as we consider it today. Actually, showing your ankles would have been much more daring. So a soiled dove would show some leg because that was pretty titillating. Sometimes they would literally be in their underwear: pan-

taloons and camisole. With the dance hall costumes, you kind of get the connection with the can-can girls of the Moulin Rouge going on about the same time. I have seen ones in pictures that showed a whole lot of leg, above the mid-thigh, with skirts hanging down in the back. So you are showing the front, but the back is covered. So even they had their own "code of modesty."

WHAT ABOUT UNDERWEAR?

[laughs] There was lots of it! The bloomers were interesting. They also called them drawers. They were very

big and went from mid-calf up and the crotch was split. Then they had multiple petticoats and in the wintertime they wore more for warmth. Everybody wore corsets. They had a camisole and then the corset over that and then a chemise — so lots and lots of underwear. Laura Ingalls Wilde. was apparently the Scarlett O'Hara of the West, in terms of being rebellious. She hated it when she got to the age where her skirts came down and her hair went up. Young girls wore their hair down and their dresses to mid-calf until they were considered young ladies—then their dresses went down past their ankles and they wore their hair up. That was when they started wearing a corset. She was very opposed to wearing one and her mother said she wasn't ever going to get a husband if she didn't wear a corset. Her mom actually wanted her to sleep in the corset because that would help keep her figure from expanding too much. But she drew the line at that.

SO REBELLIOUS WOMEN DIDN'T WEAR ONE?

[laughs] Soiled doves did wear them occasionally because it made look good. But the term "loose women" came from proper women identifying those women who did not wear corsets. You were considered to be not quite a lady if you were not wearing a corset in those days. ✪

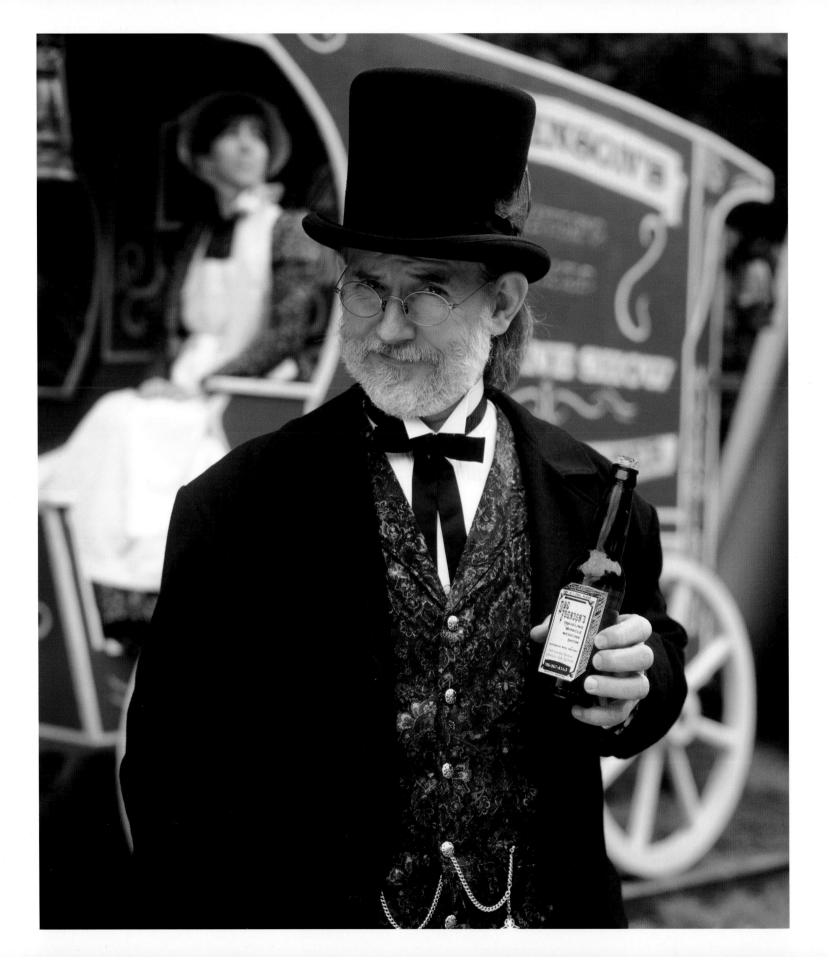

DOC JOHNSON

Medicine Man

"I'm gonna try and sell you some medicine, now if you wanna buy some medicine as a souvenir, that's wonderful. I'd appreciate it very much. But for goodness sakes, whatever Doc tries to tell you, don't drink the stuff! It's not to drink—it's to sell. I'm here to entertain you folks. I'll tell you that. But I'm here for more than that. I'm here to make you a happier and healthier individual. Happier than you've ever been in your entire life. When you walk away from here this afternoon, if you want to be smarter, if you want to be healthier—and I know each and every one of you do—then you're going to want to pay close attention to what's sittin' right there on that table. . . This little bottle of Wizard Water will save your life. One dose alone is irrevocably guaranteed to instantaneously eliminate, permanently prevent, and otherwise completely cure toothache, sleeplessness, club feet, mumps, stuttering, varicose veins, stomach ache, hernia, tuberculosis, nervous debility, impotence, halitosis and falling down stairs—or your money back."

WHO STARTED THE MEDICINE SHOWS?

One of the first companies to get into the medicine show business was the Kickapoo Medicine Company. They sold medicine from the Kickapoo Sagwa tribe, which never existed. The motto was "A Kickapoo Indian would no more be caught alone in the desert without his horse and blanket than he would without his Sagwa medicine." Now, this was all made up, of course. But that is the type of show people expect to see. It's the one I want to give them, and it is accurate, right down to my costume. The whole idea was to have the very "professorial" looking individual: black frock coat, top hat, very officious. Why? Because a "doctor" wouldn't sell you something that would harm you. If they weren't using the doctor look, they might be dressed in buckskins to give the suggestion that they had lived with the Indians. The Chinese robes were popular, too. . . "secrets from the Orient." Those were the three primary types of costumes.

WHAT KIND OF PERSON BECAME A MEDICINE MAN?

He was part used car salesman, part your best friend, part evangelist. He was preaching what he wanted you to believe in, putting his arm around you and saying, "You know, this is the best thing in the world I could do for you." And, of course, the salesman part of him painted the bottle up to look good—but at the same time, what was in the bottle was probably worth a lot less than what the buyer paid.

WHAT WAS IN THE BOTTLE?

Lots of roots and herbs mixed in for flavor, but the primary component was alcohol. One of my favorites was the Hollis Coca Wine Corporation out of New Jersey. If you look at the ingredients, it says that it was a combination of wine spirits and a "compound of the celebrated Coca, or Life plant." Basically it was cocaine and alcohol. But my absolute favorite medicine (I don't remember the name of it) was something to help children and wives out if their fathers or husbands were going out and carousing around town in the evening. After dinner, you slipped this little pill in his coffee and he'd no longer have the urge to go out and carouse; he'd fall fast asleep on the sofa. It was pure opium. One hundred percent. So you no longer had an alcoholic on your hands, you had an opium addict. Trade one for the other. But at least he was staying at home. . . Another one was a tapeworm tablet. Absolutely guaranteed to be effective. And the consumer thought it was. It was an indigestible piece of material rolled up into a ball, coated in sugar. They took the pill. The sugar melted, and the strip of material opened up in their stomach. And they "passed" it. And there was their "tapeworm" to prove that the medicine actually worked. (Laughed) Nobody ever said these guys were on the up and up.

WHERE DID THE SHOW COME FROM?

Medicine shows rose out of Commedia dell'Arte, with the "professorie" and "harlequin" characters. We don't know if they actually came from Italy, but they did evolve from that Italian genre of theater. If you look at the American medicine show of the 1800s, the harlequin became the "Jake," but he still wore a modification of the harlequin costume. (That's the diamond-shaped pattern.) He wore a shirt and suspenders and a big baggy pair of pants made of that diamond pattern.

SO WHAT WAS A JAKE?

A Jake was the sidekick. He was the foil for the doctor. If you describe it in modern terms, take Abbot and Costello. Lou Costello was the Jake. The Medicine Man was the straight man, and the Jake was the funnyman. That's how it worked.

WHAT KIND OF ENTERTAINMENT WOULD YOU SEE IN A MEDICINE SHOW?

It was pretty common to have a banjo player and a fiddler. One or the other, if not both. You'd see magic, you'd see music. And the medicine show would last for hours. Sometimes ALL DAY. They didn't just sell medicine. They sold soap, candy. . .the big deal was to sell candy in boxes. They'd hold up a watch at the beginning of the show and

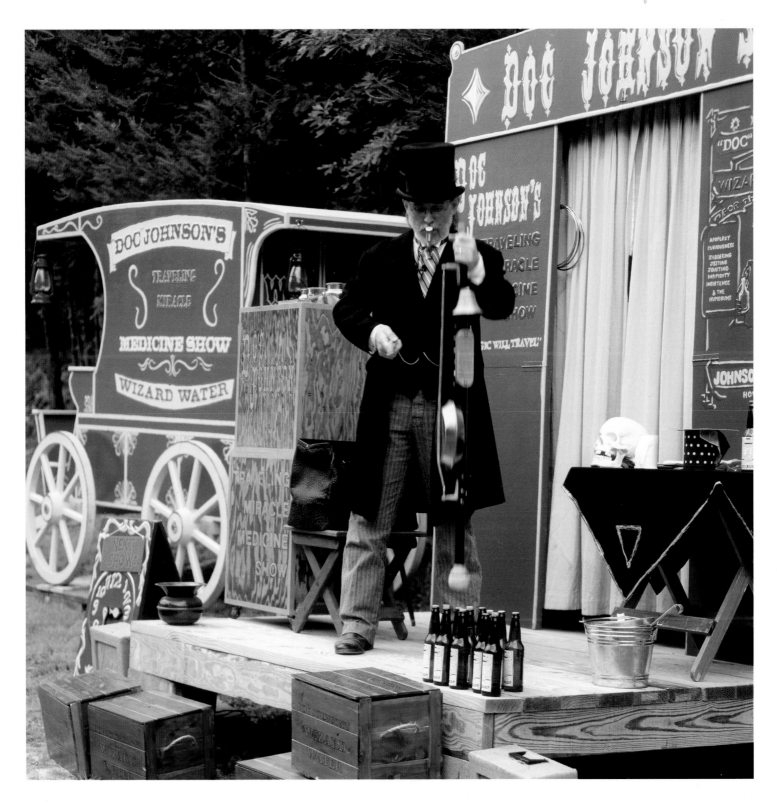

say, "We're going to be giving this watch away today. We're putting it in this box of candy and the lucky person who buys this box will receive this fine watch." Nine times out of ten, the watch box was sold to a "shill" out in the audience. He got the watch but he'd return it later to the Medicine Man. And then the Medicine Man would say, "Tomorrow we're giving away another watch for the price of a box of candy, so you folks come on back." And that's how they kept them coming.

SO IT WAS ALL ABOUT MAKING THAT DOLLAR.

And they made it. In the 1890's there were 25,000 traveling medicine shows in the United States. By 1906, there were only 25-30. And by the 1960's there was only one. Doc Tommy Scott from Eastanolly, Georgia, retired in 1996. He was the last traveling medicine salesman. He was one of my idols. I actually got to see his show, I've been to his home, and have seen some of his memorabilia. He was a smart

man—he adapted his show to current trends. He had a radio program before people were actually on the radio; he saw television coming and had his radio program filmed, so it could run on television later. It ran as early as 1948, when television was in its infancy. The last real GREAT medicine show took place in Atlanta in 1951. Senator Dudley J. le Blanc out of New Orleans, Louisiana, was running it. He created it and put it on the road. He was making over three million dollars a year profit. That's 1951 dollars.

THAT'S A LOT OF MEDICINE.

(Laughs) Yeah. And that was after expenses. When you put these shows on, every performer pulled a salary. Whoever was running the show bought their costumes, put them up in hotels, bought their food and covered expenses. Their salary was pocket money. LeBlanc had acts like Desi Arnaz and Lucille Ball, Red Skelton, Judy Garland, Hank Williams, Sr. All those guys traveled with him. And even after he paid all that out, he was still making three million dollars.

HOW DID THE MEDICINE MAN DEAL WITH LAW ENFORCEMENT IN TOWN?

Not many people know this, but "Billboard Magazine" was originally a medicine show journal. And the purpose of it was to sell medicine show trinkets and candy that they would give away in the course of their show. But it also told you what towns were "medicine show friendly" and what towns weren't. It said, "Don't go to Bumble, Indiana . . .the sheriff there is not amenable to our trade.

Go to Howard, Georgia. The sheriff there will let you work fine for ten bucks." The Medicine Man was not considered entirely reputable by the local authorities. Because the contents of the medicine were sometimes poisonous, with arsenic, cyanide, strychnine, occasionally you had a fatality, here and there. Not intentionally, you understand. But the sheriff was wary of them.

WHAT KIND OF SET-UP DID YOU NEED FOR A MEDICINE SHOW?

It depended on the size of the show. Some traveled with several wagons if they had a large cast. The show that I do as Doc Johnson is a typical one- or two-person medicine show. Most of them were small like that. The big shows were put out by the Ka-Ton-Ka and Kickapoo Medicine Companies. They would actually put people out on the road, supply a set-up wagon and give them a cut on the medicine they sold. A show like "Doc Johnson" performs would have the Medicine Man come into town and spend the night before a show sitting behind the wagon, filling bottles, and slapping on labels on his own elixir, much like we do every evening at home.

ANYTHING ELSE?

I'll tell you what the real Doc Johnson said once to a reporter. The reporter asked, "Doc, do you take your own medicine?" Doc said, "Hell no, son. That stuff ain't to take. It's to sell." ✪

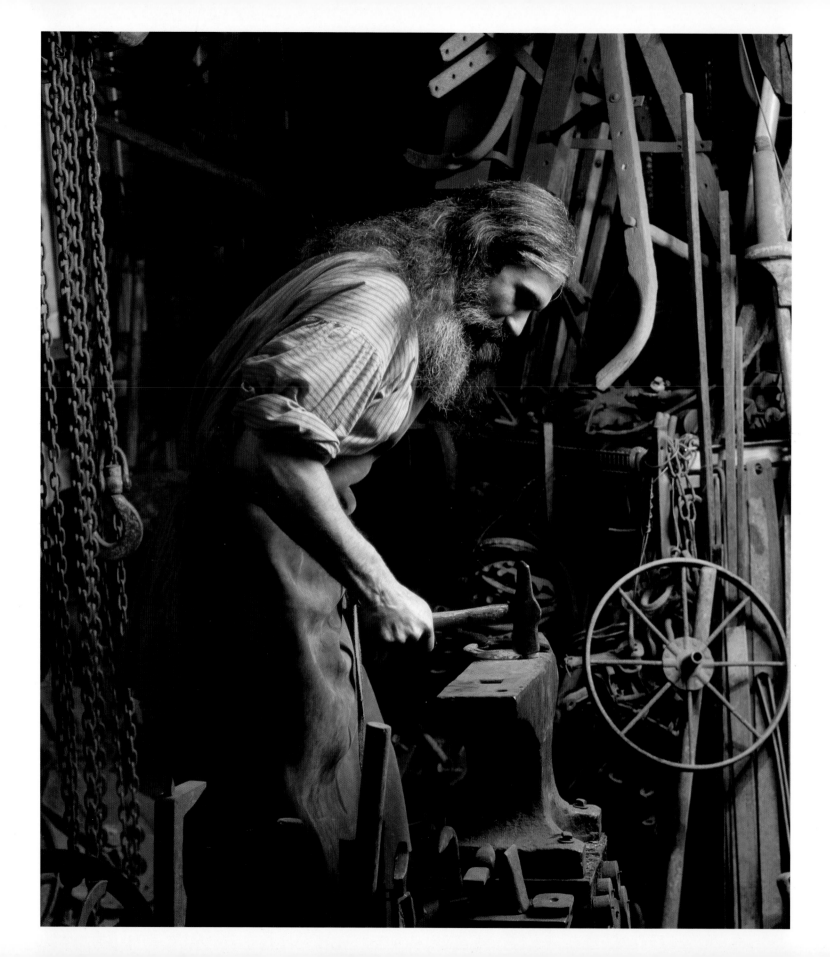

"In blacksmithing, everything's hot till proven otherwise."

Blacksmith

WHERE IS THE BLACKSMITH SHOP LOCATED IN TOWN?

More than likely it will be near the horse stables. Back then the blacksmith did all the work related to the horses. . .not necessarily because he wanted to, but because he was the only one around that COULD do it. He made the horseshoes, nails, general metal work relating to horses. He also had all the metal parts on the wagons to repair, or had to be able to make new ones.

WHAT KIND OF WORK WOULD A TOWN BLACKSMITH DO?

The blacksmith was one of the most important people in town. You think back then, everything metal in your house, the blacksmith made it. All your knives, forks, spoons, hinges, nails, everything relating to horses and wagons. . . maybe even repair parts for guns, if there wasn't a gunsmith around. If you had a simple part on a gun that broke, you could fix that. He made a lot of tools for the other craftsmen in town. Stone masons had hammers and chisels that they used for their stone work. Miners used picks and shovels. A carpenter needed chisels and all the different drills made out of metal. If you were out somewhere a long way from a major city, tools were hard to get. Today people think "OK, if I order something today, it will get here tomorrow." Back then, that stuff came by horseback or wagon to get where it was going. You might order something and it would take a couple of months to get to you.

HOW DID A BLACKSMITH LEARN HIS TRADE?

Your dad might decide that when you grew up you needed to become a blacksmith. When you were as young as seven or eight years old, he would send you to live with one. You'd do all the filing and stuff that he really didn't want to do himself. On your own time, when you had finished work for him, you'd sit there and make some of the tools,

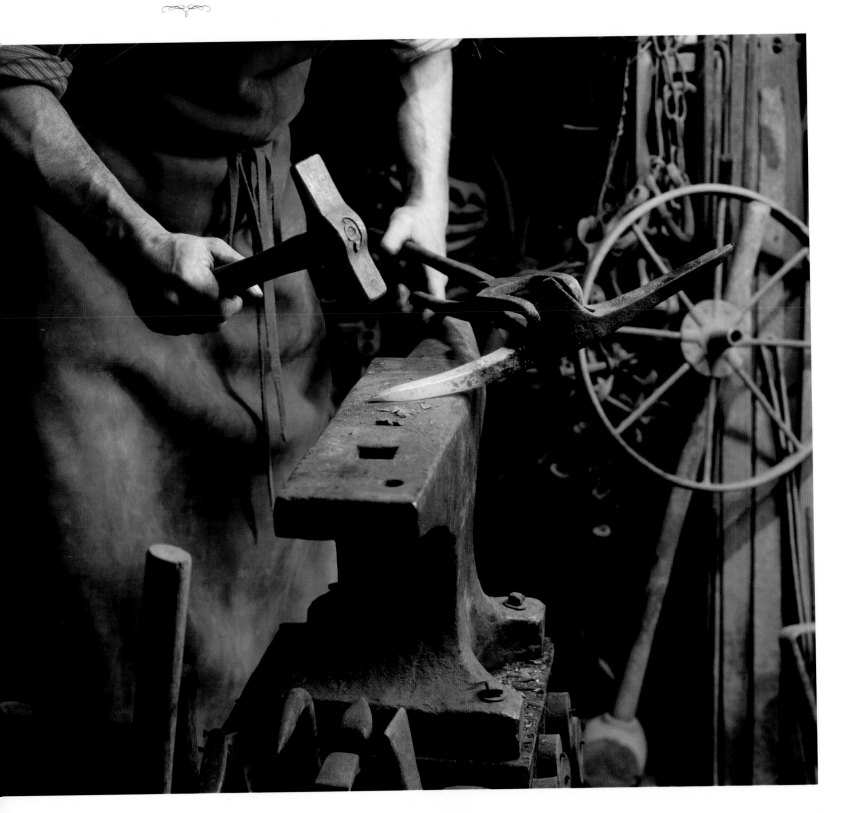

tongs and hammers for yourself. When he told you that it was "time to go," you had your own tools to take with you. Blacksmiths had kind of an honor system. . .you agreed with your master that if he would train you, you wouldn't go right next door and set up shop. You'd move down the road 20 or 25 miles before you'd open your own shop.

WHAT IS THE BIGGEST LESSON YOU'VE LEARNED IN BLACKSMITHING?

Everything's hot till proven otherwise. ✪

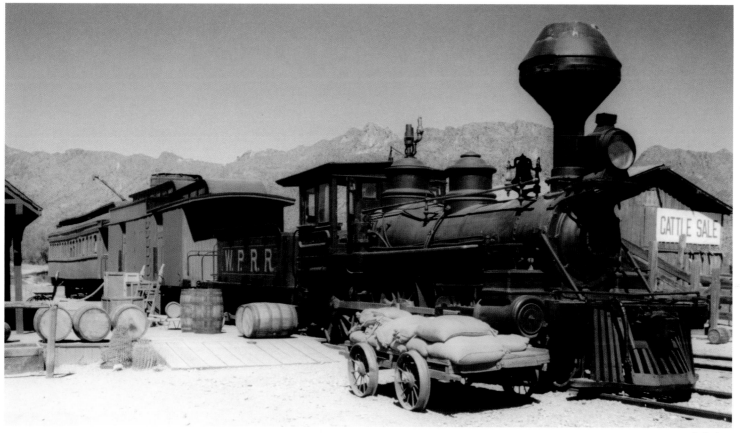

Jim Stephens

"A cowboy has got to have a hat."

BOB SMITH & CHERIE SLAVEN

Colorado Mountain Hat Company

WHAT'S THE DEAL WITH COWBOYS AND THEIR HATS?

Well, a cowboy has got to have a hat. I mean, he wouldn't be a cowboy without one.

SO IS IT FASHION OR A TOOL?

It was a tool for the original cowboy. They needed protection from the elements. That's how Al Stetson got started. He was out west and found the need for a bigger brim hat. You know, if you work out in the rain, snow, and wind, you've got to have protection. The smaller brimmed hats didn't really work very well.

CAN YOU GIVE US SOME HAT CARE TIPS?

Always set them down on their crown if you're not wearing them. Probably doesn't make much difference with a flat brim hat, but that keeps you from messing up the sizing and the breakline. Always keep it stored in a cool area.

Don't leave one in the window of your car—that will soften it and tear down the breakline and sizing. Keep them brushed up and have them cleaned once in a while. In the old days a lot of the dry cleaners used to do it, but now you can take them to a hat dealer. If you want them to look new and snappy, stay on top of them. If you want them to look like the old cowboys, don't worry about it.

WHY DO YOU CALL YOUR HAT "LEROY"?

Well, we call it Leroy because that's what it's made of: hair from a dog named Leroy. He is an Irish Water Spaniel that lives up in Alaska. A friend of ours had him shaved a couple of years back and gave us the hair. We sent the hair to the felter and he added a little beaver and rabbit to it, to help build it up a little. I got seven pieces of felt out of it, and this hat is made from one of them. ✪

"How could you meet to have a shootout at high noon if you didn't know what time it was?"

JIM STEPHENS

Watch Collector

WAS KEEPING TIME IMPORTANT IN THE OLD WEST?

Once the trains started coming in, time suddenly became vital to people. The trains had to keep exact schedules. The railroads were so determined to keep on schedule that at the beginning of the run a railroad man took his watch to the Station Master and he would set it for him. Railroad watches were higher in mechanical quality, too. So, among collectors today, you are looking at a much, much higher value for antique railroad watches.

OUT ON THE PLAINS, WERE THEY AS CONCERNED ABOUT IT?

Uusually not—they pretty much went with the sun to keep time. It was only when you moved into town or were transversing the railroad that you cared. For that matter, I am certain that stagecoaches were very interested in keeping time. Even though you couldn't keep as tight a schedule as you did with the railroad, you did try and keep to a schedule.

DID COWBOYS WEAR WATCHES?

They did. As a matter of fact, at the beginning of the John Wayne movie *The Cowboys*, the drovers start showing up and they are all going off because they heard there was a gold strike. But when they first start riding up, they are LATE. And he says something to them like "I expect you to go out and get yourself a good dollar watch." So, yes, cowboys did carry them. They may have needed watches to meet the chuck wagon at particular times for meals, or because they had shifts. Besides, how could you meet to have a shootout at high noon if you didn't know what time it was? ✪

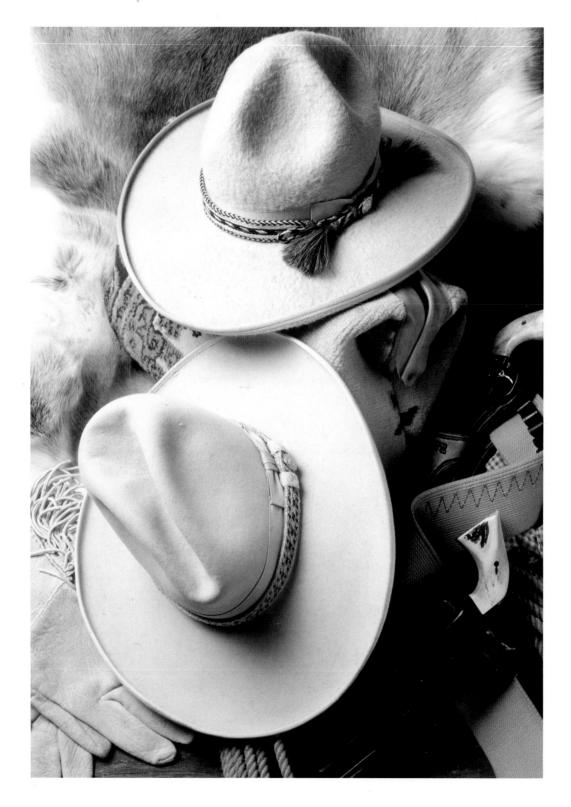

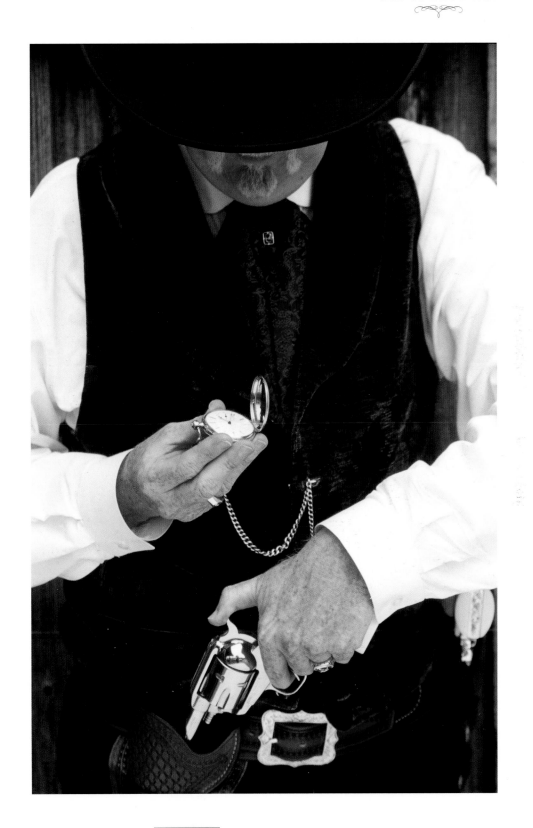

Chapter Six

THE WILD WEST SHOWS

Copyrighted, 1893, by BEADLE AND ADAMS. ENTERED AS SECOND CLASS MATTER AT THE NEW YORK, N. Y., POST OFFICE. January 18, 1893.

No. 743. Published Every Wednesday. *Beadle & Adams, Publishers,* Ten Cents a Copy. Vol. LVIII.
 98 WILLIAM STREET, NEW YORK. $5.00 a Year.

The town was still snoring when Beka hit the road. She was up and gone before the east tinged red, headed for Laredo as fast as her long-legged horse would carry her. Buffalo Bill was playing there; she'd seen it on a weathered playbill outside the Last Hope Saloon. It read "Western Melodramas, Outdoor Extravaganza, See brave Colonel Custer make his last stand against the Savage Sioux." But her imagination really sparked when she laid eyes on the rendering of Bill Cody, former Indian Scout and Champion of the West. He was handsome and tanned, smiling mysteriously beneath his luxurious handlebar moustache. She thought about all these things as she rode like the wind, flying out of Rio Grande City without a glance over her shoulder. Her throat got tight when she thought how much she'd miss her Ma, but there was adventure to be had, and Beka was determined to get her share.

The air was still. Nothing in the whole wide world was moving but her and a red-tailed hawk that wheeled above them, pointing west, pointing toward the future.

Clarence the piano player had pitched a red-headed fit when Beka told the folks at the Last Hope she was going. He said a woman had no business setting out alone in this hard country. But her Ma had stood at her side, cracking out words like a mule driver's whip, saying that "the West was a new land, where new rules were made for men and women alike. Besides," she added, "Beka's pistol will take better care of her than any man has ever taken care of me."

So here she was, riding like the devil, hair tucked beneath her hat, looking like a runaway boy. The Peacemaker rode heavy and comforting on her hip. The pounding of her buckskin's hooves and the jangle of her spurs sang a song of sun-up.

The road to Laredo was tough. It took her eight days to get there, sleeping off the trail, without a fire. At night she hid in the thick darkness of the Texas night, watching the moon herd the stars across the black plain of the sky. Lonely coyotes yelped and cicadas shrilled as she lay on the ground, wrapped up in a rough Indian blanket and the certainty of her Mother's love.

On the ninth day, Beka blew into Laredo like a fresh east wind. She didn't stop for grub or a bath . . .just rode straight to Buffalo Bill's Wild West Show. It was a fenced arena built at the edge of town, circled by a little city of dun-colored tents. Her buckskin pranced through the makeshift street as her eyes lit on the strangest sights. . . Pony Express Riders saddling up for a race, a man leading five buffaloes, tame as cows. She saw a giant, gray

beast; the elephant was twice as big as she had imagined and stank three times as much. Finally she spied fiercely painted Indian braves playing gin rummy with mustached banditos. They were deadly foes, sharing cigars and a joke. A woman with red curly hair, dressed in quiet clothes, was sitting at the rough-hewn table, cleaning her rifle. Beka stood there gawking, wondering if she was looking at the world-famous Annie Oakley.

"What's the matter, pup? You ain't never seen Injuns before?" a graveled voice gruffed from behind her.

Beka swiveled in her saddle and saw an old man dressed in fringed buckskin and trade-beads, topped with a dusty black bowler, scowling like there was sun in his eyes.

She spoke up, desire making her brave. "I was wanting to talk to Mr. Cody," she said. " I'm looking for a place in the show."

"Well, that's him over thar," the old man grumped, "but we ain't hiring no young jack-a-napes."

Beka looked across the center of the arena and saw him: Buffalo Bill in his brass-buttoned coat and hip-high boots of Spanish leather, cracking thunder out of a black bullwhip. Her eyes stung with disappointment.

But fate lent a hand as mischief's wind blew through the camp, scattering gin rummy cards, driving a little dust devil through the canvas tents. And Bill's wide-brimmed hat was sent flying across the dirt arena.

Beka watched the hat, and knew in her heart that fate was giving her one chance. Swallowing hard, she spurred her horse and rode that sweet buckskin hard at Bill. The famous man stood there, curiously watching the horse and rider as they thundered towards him. Right before she reached him, Beka reined the horse, veering right into a tight circle. Slipping Indian-style out of the saddle, she gripped the horse with her strong legs. Stretching down toward the hard ground, between the horse's pounding feet, the girl grabbed Bill's hat, finishing the impossibly small ring around him. Beka's daring display had loosened her own hat and her thick, burnished hair came flowing out like russet silk.

And before the onlookers could take a deep breath, she had hat in hand and was back up in the saddle again, trotting lightly to where the famous man still stood.

"Mr. Cody," she started, her breath coming a little hard, "I'd like a job in your show."

Buffalo Bill laughed. "Well, I'll be jiggered. Girl, you're plum crazy!" He scratched his chin, looking at her shrewdly. She had good teeth, wasn't hard on the eyes, and had a fine Peacemaker strapped to her trousered leg. A grin split his face. "I see you won't be needing a gun, young lady. But if you can shoot as well as you can ride, you've got you a job." ✐

THE WILD WEST SHOWS

The Wild West was big news in the tame east. Dime-store novels and newspaper accounts of hard-riding cowboys, grim gunfighters, long-suffering sheriffs and gold-hearted madams filled most of the imaginations east of the Mississippi. American culture had pushed all the way to the Pacific Ocean, and everybody left behind on the Atlantic wanted to hear all the titillating details. They milled about in the crowded cities, existing quietly in their charcoal gray world, but in their minds they were breathing fresh air out there on the wide open plains, riding with Billy the Kid or cleaning up the town with Wyatt Earp. Tales of the Wild West brought vivid color into their pale, humdrum lives. And with every story they heard, every tale they read, they longed to go west.

But in 1872, the West came to them. Huge traveling western shows, produced by real western heroes such as Buffalo Bill Cody and Wild Bill Hickock, toured the eastern United States, giving the American public a glimpse of the ultimate frontier adventure. Stretched before their eyes adorned in buckskin splendor, a menagerie of actors, stunt riders, and sharpshooters played out the history of American expansion.

The audiences were thrilled with what they saw. Herds of wild buffalo, careening stage coaches, battles to the death right before their eyes, and magnificent horses. Eastern folk had certainly seen horses in their daily lives, mildly pulling milk wagons, trams, and fine carriages. But the audience observed horses in the Wild West show performing feats that they had previously only read about: they carried Ki-Yi-ing Indians into battle, they galloped at full speed while lawmen and bandits shot straight over their heads. Those western horses were truly a breed unto themselves.

The shows also offered the public a glimpse of the women of the Wild West. Annie Oakley and Calamity Jane headlined, showing that women could ride and shoot just as well as any man. The show not only gave the public a grand view of western life; it paid homage to the pioneer spirit of the women who helped settle the West.

In many aspects, the Single Action Shooting Society is like that Wild West Show. It gives us a glimpse of what was once the ultimate frontier adventure and brings the vivid color of the Old West into our pale lives. In this chapter, we chat with SASS members about sure-shooting women, sure-footed horses, and the greatest cowboy show on earth.

✪

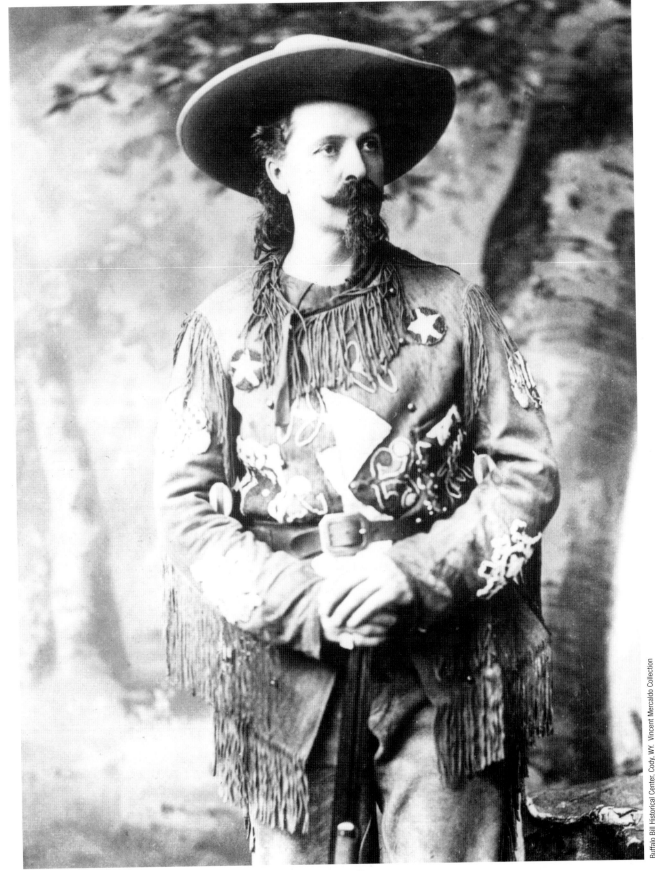

— Buffalo Bill —

> ## "In those days, if somebody got shot at a show, you just didn't worry too much about it."

JIM DUNHAM

Western Historian

GIVE US A LITTLE BUFFALO BILL HISTORY.

Buffalo Bill was an actual scout for the military who became famous by providing meat for the guys building the railroad. The railroad guys would hire hunters and there was this one guy by the name of Billy Comstock. So, what happened is they got into this argument about who was the best hunter and they had a big contest. Billy killed more buffalo in a twenty-four hour period and got the title of Buffalo Bill. Next he retired and moved to Ogalalla, Nebraska, and started a little retirement home called The Scout's Rest Ranch. One year he found out that nobody was going to do anything for the July 4$^{\text{th}}$ holiday and he was upset about that. So he decided to invite all of his old pals and buddies and have a show, which he called "The First Annual Old Glory Blowout." He put up posters and everybody showed up. It was so successful that he said, "It's silly to do this just once a year. We should travel around and make a living at." Everybody sort of agreed and that was the beginning.

WHAT WAS THE SHOW ABOUT?

The show essentially told the story of the conquering of the West. It began with Indians coming up in a procession as if they were moving camp. They had all of their regalia, their horses and dogs, and they set up their tepees and put on an Indian dance. Next they told the story of the mountain men and the explorers. Then, they basically had everybody come out one at a time and did more history, you know, everything that happened up to Lewis and Clark. Then they did the farmers coming out and building farms, and they had the Indians attack the farmers and the cavalry come rushing to their aid. They had outlaws or Indians attack the stagecoach with six horses pulling it, and the cavalry led by Buffalo Bill would chase the Indians off. It was all done with blanks. It was just shoot 'em ups – chase here and chase there, although some people were hired to fall off and play like they were dead. It was kind of the forerunner of western movies.

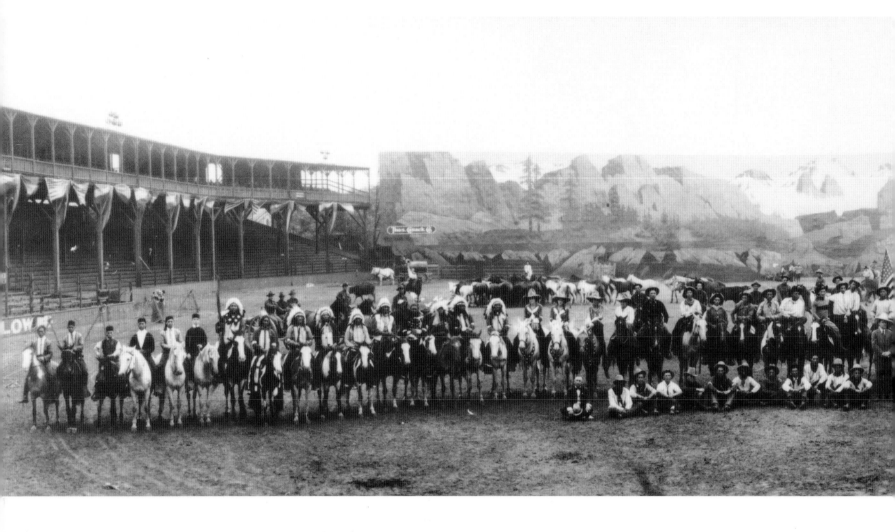

SO IT WAS A HUGE PRODUCTION?

A big, huge production that cost thousands and thousands of dollars. Hundreds of people involved. They put together their own train that traveled from town to town like a big Ringling Bros. Barnum & Bailey Circus. They had probably a dozen buffalo that they would turn loose and Buffalo Bill would ride around and shoot the buffalo with blanks. And of course, you have to take the show across the Atlantic Ocean, so you'd need a whole vessel. The bills and printing alone for the advertising was $400,000. You had 80 tons of placards and advertising material, powder and shot – and the bill for the ammunition is $500/week. In one statement of Buffalo Bill's show for the week of June 1, 1913, the Wild West took in $22,962.09, but for the same week they paid out $20,526.92. That left them a profit of about $2,400. Not too much profit.

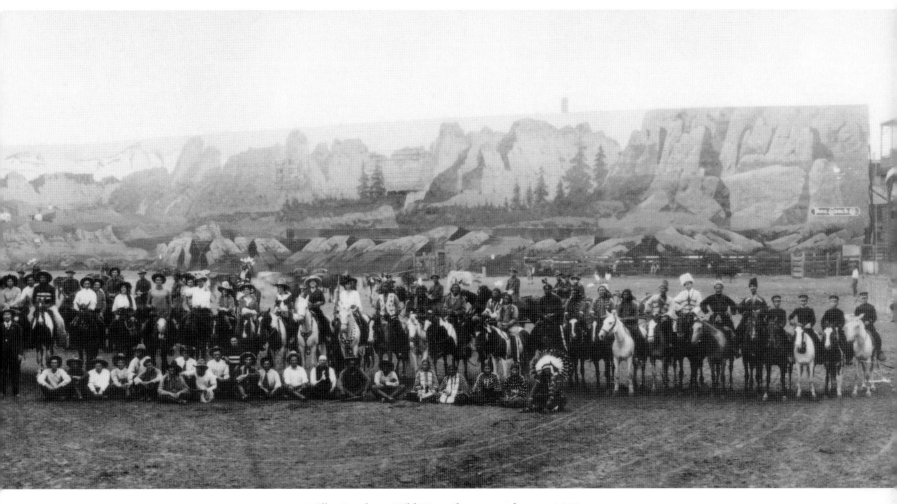

— Miller Brothers Wild West Show cast photo, c.1916 —

DID THEY EVER USE LIVE AMMO?

Annie Oakley used live ammunition, but basically she was a rifle and shotgun shot, so she used bullet traps to shoot her rifle. In other words, there was a target set up that had metal plate bullet catchers. For anything thrown in the air, she used birdshot. She would shoot straight up into the air and break glass balls with birdshot. Now, the birdshot sometimes did come down on the crowd, but it's real fine metal. It's kind of like baseball guys worrying about foul balls going into the crowd and hitting somebody—every once in a while someone gets hit with a ball and gets hurt. But, you know, it's just part of it. In those days, if somebody got shot at a show, you just didn't worry too much about it. But they weren't shooting live ball ammunition into the crowd. Even the pistols, when they were shot up in the air to break something, used a light shotgun load.

ANY CHOREOGRAPHY?

Bill's partner, Major Burke, kind of directed the thing for a while, but I think Buffalo Bill himself orchestrated. What's funny is that he probably said, "All right, you come out there and chase people around in a circle and fire blanks and figure out who is going to fall down, who's going to shoot that...." And they worked it out. They did so many shows over so many days that they kind of came up with their own thing – and really the only choreography was when specific things had to happen, like the stagecoach had to be saved by the cavalry. The cavalry had to ride out on a cue at a certain point, and then the other people had to do certain things. But it really wasn't like a dance, it wasn't necessary to be too exact. It was pretty loose. It was just a series of performing acts. You had trick ropers, trick riders, bucking horse riders … the whole thing was called "cowboy fun."

WHAT WAS THEIR MOST FAMOUS GIG?

The most famous was probably when they played for Queen Victoria. Frederick Remington was there and drew pictures of the Queen at the event. Another time was in Germany when Annie Oakley had the Kaiser put a cigarette in his mouth and she shot the cigarette out of his mouth. When the Kaiser later became the enemy of America in World War I, Annie said it was the only shot she wished she had missed. In fact, I think both the Queen and the Kaiser rode in the stagecoach when it was being chased by Indians. They got to be part of the program.

WHAT BROUGHT ABOUT THE END?

The problem is, it was just too costly. Look at the numbers. You can't have that kind of cost and play very many cities. You can't go play Des Moines and you can't play small towns. You can't get the crowds to pay the money. And so, eventually it was just too expensive to keep on the road.

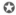

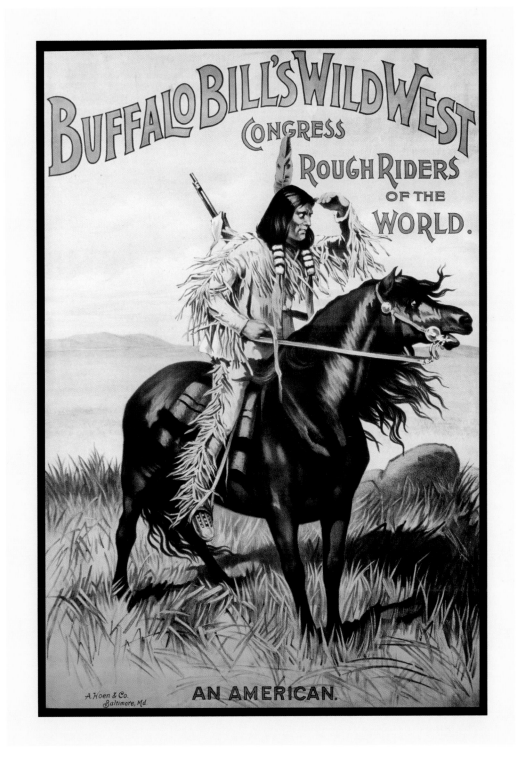

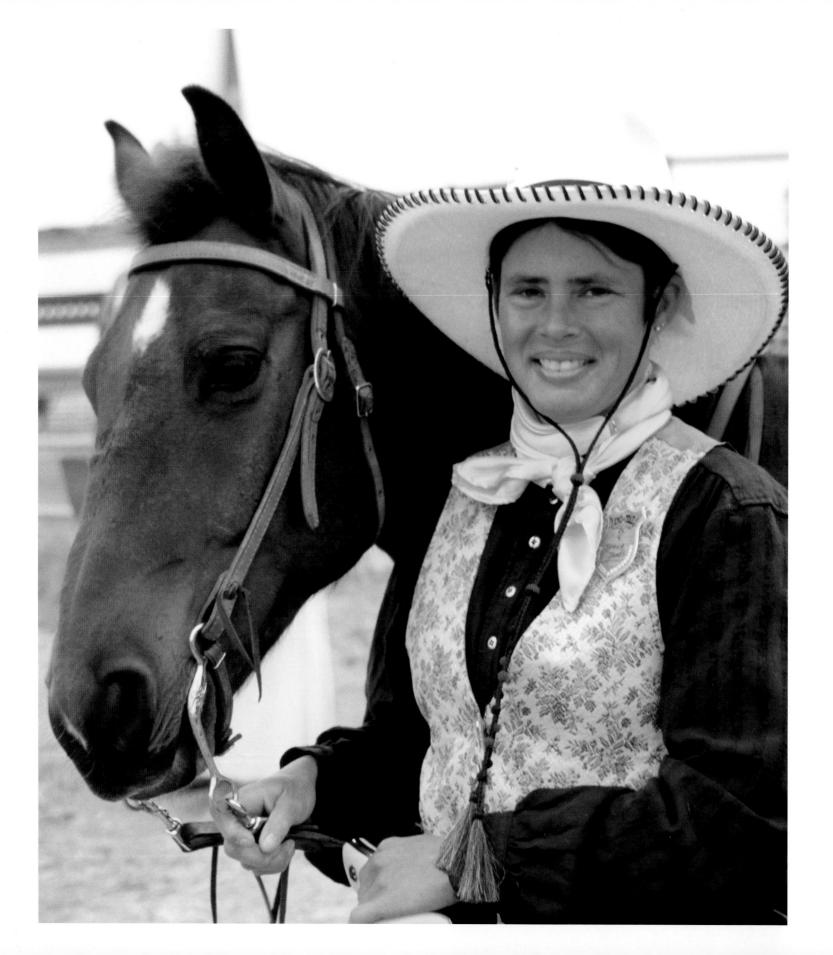

"I think if you just respect the horses for what they are and who they are . . ."

DEBBIE ROSS

Horse trainer

WHAT DO YOU LIKE ABOUT MOUNTED SHOOTING?

It's very different from dressage. You just go run out there as fast as you can on your horse and shoot as many balloons as you can. For me it's an adrenaline rush. I love the outdoors, and I enjoy the horses immensely. It's just a thrill to run "wide-open" and shoot those balloons.

HOW DO YOU TRAIN A HORSE TO EXCEL IN THIS SPORT?

Well, a horse's natural response to a gun is going to be flight, because they're going to be afraid of the noise. So what we do is, we bring the new horse in with a group of experienced shooting horses. They feel naturally comfortable in a herd situation. Then you can start working, but you don't shoot off the horse the first time. You shoot on the ground quite a ways from them and get closer and closer until they feel comfortable. You shoot all around them on the ground until they're comfortable with the gun

before you shoot off of their back. If you put them with another horse that's accustomed to guns, they acclimate to it a lot easier. But my main work is with the horses that are already shooting horses – they're used to the guns, but they need to work on their balance and gaits. A lot of my dressage background comes into play. I get them to have better canters and be more responsive to their riders. I put a good turn on them and a good stop on them. That's where more of my expertise has been than actually starting a horse from the beginning. Although the horse that I have now we started from scratch. Eventually they really seem to get into it and get very relaxed. They know what their job is and they get very attuned to what they have to do. Then they seem to really enjoy it.

WHAT KIND OF HORSE IS THE BEST BREED FOR MOUNTED SHOOTING?

I've seen all breeds. In my experience, and in talking with different people who also work with the mounted shooting

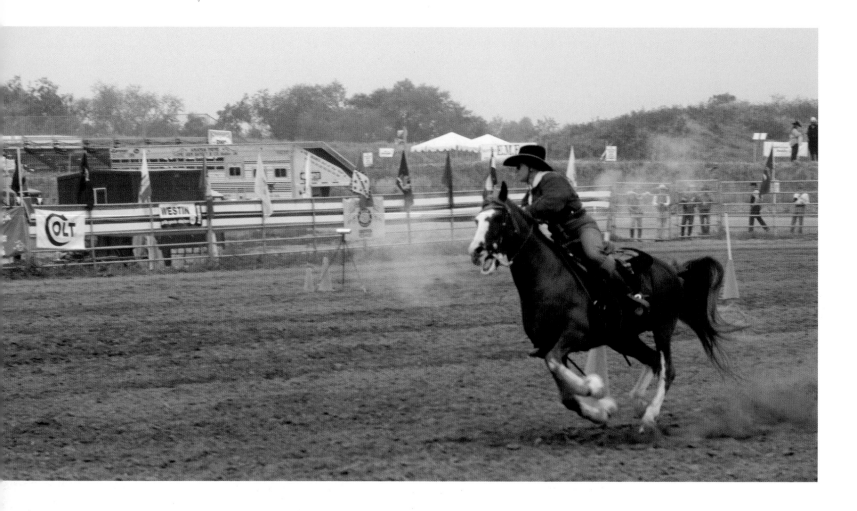

horses, I think the most difficult to train is a thoroughbred that has been a racehorse. Because they use a gun to start the race, when these guys hear the bang of the gun, they think they are supposed to run as fast as they can. So that horse generally has a very difficult time becoming a mounted shooting horse. I would say that the majority of your horses are Quarter horses. The Arabian horse also does very well. There are a lot of paints, pintos, many crosses and even some mules. Mules are actually a lot smarter than horses.

DO YOU HAVE ANY "HORSE WHISPERING" SECRETS THAT YOU CAN SHARE WITH US?

You have to look at how a horse works. A horse is a herd animal and most of the time, when people work with them, they take them out of the herd situation. Their safety is in numbers. The way they defend themselves is to kick and run away. When I go up to a horse I don't know, I approach with kind of slumped shoulders in a non-threatening way. They are more liable to be responsive to you than if you just

walk up to them with your shoulders back and your chest out in a real assertive way. I always walk up to a horse by their head first and I let them sniff me, because they do a lot of recognition by smell. Then you can pet them . . . usually on their necks. I guess the horses take about six months to a year to really bond with their rider. They definitely get attached to the people that feed them.

DON'T WE ALL!

Yep. We also use a lot of treats with our horses: horse-cookies, carrots and apples. I think if you just respect the horses for what they are and who they are . . .treat them with love and kindness, they are going to give that back to you.

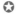

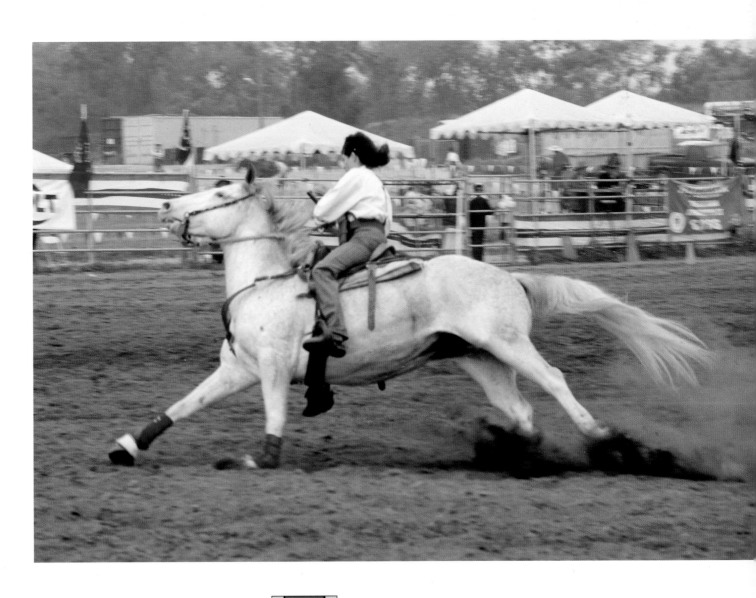

"The mustang . . . was subjected to years and years of natural selection in the North American wilds."

OCTAVIO ORTA

HOW DID HORSES COME TO NORTH AMERICA?

Horses as we know them today were not introduced to the continent until the Spanish arrived in the early 1500s. In addition to the rest of the supplies that they had to ship over, the Conquistadors came equipped with horses for their soldiers. The horses they brought were a crossbreed. First you had the Andalucians, the predominant breed of horses in the Iberian Peninsula at the time. The Spanish crossed them with Barbs, which were the horses that the Moors rode, a type of Arabian horse. So that combination of breeds was what the Spanish brought to the New World.

HOW DID THEY FORM HERDS HERE?

There were two ways, really. Number one, some of these horses would actually escape and go out into the countryside on their own. The second way was human introduction into the environment. The Spanish would go out exploring the continent, leaving from their point of landing on the East and Gulf coasts. Since they were moving overland, they had to pack their food and supplies on horses. As they moved along, they consumed the supplies and freed the extra horses.

HOW DID CATTLEMEN ROUND THEM UP?

The easiest thing to do was send people to Colorado, Montana, Wyoming, or Arizona where those horses roamed. First, the cowboys found the location of a herd. Then they made a trap by finding a box canyon or a canyon that they could close on one end. Then they would try to run that herd into the canyon. Then they'd rope the horses and walk them back.

TELL US ABOUT THE MUSTANG.

We know that the mustang is a direct descendant of the Andulucian and the Barb, the horses that came originally from Spain. It was subjected to years and years of natural selection in the North American wilds. They had to be very tough to make it and had to develop very strong hooves if they were going to survive running over rocks and hard terrain. So over time, they survived and became a very hardy animal. ✪

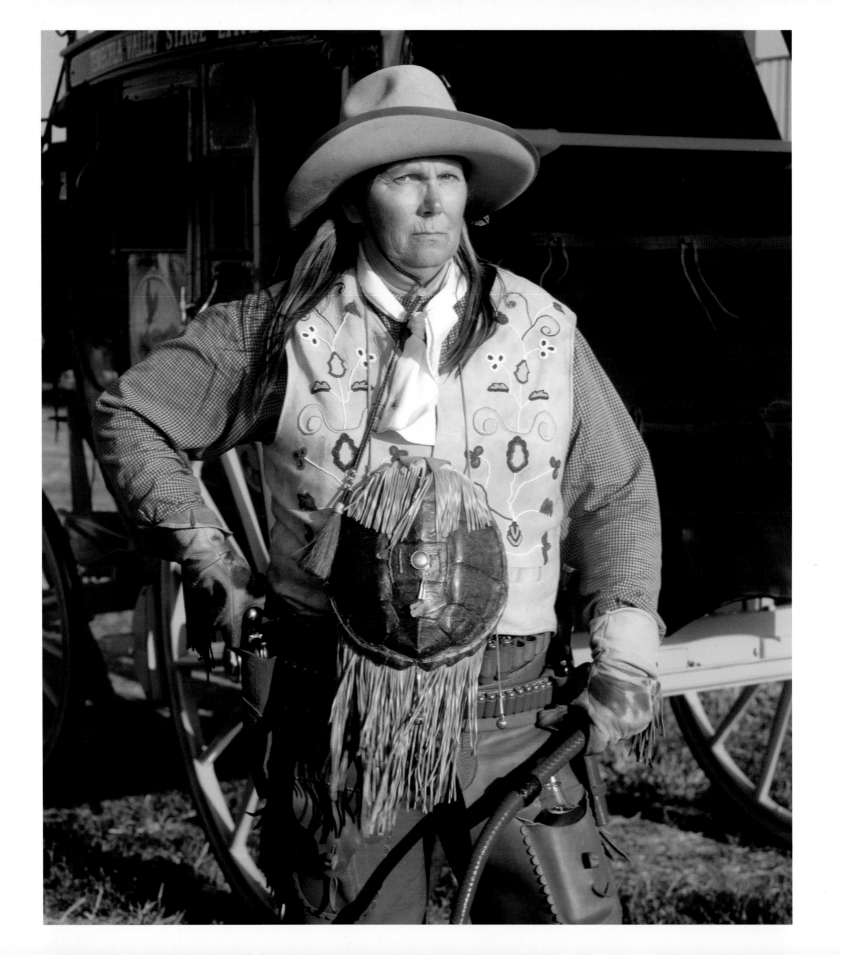

"She took life on her terms. Out in a land that had no law, that made its own rules."

Cowboy Shooter/Entertainer

TELL ME ABOUT YOUR COSTUME

The vest is a copy of Calamity Jane's vest. I've got a photograph of it. The original is in the Buffalo Bill Cody Museum up in Cody, WY. These shotgun chaps that I have on are another exact copy of a pair of chaps she owned. And the turtle I got from a Bannock Indian up in Pocatello, who gifted it to me. I've had some pretty good luck since I've had the turtle. I'm not the only actress in the country that does Calamity Jane, but the turtle has sort of become my trademark cause everybody says, "you know. . .the Calamity that has the turtle."

WHY CALAMITY JANE?

Most of the time when I get asked that question, I joke about it and say, "Well, I do Calamity Jane because I'm a drunk and a whore." And that's the quick answer. It usually gets a good laugh. But the reality of it is that she's one of my childhood heroes. Kids in my generation, we read about Calamity Jane, Kit Karson, Belle Star, all these western icons. We grew up knowing them. I just admired the freedom she had. The idea of how free she was. . .to be able to ride the plains, to ride the Pony Express. . .to be a scout for General Crook and save the Deadwood Stage and have an affair with Wild Bill Hickock. . .boy, she was something. She took life on her terms. Out in a land that had no law, that made its own rules. The biggest gun usually spoke the biggest truth. She grew up in that environment. And while the ladies back in Boston were talking about "temperance" and women's rights, Calamity was out on the frontier living the freedom that they were just talking about. But she paid the price eventually. It was a hard life, but I admire her so much. I've patterned a lot of my life after her. When I was growing up, I liked to do things that girls weren't supposed to do. And when I became an adult, I carried that over. I was in the military for a while, which was kind of unusual. After I got out, I was oftentimes the first woman in engineering organizations, in corporate America back when they were getting "token" women to fill their quotas. I got

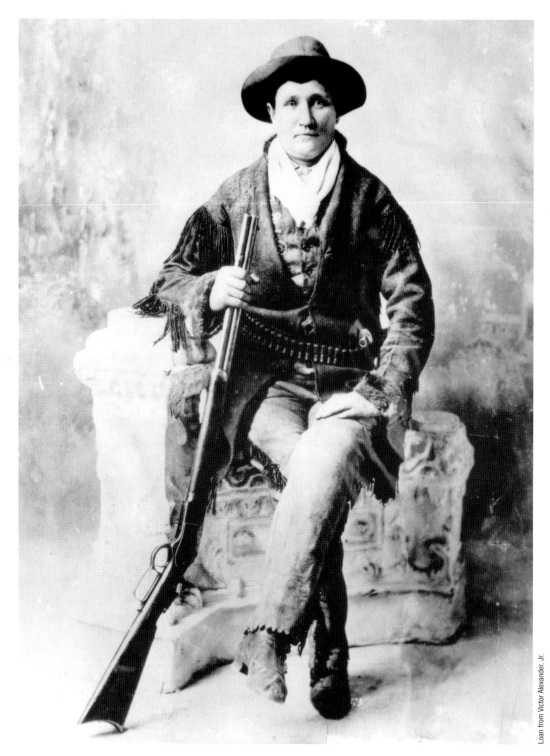

— Calamity Jane seated with rifle —

beat up pretty good, but I looked at it like it was opening doors for other women. I think Calamity Jane was like that, too. I still live my life that way.

DID CALAMITY CARRY A WHIP?

She was expert with a bullwhip. When Deadwood first boomed and became a gold town, there were two places to get supplies. They would bring them up from Cheyenne, which was quite dangerous because that was Indian Territory and white people weren't supposed to be in there. The other place you could get supplies was Fort Pierre, South Dakota, off the Missouri River. Calamity used to drive freight trains from Fort Pierre. They could have anywhere from 20-30 bulls (oxen). That's why they called them bull whackers. It is said she could take a fly off a bull's ear at twenty feet with a bullwhip. The bull whackers weren't allowed to ride the wagons; the wagons were filled with every pound they could get on them and they would be hitched to each other, and then you would have this long string of bulls. The bull whacker would walk alongside the teams and part of the job was cursing at the bulls. The best bull whackers could curse to make your ears melt. So, Calamity was a taskmaster of profanity. Of course, I am, too, but oftentimes I got children around so I have to watch how I handle the language.

WAS CALAMITY INVOLVED WITH BUFFALO BILL AT ALL?

Yeah, from time to time, but he didn't like to hire her for the Wild West Show. Of course, he had Annie Oakley, who was his little star, and Frank Butler. Calamity just liked to hit the sauce a little too much. You'll notice that part of my costume is a nice flask of Jack Whiskey. Calamity was no stranger to the bottle. Some people say that she was a drunk and a whore, but I've never been able to find a record of her ever accepting money for sexual favors. She just liked to drink a little bit and have fun with the boys, you know, not unlike a lot of women today. She was out there having a good time. She felt that she was equal to any man and so she lived her life that way. She thought that if you were her friend and you were sharing your whiskey with her, she might as well pull a pant leg off and have a good time, too. If you were her good friend, she'd go to the wall with you. I'm kinda that way myself. If I don't like you, you are in big trouble. But if I like you, I'll go the whole route with you, you know.

CALAMITY WAS NO STRANGER TO TROUBLE, WAS SHE?

They put her in jail all the time. I don't think there was a town in the West where she wasn't in jail at least once. She'd get charged with stuff like fornication. If you made love to anyone other than someone you were married to, you would get charged with fornication. She was always drunk and shooting up places and stuff, so they were always putting her in jail.

WAS CALAMITY THERE WHEN WILD BILL HICKOCK WAS SHOT?

The summer of '76 was the Centennial year and everybody was down in Cheyenne. I think Calamity had just gotten

out of jail. They probably were running her out of town, so she asked Charlie and Bill if she could go along to Deadwood. They say it was quite a sight. They rode up there and I guess the whole town yelled, "Here comes Charlie Udder's wagon train into Deadwood full of whores" and Wild Bill was on one side of the wagon in the lead, as the outriders and Calamity Jane were on the other. They had these brand new white Stetsons they got down in Cheyenne and were dressed to the Ts. They came riding in there with the whores screaming and people coming out and screaming, and it was just a great sight to see. It wasn't two weeks after that, on August 2, when Wild Bill met his fate in the number 10 saloon at the hands of Jack McCall. Calamity claims she was there, but some say she wasn't. Calamity claims she captured Jack McCall. Some say she captured him with a meat cleaver in front of Shaddy's Meat Shop, some say she didn't. Calamity's life was like that— you don't know what to believe and what not to believe. Even when it was in the newspapers, you still wasn't sure what to believe about Calamity.

HOW DID CALAMITY DIE?

I hate telling that part of the story. There is a little mining camp about a mile and a half from Deadwood that doesn't exist now, but some of the foundations are still there. Calamity came back from the East. She was working for this Middleton outfit doing a Wild West Show kind of a thing. They put her on display and she hated that. She had a little book that she sold. She was getting up in years a little bit and not looking too good. People would make fun of her

and she just hated it. She got back into the bottle again and eventually got fired. There was some rich lady in St. Louis that offered to put her up for the rest of her life in comfort on one condition: that she quit drinking. Calamity lasted about two weeks and decided to go back to the Black Hills – of course that is the place she loved, there in Southern Montana and Northern Wyoming. Somehow she knew that she was on her downside. She went all over the place and finally ended up back in Deadwood. She went out and visited Wild Bill's grave. A photographer caught her there and said, "If you're going out there, then I'm going to take your picture," and he took one of the last pictures of her in front of Wild Bill's grave. She went back into town and said hello to everybody. This gentleman had a saloon with a little rooming house upstairs. She was drinking in the saloon there and started feeling poorly so he took her upstairs and put here in one of the rooms and she died there. They think it was from cirrhosis of the liver and pneumonia. Back then there was no "twelve-step" program and there was no AA. In fact, there wasn't much medicine at all, other than Indian medicine or what you brought with you from the East. So, she just kinda took it as it came.

SO THAT WAS IT?

It was real funny. She was a social pariah because she was non-conforming. But after her death, she was so famous in her own lifetime that Deadwood threw the biggest funeral they ever had for Calamity Jane. They said it was just a mad event, that they had to put chicken wire over her coffin because people kept coming by and cutting her hair.

They were afraid that by the time they got her in the ground she would be bald. On the other hand, Wild Bill Hicock was killed there and they couldn't even get anybody to carry his coffin. They hired some teenage boys to carry the coffin of Wild Bill Hicock. I don't know why he gets so much press. Calamity kicked around up there and created excitement for thirty years after he got shot. She was really something. ✪

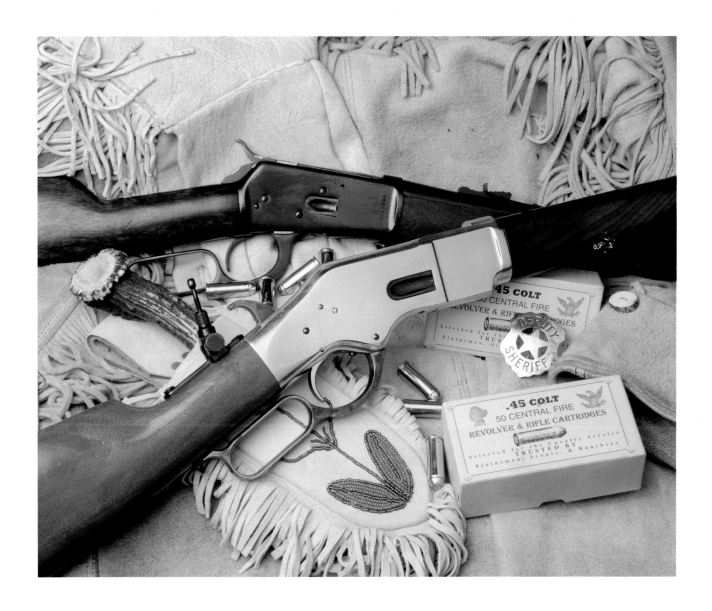

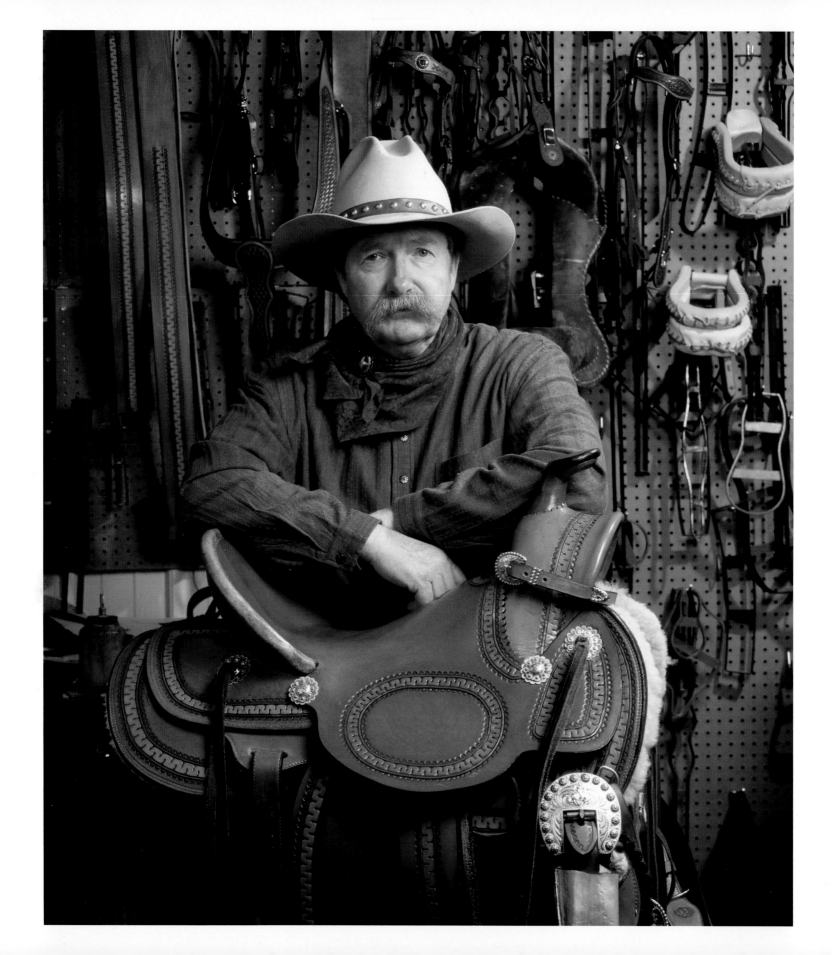

"Some of these old cowboys would save up for years just to get the saddles they wanted."

LAMAR GREEN

Saddlemaker

WHO DID THE REAL LEATHERWORK IN THE WEST?

There were artists back then, really good craftsmen who did nothing but leatherwork. They had saddle shops in all the major towns, because leatherwork back then was a big deal. You had to have a saddle and bridle to ride. They made saddles and chaps, harnesses, holsters, rifle scabbards, and shooting cuffs. They were pretty much a shop like ours. Nowadays you can make 100-125 saddles a week. I would guess that back then it would take 3-4 weeks to make a saddle. At our shop we don't build a lot of different saddles. This old-timey A-port is all we do. We're fixing to start working on a wade-tree; that's another old-timey saddle with a big post horn on it.

BACK THEN, COULD YOU HAVE ORDERED A SADDLE FROM SEARS AND ROEBUCK?

No, the real deal would have been ordered from a saddle shop. It was sort of an individual thing. The shop would make some up to have in inventory, but a cowboy would need to come in and try them out. Nowadays you get folks wanting a 16-17 (sized) seat. But back then they wanted little seats—they'd get a 15.

WAS THERE AN EVOLUTIONARY PERIOD FOR THE SADDLE?

The cowboys started designing something that "worked" for them. It took several years to get there. I think the Vaqueros brought the saddle over to the New World. See, the Mexicans were the real cowboys. A lot of our cowboy stuff is adapted from the Vaqueros. The Mexicans were using a big horn saddle and the American cowboys started adopting that style. The old pony express saddles were boxier. But all of them were slick seat-saddles. Saddle blankets started out being wool pads, wool blankets, although they did use some fleece.

WHAT ABOUT DIFFERENT STYLES OF SADDLES?

The Spanish saddle came out with that big old horn. I think it was their philosophy that it was a stronger saddle for roping cows and calves. In general, they had "rank" saddles back then. You can look in some of these old books and you won't see flat-seat covers and "barrel racers" and little old "back ropers," "bull-doggin'" saddles like they have now—that low back just didn't happen. They had different styles, like round skirts and big square skirts. Pretty much all of them had the same type horn. That high back and slick seat was the trademark. They would have never put a suede or padded seat on their saddles. Sitting on a suede seat was like sitting on a piece of sandpaper, as far as I'm concerned. You're sitting there, rubbing . . .it makes you sweat. That slick seat is like sitting in a recliner. You could sit in it all day.

WHAT WOULD A SADDLE COST BACK THEN?

Anywhere from 25-40 dollars. They'd usually pay more for a saddle than they would for the horse! There's an old saying: "You got a 50 dollar saddle and a 10 dollar horse." That's how they felt about it. When the cowboys came in off the cow camps, they'd come into town, and most of them would take a day to sit and just clean up their gear. They took care of their equipment. Saddles, gun rigs. . .they took care of it. They had to. It was their livelihood. And I've read where some of these old cowboys would save up for years just to get the saddles they wanted. ✪

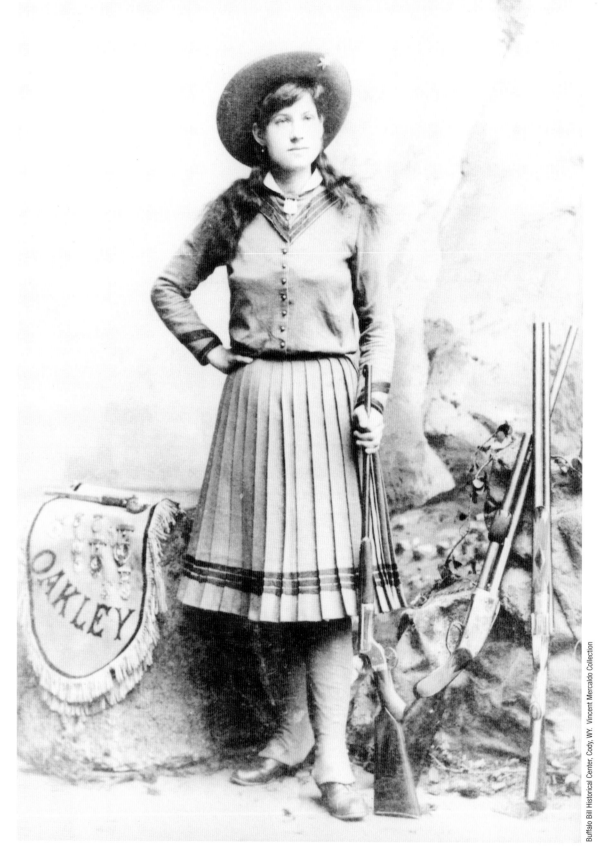

— Annie Oakley —

A few words about Annie Oakley

JIM DUNHAM

Western Historian

Annie Oakley was from Ohio. Her real name was Phoebe Ann Moses and she came from a very poor family. She actually provided the meat for the family table by going out hunting. Basically, she took her shotgun and shot pheasants and game animals. She was so successful that she took the extra birds she killed and sold them to the butchers and people in town. Eventually she became renowned for doing competition shoots. At that time, they didn't have TV or radio, so one of the most popular things in a community was shooting competitions.

This usually happened on a Saturday and the whole community would turn out to see who was the best rifle shot, the best shotgun shot . . . so she would go to these as a young girl and win them. She really became pretty well known. People around her told her she needed to get on with one of these Wild West Shows. I think she worked for another one for a short time before she went to Buffalo Bill. When she joined Buffalo Bill, the best show on the circuit, she approached Frank Butler for a job. Butler saw what she could do, and she became so good that he agreed to work with her. Eventually she became the headliner and he took second billing. In fact, he would hold targets for her. Then he fell in love with Annie and they got married. Their marriage is one of the great romance stories of the West, because it was apparently a very good one, full of love, that lasted their lifetime. So the musical "Annie Get Your Gun" is essentially a true story.

Sitting Bull, who traveled with the show for a while, was so impressed with her that he called her "Miss Sure Shot." So they advertised her as "Little Miss Sure Shot" on the billboards and the advertisements. She apparently was something else—one of the best shots that ever lived. ★

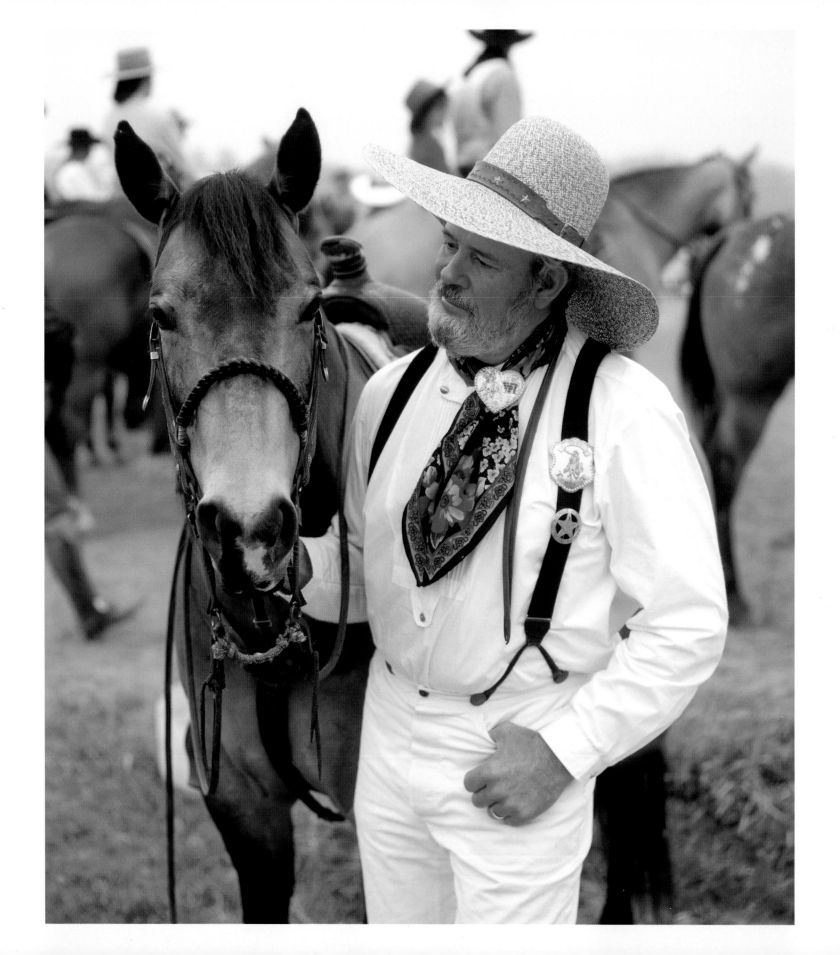

"I've been around horses and guns all my life and it's just a natural thing for me."

DOC BONES

Founding Member/SASS Mounted Shooting

WHAT DRAWS FOLKS TO THE "HORSEY" PART OF THE SASS?

In reality, most of the people who play in this sport were "horsey" before they got to us. It's pretty costly to get into. You have to look at buying horses, horse trailers, a Dually truck to pull it. So it's something that you don't get into just because you think you might like to try it. As a result, most people already have the horses, the trailers . . . and they think "Wow, that's something else that I can use my horse for." We do have some people in the regular cowboy shooting (we call them "Ground shooters") that are curious about us after they've found the sport initially, maybe have horses already but they haven't really gotten into mounted shooting yet. But for the most part, most of us are already horse people.

WHY DO YOU LIKE MOUNTED SHOOTING?

I rodeoed when I was in college, and now it's gotten where I'm not going to get on a bull or a bucking horse anymore, and really can't even step off a roping horse without blowing out both knees. So this is something that I can still do in my "golden years". Can't say that for many other sports. Being able to dress up in period clothes, playing buckaroo—it has a lot of draw. I've been around horses and guns all my life and it's just a natural thing for me.

HOW DO YOU TRAIN A NEW RIDER FOR THE SPORT?

Well, I coached football for nine years. So I thought, "Hey, we need to do this just like in football, break it down to the basics." So when you teach a new rider about mounted shooting, you need to take him off his horse so he can learn *basic* shooting. So we teach them while they're on the ground and not having to worry about a thousand, twelve hundred pounds of horse moving around underneath them. We teach them the correct, most accurate way to shoot. We try and break it down to the half a dozen elements that are in mounted shooting. Once people get up to speed, they shoot at five balloons while riding in a straight line. So when they're learning, instead of being on top of a horse, trying to run at thirty miles per hour, we put those five balloons ten feet apart and have them walk and shoot. ✪

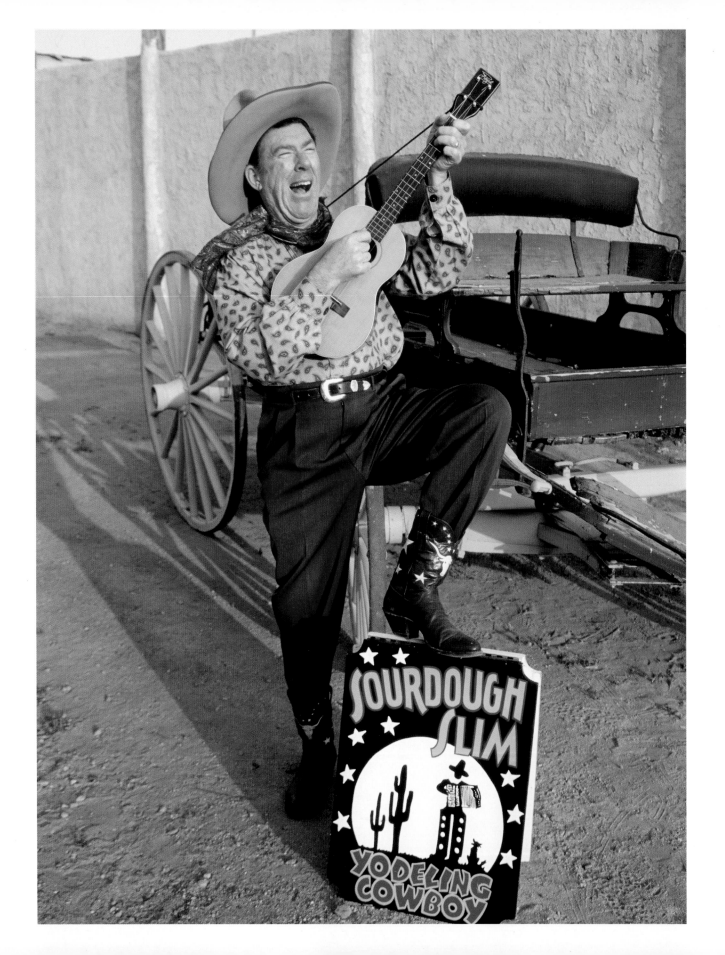

"Sidekicking just comes natural to me."

SOURDOUGH SLIM

Cowboy Entertainer

I'm really fascinated with the history of show business in the Old West. Buffalo Bill had a *huge* influence on that end of things and on the dime novels and all of that. He brought it into everybody's living room or town, even on the East Coast. So, everyone got the experience of the Old West, and its popularity began. And then, of course, the movies came. The cowboy singers took advantage of the whole entertainment aspect of it. Even vaudeville had cowboy singers such as Will Rogers—of course he wasn't a cowboy singer, but a cowboy entertainer. But that's where he got his start, in vaudeville. So when I'm performing, I like to trace that musical history from the time when they were just singing to the cows and to themselves, and then move into the tradition of show business with Buffalo Bill, and then on to vaudeville and the singing cowboys from the movies of the 1920s, '30s and '40s. Being that I'm such a comical character—it's just my nature to be a goof, you know—I've been dubbed the 'cowboy sidekick,' because I'm more of a sidekick than the hero in a white hat. Sidekicking just comes natural to me. So, that's why I tend to do the humorous side of it, the humorous songs: it just comes natural." ✪

Chapter Seven
THE END OF THE STORY

Copyrighted, 1893, by Beadle and Adams. Entered as Second Class Matter at the New York, N. Y., Post Office. January 18, 1893.

No. 743. Published Every Wednesday. *Beadle & Adams, Publishers,* 98 WILLIAM STREET, NEW YORK. Ten Cents a Copy. $5.00 a Year. **Vol. LVIII.**

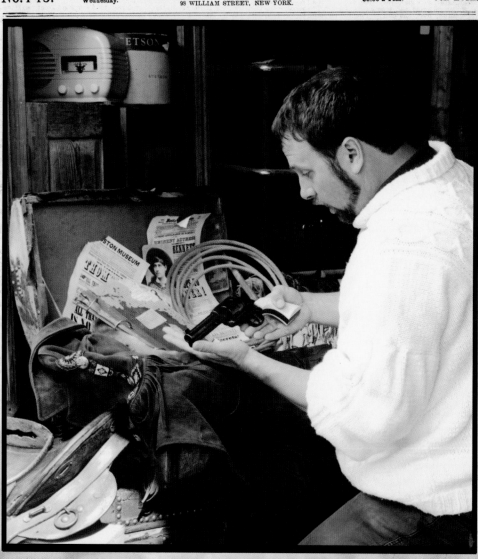

Jesse was fine-tuning his western passion. He had always been fascinated by the history of that untamed and wooly time. He'd read every book he could get his hands on, and his favorite movies always had at least one chase scene involving thundering guns and galloping horses. But lately, he'd found a new love, the Single Action Shooter's Society. He bought a wide straw sombrero and a calico shirt, and was making his way into this new world, soaking up the cowboy atmosphere, meeting current-day gunslingers, and watching as they plugged holes through their modern cares and woes.

A few of his new-made friends had let him borrow guns so he could get a feel for the sport, but he hadn't bought his own yet. "Stringbean Stevens" was selling a sweet Remington 44-40 for a pretty good price. The "Macon Kid" was getting rid of a Smith and Wesson Schofield that felt pretty good in the draw. But none of them sang when he held them in his hand. Until he found his perfect match, he'd wait and dream of the day when he could walk down the dusty main street of their weekend western town with real iron strapped to his leg.

In the meantime he studied. He pored over books as gunfighters, lawmen, Buffalo Soldiers, and hardheaded frontiersmen came to life, their stories leaping out of the flat, black and white text and tin-type photos on glossy pages. He checked into his own family's history as well. Jesse found that he had sprung from a long line of Texans who had forged their own way through the perilous Wild West. His family history read like a dime store novel, detailing bloodlines good and bad: a card hustler, the owner of a two-bit saloon. He even found out that his Great-great-aunt Beka on his mother's side, had been a rider in Buffalo Bill Cody's Wild West Show.

Apparently Aunt Beka had never had any children, and when she died, still spry and riding horses at the age of 95, all her things were packed up and left in the old "home-place" outside the town of Laredo. She had willed it all to his grandmother Katie, who lived there now.

Jesse was fond of the old woman. Even

had "favored grandson" status, and when Grandma Katie found out about his love for Western history, she told him that he needed to come and see what Aunt Beka had left behind. She added, with a twinkle in her voice, that Jesse could have anything he could find, so long as he took good care of it

Jesse soon found himself climbing the creaking stairs into the attic of the old house. Grabbing the tarnished brass doorknob, he opened the door with a brittle creak. The young man took in a snootful of the musty smell of passing time. A moth-eaten deer head regarded him with wide, glassy eyes and sunbeams do-see-doed with a thick cloud of Texas dust. Wasn't much there . . . an old iron bed and some boxes standing watch in the corner. The young man was a little disappointed, but he rolled up his sleeves and began to tackle the stack of boxes.

He uncovered the kind of stuff you'd find at a church rummage sale. Paperback romances and faded "little old lady" clothes. But then he found the trunk. It was over a hundred years old, from the looks of the heavy brass fittings. Putting his hands on the camel-backed lid, he opened it, careful of the crumbling leather hinges.

It smelled old. But this was different from the stale smell of the attic. It was a crisp scent, like aging linen and lemon verbena. There was a small buckskin jacket on top. The doeskin leather and intricate Indian beadwork crumbled in his hands as he carefully lifted it out. Beneath it was a packet of heavy, creased paper. Carefully he unfolded it, revealing a dog-eared poster, still bright and proclaiming, "Buffalo Bill's Wild West Show!" In a leather keepsake book he found playbills advertising "High Drama from the Western Plains." And "See Buckskin Beka as she SINGLE HANDED-LY SAVES her TRUE LOVE from the RUN-AWAY STAGE-COACH!" In the back of the book he found a picture of her. . .a tintype photo of a pretty, dark-headed girl and a light-colored horse stiffly posed in front of a painted backdrop.

The trunk was almost empty when Jesse reached down into the dark bottom and brushed an oilcloth bundle. Wrapping his

fingers around it, he started to pull it out. His heart jumped when he felt its familiar weight. Could it possibly be a gun, left up here for a hundred years? The young man carefully untied the twine, unfolding the stained cloth. He was certain now. It was a gun, wrapped in a shroud of fine linen.

No telling what shape it was in, after all these years. Probably rusted and stiff with age. He pulled back the last fold of linen and held his breath. There she lay. . .the Peacemaker. . . .the gun that had tamed the Wild West. Her steel gleamed softly in the faded attic light. He ran his thumb across the engraved ivory grips. Beka had loved this gun, carefully cleaning and oiling it for the last time before she laid it to rest. Jesse took it into his hand and it fit like a dream. . . like it had been waiting just for him.

The late afternoon sun slanted thick across the wide sill of the window as Jesse carefully packed up the things he'd found in the old trunk. Holding the oilcloth bundle in his hands, he stood and brushed the Texas dust from his pants. And as the sun's last rays chased him out of the attic, he bounced down the creaking stairs, holding the Peacemaker tightly to his heart. ✎

WANTED

DON CONTRERAS
Alias
OSO CONTRERAS

Guilty of photographing *We Dance Because We Can: People of the Powwow* (Longstreet Press). Wanted in connection with twenty years of commercial and catalog work. Contreras has recently been spotted in Atlanta, Georgia, but has been known to travel internationally, shooting film without mercy. Has been found guilty of shooting book, magazine, and portrait work. He is considered armed and dangerous and is known to carry a loaded Canon at all times.

WANTED

MIMI ALTREE
Alias
DIXIE WHISTLER

Guilty of word pandering and other assorted crimes against the grammar of the United States of America and combined territories. Also sought for Assault and Battery against the English language. Known for consorting with, and writing for, known video production companies, Altree is the Senior Writer for the Weather Channel's Cable in the Classroom series. Believed to have fled to Georgia, she has resumed her life of crime by writing a weekly column for the "Times Georgian" newspaper.

CONTACT LIST

CHAPTER ONE

SINGLE ACTION SHOOTING SOCIETY
23255 La Palma Avenue, Yorba Linda, CA 92887
714-694-1800
www.sassnet.com

TB BOSS ENTERPRISES
Old West Clothing and Gun Parts
770-345-0385
TBEnterprises@mindspring.com

BUFFALO BILL HISTORICAL CENTER
720 Sheridan Avenue, Cody, WY 82414
www.bbhc.org

JIM DUNHAM
Trick Shooter and Western Historian
435 Briar Ridge Lane, Cummings, GA 30040
770-886-7809
sandjdunham@aol.com

LARRY BLANKS
Film and Western Memorabilia
770-460-0752
lblanks@pearlnet.com

CHAPTER TWO

HOG LEG SMITH — Gunsmith
Aka Neal Spruill — Southern Machine Works
Recoil@avana.net

ROD KIBLER SADDLERY
2307 Athens Road, Royston, GA 30662
706-246-0487

JOE WEST — Gunsmith
West Brothers
404-261-4869

JIM DOWNING
PO Box 4224, Springfield, MO 65808
www.thegunengraver.com

BRUCE BROOKHART
Atlanta Cutlery/Museum Replicas
770-922-7500

CHAPTER THREE

LAMAR GREEN — Leatherwork
Tumbleweeds Ranch
706-777-3600
www.tumbleweedshop.com

JERRY WARREN — Cowboy Poet/Performer
835 Buckhorn Rd, Clarksville, GA 30523
706-754-7244

JOE BOWMAN — Shootist/Entertainer
PO Box 571024, Houston, TX 77257

CHAPTER FOUR

TAMMY MCDONALD — Cowboy Recipes
1375 Outer Marker Road, Castle Rock, CO 80104
Cooking It Up/On the Trail, Part II

DOC STOVALL — Cowboy Poet/Songwriter/Singer
PO Box 574, Lithia Springs, GA 30122
770-948-5570

TONY NORRIS — Western Singer
9475 N Doney Park Lane, Flagstaff, AZ 86001
520-526-6684

CHAPTER FIVE

TED VOGELSBERG — Ornamental Blacksmith
Carrollton, Georgia
770-832-6913

COLORADO HATS
431 Front Street, PO BOX 1482, Fairplay, CO 80440
719-836-1411
www.cmhats.com

DOC JOHNSON — Traveling Medicine Show
249 Martin Street, Jefferson, GA 30549
706-367-4163

CHAPTER SIX

SOURDOUGH SLIM — Yodeling Cowboy Comic and Songster
530-872-1187
SOURDOSLIM@aol.com

OCTAVIO ORTA
1301 Hearst Drive N.E., Atlanta, GA 30319
404-264-0292
404-218-7358

CARROLLTON ANTIQUE MALL
Antiques and Western Artifacts
Hutch and Loree Hutchison
770-834-3070

ACKNOWLEDGMENTS

Thanks to our families, our friends in the Single Action Shooting Society, and everyone else who contributed to our dream of making this book a reality.

✪ Don Contreras & Mimi Altree